Printmaking as Therapy

of related interest

The Expressive Arts Activity Book
A Resource for Professionals
Suzanne Darley and Wende Heath
Foreword by Gene D. Cohen MD PhD.
Illustrated by Mark Darley
ISBN 978 1 84310 861 0

Inner Journeying Through Art-Journaling
Learning to See and Record your Life as a Work of Art
Marianne Hieb
ISBN 978 1 84310 794 1

Art Therapy and Social Action
Edited by Frances Kaplan
ISBN 978 1 84310 798 9

Clayworks in Art Therapy
Plying the Sacred Circle
David Henley
ISBN 978 1 84310 706 4

Self-Healing Through Visual and Verbal Art Therapy
R.M. Simon
Edited by S.A. Graham
ISBN 978 1 84310 344 8

The Healing Flow: Artistic Expression in Therapy
Creative Arts and the Process of Healing: An Image/Word
Approach Inquiry
Martina Schnetz
Forewords by V. Darroch-Lozowski and David C. Wright
ISBN 978 1 84310 205 2

A Practical Art Therapy
Susan I. Buchalter
ISBN 978 1 84310 769 9

Printmaking as Therapy
Frameworks for Freedom

Lucy Mueller White

Jessica Kingsley Publishers
London and Philadelphia

First published in the United Kingdom in 2002
by Jessica Kingsley Publishers
116 Pentonville Road
London N1 9JB, UK
and
400 Market Street, Suite 400
Philadelphia, PA 19106, USA

www.jkp.com

Library of Congress Cataloging-in-Publication Data

White, Lucy Mueller, 1944-
 Printmaking as therapy : frameworks for freedom / Lucy Mueller White.
 p. cm.
 Includes bibliographical references and index.
 ISBN 1-84310-708-2
 1. Art therapy. 2. Prints--technique. I. Title.

RC489.A7W476 2002
615.8'5156--dc21 2002021895

British Library Cataloguing in Publication Data
A CIP catalogue record for this book is available from the British Library

ISBN 978 1 84310 708 8

Contents

Acknowledgements

This book began because of Dr Simone Alter Muri's vision. She asked me to teach Printmaking for Art Therapists at Springfield College, Springfield, MA. Students and clients have contributed to the book's content and beauty by sharing their printmaking experiences and by allowing me to publish their artworks. I am very grateful to all. The book is an acknowledgement of three coexisting roles: art therapist, teacher and artist.

Deep appreciation goes to my mother, Jane K. Mueller, for being an artistic inspiration and for introducing me to collagraph printing in 1971. My two children, Laura and Curtis, continually teach me that there are no limits to creativity.

Printmaking as Therapy is dedicated to my father, Robert K. Mueller, (1914–1999), author.

Introduction

Printmaking as Therapy presents various techniques of printmaking for use in therapeutic, occupational therapy or educational settings. The therapeutic use of printmaking is presented because it is very effective in many situations but may not have been explored due to its association with expensive and imposing equipment and complicated processes. Printmaking can use common materials and be introduced in easy, understandable steps to be used expressively by almost anyone.

The definition of printmaking centers on creating a plate or a master from which multiple prints are made. It is an indirect process. Printmaking is at least a two-step process in which the image is created, paint applied then transferred to produce the final product. Printmaking takes more steps than painting or drawing and involves both fine motor and gross motor movement.

Most processes produce an image in reverse. Some printing techniques rely mostly on drawing or linear creation, and there are others that require no drawing skills, just shape making. Printmaking sometimes uses found objects and simple shapes to produce astonishingly beautiful and complex artworks. Non-artists have great success with printmaking because the process itself creates an artistic, graphic product. These aspects have both advantages and disadvantages in their therapeutic application.

Chapter 1 considers the purpose of creating artwork with your clients. For what purpose are you considering printmaking? What are your needs and what materials are available? Are you looking for a medium that will allow maximum expression for the client to focus on his or her issues? Is the process of creating an artwork the primary satisfaction for someone? Does finishing a product he or she can be proud of

serve another clients best? Actually all three aspects can be served by different printing processes.

The history of printmaking is reviewed in Chapter 2 to show a direct correlation between developing a process and meeting a need. Historically artists have used each printing medium to express emotion, disseminate information, encourage social change, advertise, illustrate, document, identify groups, organize their wares and for many more reasons.

Chapter 3 provides general information about using printmaking in a therapeutic setting as well as details specific to printmaking. At the end of this chapter each technique is rated according to physical and cognitive difficulty, safety, time needed, line or shape suitability, appropriateness for long or short term applications and whether a press is required or not.

Chapters 4–9 follow a specific format. There is a general description of each one of the four processes (relief, intaglio, planographic and screen). The relief processes of stamp printing and relief plates make up two chapters, and screen processes are divided into stencil and screen chapters for convenience. Explanations are given for general equipment or supplies needed for the process followed by specific instructions for a variety of different techniques within the process. Instructional chapters are presented in order of the way they developed historically not according to the level of difficulty of the process.

Each instructional chapter also includes clinical applications to illustrate theoretical concepts. In art therapy journals and books, I have found very few mentions of printmaking used in art therapy. The theoretical concepts and associations of this book are my own. Case studies are from my own clinical experience. My discussion of supporting literature to illustrate a theoretical concept is either my knowledge of art therapy added to a teacher's experience or my experiences as a printmaker reviewing the comments of another art therapist writing about an experience with another form of artmaking.

Relief printing requires several simple steps and repetitive motion to stamp, roll or print. Much of the theoretical emphasis of Chapters 4 and 5 relates to encouraging motion and enhancing the cognitive and physical abilities of clients to engage in the process of artmaking, the process of art

therapy. Another focus is on reducing resistance to allow clients to partic-
ipate in the process.

Intaglio processes described in Chapter 6 are most suitable for line
reproduction and as such are most appropriate for populations interested
in drawing. A client's process affect the content of his or her work and
allows him or her personal process to remain in control. The links
between art teaching and art therapy are also explored. Intaglio process
lends itself to long-term art therapy situations.

The most clinically appropriate planographic process is monotype
printing, described in Chapter 7. Because monotypes are one of a kind
and because they are so spontaneous and fluid, the theoretical emphasis
of this chapter is upon spontaneous image making and focus on the
person creating the artwork. There are instructions for many variations
and applications to diverse populations.

Screen and stencil processes require more time and equipment and
produce many multiples, so the emphasis of Chapters 8 and 9 is upon the
products of art therapy. The chapter also includes examples of
printmaking in workshop situations to build group cohesion or develop
cultural identity.

After these informational chapters, Chapter 10 is about creating
books using prints. The instructions can also be used to create blank
books. Examples are included of traditional and expressive book forms.
The range is from simple to complex, but the emphasis is upon the thera-
peutic and symbolic use of the book form rather than on technical com-
petence.

Chapter 11 discusses the combination of art history and art therapy.
Prints of the American Abstract Expressionists document the expressive
power of printmaking. There is a summary of printmaking advantages
and disadvantages and suggestions for when printmaking would be most
valuable. The Appendix suggests material suppliers.

I hope that this organization will help you develop skills and master
the basic processes then encourage you to experiment and combine.
Certainly printmaking is to be considered one of many techniques for
expression, and the materials may be used in many ways. I do not propose
to substitute printmaking for drawing, painting, clay modeling or any

other art expression. The intent of this book is to suggest printmaking as a supplement or alternative to the many methods of artmaking.

The issue of production is an integral part of this book because printmaking produces multiple images and thus the opportunity to do something with the products created from a session. Fortunately the physicality of printmaking also makes it easy to focus on the process of artmaking because it is easily observed as well as satisfying in and of itself. Some of the techniques are almost as fluid as painting and allow maximum expression, so the person creating the artwork can be the focus of a printmaking session. Whether the therapeutic focus is upon the product, process or person, there is a printmaking process that could be advantageous for most clients. My goal is to encourage experimentation and innovation and provide more tools for the therapist, teacher or artist (Figure I.1).

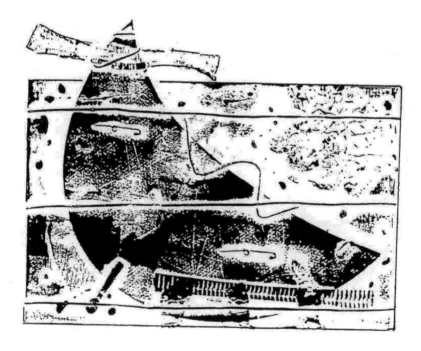

Figure I.1 Untitled two-session collagraph relief by JS

Printmaking bridges the gap between craft and artmaking. In art therapy we encourage original creativity complete with its own set of problem solving experiences and rewards. Although there is satisfaction in following a pattern to make a basket or tracing a drawing, we consider that art activity is not art therapy mainly because there is no opportunity for developing personal imagery and ideas. Printmaking involves steps and construction similar to many craft projects, but it provides the opportunity for individual image making and creativity. 'Working with your own image-making process connects you to your creative potential' (Malchiodi 1998b, p.69). The thesis of this book is that printmaking provides for art therapists an intriguing way to get people started making artwork, provides a structure and safe form for expression but also allows for creative expression. Some printmaking processes encourage more spontaneity than others, some are linear methods, some work best with shapes, but there is a printing process that is helpful for most clients.

Removing the mystics of chemicals, fancy equipment and complex directions are the goals of this book. Encouraging the practice of printmaking with various populations for a wide variety of goals is the focus of this book. Removing the blocks and ignorance surrounding this very valuable and expressive art media is my passion. I hope that this book will be a resource for art therapists, occupational therapists, rehab therapists, teachers and artists.

Why Choose Printmaking for Art Therapy?

Product, process and person

Ault (1986) proposed a three-part understanding of art therapy: the product, the process and the person. The word 'process' may be confusing because it is used so frequently here. Ault uses it to describe how someone does or engages in the artmaking. Printmaking is also described in four main processes, four ways that the artmaking is actually done. In Chapters 4–9, I have focused on the strengths of each printing process to serve different needs.

Product

The unique aspect of printmaking compared to other media available to art therapists is the production of multiples. Multiple products are discussed in Chapters 8 and 9. In cases where a product is a valuable goal for therapy, printmaking is invaluable. Artistically satisfying products can be made with beautiful colors and adapted materials. Useful products can be created for many purposes. The interaction of a group to produce a product, and the purposefulness of printing for rehabilitation and vocational training are emphasized in Chapter 9.

Process

Focus on the process of creating artwork is also an extremely valid reason for choosing printmaking. It is especially appropriate for relief printing as presented in Chapters 4 and 5. Each printmaking process involves at least two steps to completion. In cases where process needs to be divided into small increments, printmaking is well suited. Training skills are measurable. In addition, these processes can be shared by several clients, used to enhance group development or understand group process. The physical demands of printing can also be a challenge or a benefit when working with physically challenged individuals. The sensory stimulation of the movements of relief printing in particular is especially helpful to selected clients. Repetition with subtle differences can be satisfying and soothing.

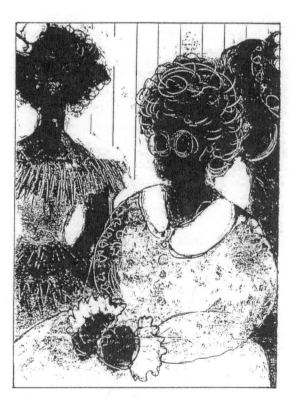

Figure 1.1 'Family Secrets' combination monotype by LM

Person

The variety of expression available in the monotype planographic printing process is the central benefit explained in Chapter 7. The fluidity of monotypes puts the center of attention upon the creative expression of the client and gives another medium to the therapist who needs to focus on issues of personal exploration, self-understanding and insight. The plate contains the emotion and allows the client to develop some mastery of intense feelings and still feel contained and safe. The multiplication of an image can also be useful to explore different possibilities with one image in order to thoroughly explore it (Figure 1.1).

Variety of expression: lines and shapes

Each of the four processes (relief, intaglio, planographic, serigraphic) involves a different way of creating a plate or master image, applying paint and actually printing the image. Some of the processes are more suited to line images, others to images created from shapes or planes. Some are more expressive than others; some require drawing skill, others require none at all. Some clients love to draw, many do not. For clients who love to draw, Plexiglass® drypoint, an intaglio technique described

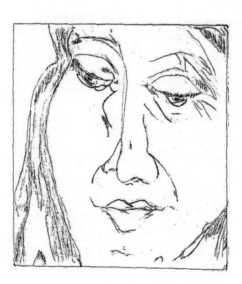

Figure 1.2 'Lydia' drypoint by AS

in Chapter 6, can be compelling and focus energy in a powerful way. See Figure 1.2 for an example of drawing using drypoint printing. Unfortunately some clients are physically unable to draw and can benefit tremendously from the many techniques that print shapes. At the end of Chapter 3 is a table listing each of the specific techniques presented and characteristics including whether it is easier to work with lines or shapes.

Therapeutic distance

Printmaking is indirect and most of the time the images are in reverse; that is a challenge and opportunity. This complex and multi-stepped artmaking process has a distinct advantage for art therapists because it produces a distance from the artwork that can be beneficial for some clients. All relief, intaglio and planographic printing creates an image in reverse; that surprises me even though I am prepared for it after over 30 years of printmaking. I am never exactly sure how a print will come out: the 'pulling of a print' is always a bit of a mystery and holds some apprehension. This I see as a benefit in creating therapeutic distance. There is a lack of control and a sense that the process itself creates some of the resulting artwork, and that can be frustrating but enormously freeing. The simplest example is an inkblot or foldover monotype. No one can predict how colors will mix and blend when folded between a piece of paper. What a perfect opportunity for projection.

The distance between the finished artwork and the beginning of creating a stamp or plate gives clients a chance to slow down, engage in the therapeutic process and even control violent imagery. Making a drawing of a horrific memory is sometimes more than a client can do. Taking time to create a plate from tapes, strings, glue and collage is a different experience. One is not better than the other, but printmaking gives another option, one with form and structure – a framework.

Printmaking reduces resistance because of its mechanics and unpredictability. Printmaking will probably be a new experience for your clients, so they will have to rethink old images, see them in reverse and in a new way. Even experienced artists will be challenged.

Because printmaking has several steps and feels more like a craft than painting, printmaking allows clients who are afraid of their own

pathology or embarrassed about their deficits to participate in art therapy. Many more clients may be included in art therapy who would otherwise be excluded or self-exclude. One of the differences between art therapy and other talking therapies is its ability to show a client's strengths as well as pathology, and printmaking facilitates artmaking for many.

Sustaining a vision

Chapter 10 evolved because of the proliferation of prints that students create when taking my graduate course Printmaking for Art Therapists. Their final project is to make an artist's book from the semester's prints and learning. The intensely personal, powerful books that they create thrill me more than anything else I have seen since I started printmaking. The holding power, the containment and the beauty of creating a book have immense therapeutic value. The range of collections of prints that are called books is surprising and inspiring. Using prints makes creating artists' books easy.

Structure and containment

The benefits of using printmaking for structure and containment are illustrated by a discussion of the life of Edvard Munch (1863–1944) and his production of both paintings and prints. Munch's life and art were mired in recurrent themes: 'the nature of sexual attraction, the meaning of death, and how both could be related to his art' (Dunlop 1977, p.1). Munch's personal struggle with physical and emotional illness was obvious and reflected in his artwork. Clearly emotional, his paintings struggled to find the right form to express his intense feelings. He was obsessed with subjects and painted them over and over again.

In 1895 Munch began making prints; this enabled him to repeat and refine his images and themes still further. The techniques seemed to give him fresh inspiration. It is interesting to me to see reproductions of a painting juxtaposed with a print (etching or lithograph) of the same subject. Some of the prints are reverse images because the artist had to work in reverse to produce the same image; sometimes Munch did so and other times he did not. The changes in style and details are also interest-

ing, and I wonder if it was the smaller size or the physical demands necessary to make each mark that made the changes. Munch started out making etchings, then lithographs, finally woodcuts. Dunlop (1977, p.4) remarks that 'in this almost lost art form he showed amazing ingenuity.'

Munch combined techniques and experimented with printmaking in many ways. Dunlop goes on to say that printmaking provided 'a more intimate platform for his work' that I maintain is attributable to the containment and structure provided by the printmaking process. Woodcuts require very controlled motion, specific hand strength and are limited in size to the size of the plate or paper available for printing. Prints slow down the creative process. From Munch's words, 'art is crystallization,' I deduce that printing crystallizes the emotions. The availability of prints of Munch's work also spread his fame, helped his finances and improved his critical standing.

Munch's personal and emotional problems forced him to seek psychiatric help in 1908. The records are vague and speak of 'nervous crisis,' 'depression' and some indication of paranoia (Selz 1976, p.68). It is known that he went to the neurological clinic of Professor Jacobson in Copenhagen and stayed for seven or eight months (p.65) while he underwent treatment. During that time he created prints including one with a nurse and equipment for electric shock therapy. Munch wrote on the caricature, 'Professor Jacobson is electrifying the famous painter Munch, and is bringing a positive masculine force and a negative feminine force to his fragile brain' (p.68). After hospitalization Munch's alcoholism was reputed cured, and he returned to Norway and produced a great deal of artwork. His later work revealed fewer of his anxieties.

Selz assesses the effect of Munch's hospitalization on his long career negatively. According to Selz (1976, p.76), 'everything in his painting that bears the mark of genius – that plunge into the dark recesses of the human being, which he expresses with a gripping power' occurred before his hospital stay. Dunlop concurs and suggests that Munch's old fears were probably still there but 'perhaps his breakdown had made him reluctant to examine again the anxieties which had inspired the great pictures of the 1890s' (Dunlop 1977, p.5).

It is important to note here that Selz and Dunlop are art historians, critics of the artwork, certainly not practitioners of art therapy or thera-

pists of any kind. Other details in both books cited here describe Munch's life before 1908. There were aggressive outbursts and fights including one where he lost a part of one finger. A horrible prank was played on Munch by friends. His friends told Munch that a woman who was seeking his love unsuccessfully was dead. They brought him to see her 'lifeless' body, and she popped up, hoping that in his joy of seeing her alive he would marry her. The prank certainly had its repercussions to his mental health and relationships. Munch's many fights, the deaths of many of his loved ones and his alcoholic binges are familiar to many art historians. Selz's and Dunlop's assessments are based in their understanding of the success of Munch's art style not the satisfaction or sanity of his lifestyle.

Selz's subchapter 'aesthetic disorder' describes the difference in Munch's work by describing his painting before and after 1908 (and his hospitalization.) Munch's early works, according to Selz, were paintings 'executed in an atmosphere of reflection' (p.76). It was a system of 'complete mastery' of color, composition and technique, that was non-violent even though it showed his anxiety and fears. Then the paintings got violent, 'ruthless and disorderly' with rapid brush strokes and clashing colors and disharmony. How often do we see that in the work of our clients? Selz goes on to say, 'it is as if the violence of which we find numerous examples in Munch's life, and of which he had been cured by his sojourn at the clinic, had been suddenly carried over into his painting. But if such a process was beneficial for his mental condition, it was to the detriment of his art.' The violence in his paintings I see as sublimation of his violent thoughts and self-destruction.

After his clinic visit, Munch said that he would 'wish to find a corner of absolute tranquility so that I can paint in peace' (Selz 1976, p.83). Selz continues to assess that Munch's more tranquil later works were 'extraordinarily agitated in style,' without draftsmanship, structure and paint was 'hurled' at the canvases. She uses terms like 'haphazard,' 'unrestrained,' 'helter/skelter' and sums up the effect as 'aesthetic disorder.' She also calls this work 'spontaneous' and 'unreflective' and describes some of his later murals as 'laborious,' 'impoverished' and concludes 'patient effort has succeeded violence' (p.89).

In spite of the change in his work, Munch became a national hero during this later part of his life. Selz's disappointment at the uneven

development of Munch's work and thus her inability to categorize him in one theoretical school of art is frustrating for her, but she does end the book saying that his art was very much affected by his personal life.

One of the few references I have found to printmaking and art therapy is Landgarten's (1990) article 'Edvard Munch: an art therapist viewpoint'. Landgarten reviews Munch's artworks using the House Tree Person assessment and discusses the effect of his hospitalization on his creative expression and emotional health. Landgarten suggests that if she had been an art therapist at the sanitarium in 1908 and had Munch as a client, she would have suggested printmaking for his artistic and therapeutic artmaking.

In Landgarten's article, her clinical assessment is that Munch's early large, multicolored painting totally immersed him and intensified his obsessions. His painting kept him 'in a heightened emotionally unbalanced state ... Munch's demons were not exorcised through his art, they served to fan his torment' (p.15). As an art psychotherapist she would have offered him symbolic containment, greater control including smaller size, reality based subject matter and limited use of color and hue. 'The nature of the print-making media provides the necessity for both structure and control: these two elements were necessary for Munch to function as a person, one who would cease his self-torture and self-destruction' (p.16).

Munch's life story is indeed an interesting case study for all art therapists who struggle with issues of madness and creativity, structure and expression, containment and expansion. We must constantly weigh the benefits of creative expression with safety and personal satisfaction. 'Aesthetic disorder' is not a negative term when it explains how art can sublimate intense emotions.

My inclusion of Munch's story in this book mirrors personal clinical experience. Munch's exposure to printmaking changed his artistic expression and contributed to his 'aesthetic disorder.' The prints he produced were small (20" x 18") compared to his oil paintings (some 45" x 60" or larger) which were often life-sized portraits. The size of printing plates alone would tend to provide more control and structure or containment of his often overwhelming expression.

In his lifetime Munch produced 1,008 paintings, 15,391 prints, 4,443 drawings and watercolors and six sculptures. Munch said: 'the last part of my life has been an effort to stand up. My path has always been along an abyss.' It is of interest to me that his prodigious production of prints happened after the emotional painting of the 1890s, but he kept working and stayed perhaps less appealing to his critics but sober and not controlled by his fears and demons. During the last 30 years of his career the range of his vision increased. He revealed the harmonies of nature and issues of his native Norway. He reworked previous themes with greater objectivity and also created duplicates to assuage the pain of parting with sold artwork.

Selection of an appropriate process

The selection of a printing process for a client is an important one. What works for one person may be a disaster for another. I hope that this book will serve as a guide to help you choose what might be most rewarding for your client. The review of history that follows is to show the relationship between materials, form and function. The art of art therapy is powerful and expressive, but your clients will experience it most effectively if you provide the structure and simple materials to allow for safe exploration and creativity.

The immense variety of materials and technical printmaking processes poses quite a challenge to the art therapist who wants to incorporate printmaking into art therapy. The goal of this book is to provide encouragement, information, practical applications and a desire to experiment. The many therapeutic advantages and distinct disadvantages are discussed in detail, but full application of these processes are still to be explored.

CHAPTER 2

A Brief History of Printmaking

Printmaking is basic

The history of printmaking from the earliest remaining examples to
current methods is actually a review of the materials available and their
use to meet the needs of different civilizations. In general, the study of art
history makes the past become visible and accessible because we actually
see objects and images that have survived from past cultures. We try to
deduce function and meaning from observation and study of these
artifacts.

The evolution of human hands and their ability to form tools made
humans 'creating' creatures. From prehistoric times about 2 million years
ago, we have fragments of early tools. Humans are able to make not only
functional objects but also images of objects in the world around them
and of unseen but imagined or felt ideas. We have early Paleolithic figures
carved by rough tools dating from about 40,000 years ago (Preble and
Preble 1994, p.279).

We know now that early humans also made the first prints. In an
article in the *INORA International Newsletter on Rock Art*, Baffier and
Feruglio (1998) published research on the art discovered in
Chauvet-Pont-d'Arc cave in Ardèche, France. Their research dates the
origin of the cave art as created 30,340–32,410 years ago. The discovery
shocked the archeological world because of the over 400 drawings of
beasts that are portrayed there (rhinoceroses, bison, mammoths, horses,
reindeer, birds, lions and bears) and the original shading and perspective

of the rendering. Of special interest to this book are the two groupings of red, painted dots near the current entrance to the cave.

Researchers figured out how these dots were done and made an assessment of the people who made them. The dots are palm prints. There are traces of marks made by the fingers also, but the intent clearly seems to be to make prints with the palm. A thick layer of pasty ochre colorant was applied and pressed onto the cave wall in a pattern of about 50 dots by one person and a similar adjacent pattern a little lower by another person. Researchers say that the lower dots were made by a moderate size female or teenage boy, the larger set by a male around 1.8 meters tall. The traces made by the fingers show us how the artist must have been positioned. This is the first discovery of its kind in parietal art, but it probably will not be the last. The authors imply that there is symbolic meaning to the dots, but they do not know their significance.

Additionally, farther in to the cave in the 'Gallery of Hands' are stencils of hands. Pigments were blown against the cave wall around an outstretched hand. They are stenciled hand prints within a colored background. Nearby there is also a trail of footprints about 50 meters long in the clay made by a male about 1.3 meters tall and about the size of a modern 8- to 10-year-old.

In a more recent article, 'The 32,000-year-old woman,' scientists are saying that the cave was used 'as a sanctuary for practicing religious rites' (ARTnews 2001, p. 80). Drawings of a female form claim to be the 'oldest depiction of a human being' ever discovered.

Can we assume that early people also made impressions of their hands, feet and bodies as a mark of their identity? As magic to ward off the enemy? Just for fun? To mark their territory? What did they mean? When we watch a small child today playing with finger paints or food, do we see the first attempts at printmaking with a hand print? A thumb print? Is this first printmaking innate to the species?

In my first classes on printmaking, I have students introduce themselves by making small cartoons with their thumb prints. It is easy, natural and very much a reflection of who they are. Making cartoon people or creatures from a fingerprint seems to come naturally and needs little instruction.

As a common practice in US hospitals, a baby is first identified by a foot or hand print placed with other identifying information and the mother's fingerprint. Unfortunately, in our current culture where finger-printing is often associated with crime, some people may rebel against creative exploration of fingerprints or thumb prints; but each fingerprint is a unique representation of a person and as such is the beginning of the history of printmaking of our species.

The physical gesture of printing the finger, the thumb or the hand is an action that could be helpful and powerful as a tool in art therapy because each is a part of the self. A child experiments with voice and movement from infancy on, but those experiments produce results that are transitory, no evidence remains. The child tries to control his or her body and environment with sounds and movement. When the action results in a permanent mark and the child recognizes that correlation, the beginnings of what theorists describe as the scribbling or manipulative stage begins (Lowenfeld and Brittain 1987, pp.100–115; Hurwitz and Day 1995, pp.62–70).

The stage of artistic development Lowenfeld and Brittain (1987) clearly describe is the period from 2 to 4 years, the scribbling stage, the beginnings of self-expression. They call it scribbling and mark making but delineate only the scribbling stages. Scribbling is mark making with a crayon or other implement to make marks that are different each time until the child masters the skill and is able to repeat the same mark.

Is experimenting with a thumb in mud and making repetitive marks first in a random fashion and then in a controlled way also a part of the beginnings of self-expression? Using a crayon and creating distinctly different marks involves greater control and perhaps creativity, but there is also value and creativity in using an object to print marks. From that early discovery of reflection of self ('I was here!') in an empowering gesture such as a hand print, can come the power of multiplication, making multiples, quickly and easily. Stamp printing or using found objects to print is a natural evolution from hand or finger printing and is introduced here for consideration for therapeutic use.

As therapists and teachers, we often have clients who for one reason or another are not able to make marks with a brush or crayon and could benefit by being able to make marks, indeed complex designs or stories,

with simple stamp-printing methods. Clients with physical impairments, either genetic or acquired, developmentally delayed clients and elderly people may have physical or cognitive limitations that suggest simple stamp printing would be beneficial. Simple stamp-printing activity can also be helpful to reduce resistance or overcome blocks to participation with clients who have the physical ability but need to have some immediate success with their artmaking.

In contrast, stamp printing has been enormously popular with sophisticated fine crafts people marketing goods, especially clothing, to contemporary speciality outlets. Clients can also use simple stamps to create powerful, complex and meaningful artwork. See Chapter 4 and Figure 4.1, 'Very Mad Man,' as an example of this aspect of printmaking and its many applications.

Connection between materials and function

Prehistoric hand printing, although innate, was individual and has not changed. Technology and materials remained unavailable for further development in printmaking until the last 2000 years. The most popular reasons for the development of printmaking have historically been pragmatic ones. The earliest technology evolved first from simple, available materials. The history of printmaking mirrors the history of technology and the advancement of civilizations and their technological needs and the materials available to meet those needs.

In the following description of the history of printmaking from that time, consider that it is the need for reproduction or repetition and the materials available that determined the development of the various printmaking techniques. Keeping that in mind can also help you to determine what materials and printmaking techniques respond best to the need and functioning ability of your clients.

Relief processes: stamps, woodcuts

Relief printing refers to the process used to create a print. There are four basic ways (processes) to make a print from a plate (see Figure 3.3, a drawing of the four processes, in the next chapter). Relief printing was

the first to evolve and is the simplest. Briefly, relief prints result from applying paint to the raised printing surface, the paint is on top of the plate. The areas to be printed are raised or the unwanted part cut away. Paint is applied to the raised surface. The plate is then either pressed onto another surface to be printed or paper is put on top and pressed to release an impression.

Early civilizations used carved relief forms to make multiple impressions for practical reasons. In the Indus Valley of northwest India, excavators have found evidence of a highly developed culture estimated to be flourishing around 2000 BC. Among the artifacts recovered by anthropologists are many stamp seals, most with still undeciphered script and bas reliefs of animals. Similar seals were found in Mesopotamia. Their use is unproven, but the style and skill used in the carving is exquisite (Lee 1964, p.22). The Mesopotamian seals were carved from semi-precious stones and metals and served as signatures. Evidence has been found of seals for men, women, slaves, commoners and kings. They were as common and important for identity as a driver's license is today. Similar artifacts remaining from other cultures are assumed to have been used for branding animals or criminals, marking property, recording ownership or inventorying. Cylinder seals replaced stamp seals in the fourth century BC but then later returned (Avrin 1991, pp.67–68).

Use of printing on different surfaces was a functional one of identifying, sorting, labeling and mainly served commerce. People used what they had to do what they needed to do in as efficient a manner as possible. Looking at examples we note that early relief, stamping symbols also reflected individual styles and some decorative attention.

A coin by definition is money that is stamped according to some standard of weight and value. Some of the oldest coins were made in Aegina, Greece. Early coins were stamped with portraits of the gods and goddesses, and it was not until 330 BC that Alexander the Great had his portrait imprinted on coins. This is how we know what some of these ancient rulers looked like.

In the evolution of thought very few inventions have been as important as the development of the printed word. 'The cultural impact of printing was without parallel until our own age of computers, photography and mass communications' (Saff and Sacilotto 1978, p.7). We look

to Asia to see how printed images functioned in the beliefs and thinking of a prominent culture that eventually disseminated over a large geographical area.

The earliest printed images were found in China and were relief prints. Chinese artist craftsmen used wood blocks to print on cloth earlier, but the first images reproduced on paper originated in China with the invention of paper about AD 105. Images from carved stone or wood were transferred to paper and used in the spread of Buddhism. The sutras or essential truths of Buddhism were transferred by scrolls of words and pictures to millions. The classic Diamond Sutra by Wang Chieh in AD 868 is a magnificent example of early printmaking taken from a woodcut. It is printed book on seven sheets of paper (Avrin 1991, p.322).

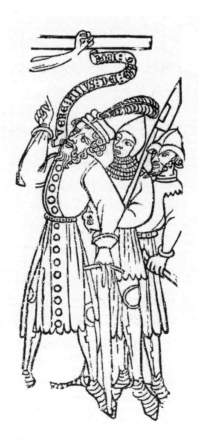

Figure 2.1 'Bois Protat' woodcut, c. 1380, French

The need was to spread the word of Buddhism; the materials readily available in China at the time were wood, stone and then paper. The emotion, artistry and information contained in the prints is of great historical significance and shows the power of the multiple images to spread a doctrine to large numbers of people. Looking at examples of these early works shows us not only much information but also emotion.

It was centuries before western woodcuts developed to fill a similar function. The earliest surviving woodcut block from Europe dates from about 1380. Known as Bois Protat, it is a fragment of a block depicting the Crucifixion and was used to print on cloth (Figure 2.1). It was not until the 1400s that enough paper was available in Europe for printing of religious and secular images.

Germany was the fifteenth-century hub of printing and many examples remain. The woodcuts called heiligens were a way for people of modest means to have images to venerate even if they could not afford a painted picture. Much superstition ruled their lives. Pilgrimages to holy shrines were important, and artisans made souvenirs to sell just like they do today (Avrin 1991, p.332).

In contrast to the dominant position of religion in people's lives, printmaking provided cards for card games which were a principle source of secular pleasure in all classes of society. Early in the fifteenth century, woodcuts were also used to illustrate simple books. The books, mostly of biblical stories, had pictures and words carved on the same block. Most of the general population was illiterate, so the illustrations were the main way to understand the religion that was the main force of their lives. Development of movable type by Gutenberg in 1450 and improvements in technique raised woodcut art to new heights during the renaissances and reformations that affected specific areas of Europe at different times.

Considered to be the master of woodcut artistry, the German Albrecht Dürer (1471–1528) worked to support the growth of Protestantism and also on propaganda projects for Emperor Maximilian. Dürer's popular success as a printmaker was related to most Europeans' horror and obsession with the changing of the century. The fear that 1500 would be the end of the world spawned Dürer's illustrated Apocalypse, 14 full page woodcuts. 'Four Horsemen of the Apocalypse' (1498) is the most famous (Cole and Gealt 1989, p.129). During this century

relief printing was the main means of communication other than talking, music and dancing.

Metal was introduced and used for printing in the same relief manner as woodcuts. During the seventeenth and eighteenth centuries most printing was for making books (chap books) for the general public, the major source of visual communication. In the early nineteenth century movable type wood blocks, one for each letter, were replaced by metal block presses that could reproduce more images and more quickly. Nineteenth-century relief prints in the United States and in Europe were used for illustration, political commentary and the beginning of cartooning. In the late nineteenth century, relief book illustration was quickly replaced by photography, and printmaking became relegated to use by artists for expressive purposes.

The culture of Japan was virtually unknown to foreigners for hundreds of years until Commodore Perry initiated trade with Japan in 1854. Japanese ukiyo-e woodcuts of everyday life became available first when they were found as packing paper in goods from Japan. These interesting prints sparked the interest of the western world. The unique artistic style of the East influenced many artists of the time. Westerners started to copy the style of Japanese printmakers. Notably, Paul Gauguin and Edvard Munch incorporated the flat planes and shortened perspective of Japanese artists like Katsushika Hokusai and Ando Hiroshige (Saff and Sacilotto 1978, pp.7–36).

In Asante, Africa, starting in the nineteenth century pre-colonial times, relief printmaking was used to make one of the prestigious royal crafts, symbolic cloth. Adinkra printing on cloth reportedly began following the capture in Ntonso of a rival monarch named Adinkra. The cloth he wore expressed his sorrow at being taken to Kumase as a captive. The cloth and designs are still printed today (Adire 2001). See Chapter 9 for discussion of the use of such cultural identity in art therapy.

Contemporary printmakers Leonard Baskin, Helen Frankenthaler, Carol Summers and Jim Dine are a few of many contemporary artists who have explored woodcuts with dramatic results.

The skill and strength required to create a woodcut can be daunting and even dangerous but the relief process is important to the purpose of this book. The materials and resources available to us now can create

prints similar to the woodcut without the need for sharp carving implements and hard wood. The process of relief printing is very appropriate for the art therapist because of many simple adaptations as described in Chapter 5. Modern plastic products provide many soft, impressionable surfaces to cut into, often with minimal pressure. Adhesive products allow clients to build up a surface easily. Relief prints can be created ('pulled') by rubbing with fingers, spoons, rollers, pressed with feet as well as with a press. Relief prints can be made by stamping or pressing the plate/block into or onto a surface. The adaptations are numerous and described in detail in Chapter 5.

Intaglio processes: engraving, etching

The second process of printmaking is called intaglio. In relief processes the raised surface receives the ink or paint; but in intaglio processes it is exactly the opposite. Intaglio prints come from incised or depressed areas of the plate that are filled with paint and then printed. The paint is in the crevices (see Figure 3.3 in next chapter). Traditionally the intaglio image is carved or pressed into the plate. The depressed areas filled with paint, the non-printing surface wiped clean and pressure forces the paint from the incised areas onto paper. Getting the incised areas to release paint often requires a press or great pressure. The incising of a hard surface is often demanding, and errors are difficult to correct.

The history of metal intaglio printmaking actually starts in the Middle Ages with goldsmiths and makers of armor. These craftsmen engraved designs into the metal of armor for identification and decoration. They transferred these images by pressing pigment into the designs, placing a piece of paper on top, then pressing to transfer the design for future reference. See Figure 2.2, Martin Schongauer's 'Wild Man Holding Shield with a Greyhound,' 1480–90, taken from a coat of arms as an example of this intricate artwork. In the fifteenth century the use of this transfer onto paper was further developed and called etching or engraving. Like wood block prints, the process was used to create religious imagery for instruction and spreading of the faith. Secular uses included illustrated playing cards, maps and important botanical and medicinal treatises from the Middle East.

*Figure 2.2 'Wild Man Holding Shield with a Greyhound' from a coat of arms
by Martin Schongauer*

Etching, drypoint, mezzotint, engraving are all adaptations using various means to incise lines on hard surfaces, metal or wood. Dürer was also a master of intaglio processes. The many examples of his intaglio prints are exemplary. The line is very expressive, fine details are possible, and contrasts between lights and darks are pronounced.

By the fifteenth century, making multiples of famous artworks was a major function of intaglio processes. The growing middle class wanted artworks by the masters. They could not afford original works because an artist can produce only a limited number of expensive paintings a year, but the artists could produce affordable copies by these intaglio processes. As the centuries passed, the middle classes also responded to satirists who used etching to criticize everything from their government to the social pleasantries of the day. Detailed intaglio prints were used for social criticism during the upheavals and class struggles in later centuries.

Commerce expanded and many needs were met by printing multiples. Exploration of the new world in the sixteenth century found mapmakers employing intaglio processes. As literacy grew so did the demand for printed and illustrated material. Every government and religion used printing to inform, control and satisfy people. The best known etcher of all time was Rembrandt, and surviving examples of his work are numerous. Most famous twentieth-century artists experimented

with printmaking, but some are remembered mostly for their prints. Käthe Kollwitz's prints expressed the horrors of oppression, family anguish and war (Saff and Sacilotto 1978, p.115).

Artists continue to experiment with materials and techniques, and art therapists today can do the same. Instead of the toxic chemicals of the past, modern artists can use polymers to create similar effects with little danger to health or environment. The intaglio process is the least appropriate for art therapy, but modern materials do provide a way for art therapists to use this process in a very creative and expressive way for some clients. The technique of drypoint originally done by scratching up a burr on a metal plate can now be done by scratching on Plexiglass®. Collagraphs can be printed as intaglio prints even without a press. See Chapter 6 for suggested techniques and applications.

Planographic (surface) processes: lithographs, monotypes

Planographic process is not like relief that requires a raised surface or intaglio that requires a depressed surface to hold the paint, but the term planographic describes a process where the paint and plate are all on one plane or surface. The plate is flat (see Figure 3.3 in next chapter). This third printmaking process evolved from frustration and experimenting with the earlier processes.

The discovery and development of lithography is documented, and the story quite amusing. In the 1790s a young, mostly unsuccessful actor and playwright Alois Senefelder was struggling to find ways to reproduce his plays without the expense of the copper plates required for etching. Trying to write backwards on his copper plate and conserve its use, he was using a smooth limestone slab for inking. The materials for etching (wax, soap, lampblack, acid) were nearby. It is reported that his laundry woman came in, and he used the limestone for a laundry list. Later he discovered that this laundry list written in greasy crayon attracted ink and the smooth surface of the limestone could be washed with acid to resist ink so that the crayon image could be transferred to make prints. Senefelder worked with his discovery and perfected this technique called lithography based on the concept that oil and water repel one another

(Saff and Sacilotto 1978, p.183). The term comes from the Greek word *litto*, which means stone writing.

Lithography became highly refined and was used with great commercial success to produce playbills and popular art. The process was simple, free and expressive. The artist could just draw with a crayon or waxy ink onto the surface of the smooth stone. Honoré Daumier used the lithographic process to produce visual satire against the corrupt government of his time. Goya spent his last years exploring the new media. Later, Berthe Morisot, Manet, Degas and Mary Cassatt, to name a few, produced dramatic sensuous lithographs. Alphonse Mucha, Edvard Munch (see Chapter 1) and Henri de Toulouse-Lautrec were noted for their own unique styles often highlighted by this flexible process. Most twentieth-century artists including many American Abstract Expressionists experimented with lithography as they did with other printing processes. See Chapter 11 for the relationship of their work to art therapy.

Traditional lithography is done on an extremely large, heavy expensive limestone 'plate,' often several inches thick. Considerable effort needs to be expended to prepare and ink the stone. Contemporary printing for commercial processes evolved from the traditional methods. Modern presses use photography or computers to separate red, blue and yellow and make flexible planographic metal plates for each color plus one for black. The basic concept of oil and water repelling one another is still the way the ink is attracted only to the treated image. Each color is run through the press separately, and as each color gets added all the colors merge into a multicolored image. The basic chemistry is the same as Senefelder's but enhanced by modern materials, technology and production.

Contemporary fine art lithographers sometimes use the limestones (that are becoming increasingly difficult to find) or use zinc plates to draw on with greasy crayons. There is also a commercially made product called Litho Sketch® which is a treated paper that works the way a stone does. The paper is relatively inexpensive, the fluid used is non-toxic. The process is somewhat messy but extremely rewarding for some clients (see Appendix for sources).

Another currently popular planographic process is the monotype; only one image is produced. Invented in the seventeenth century by

Giovanni Castiglione, monotypes were made popular by Manet. Essentially, a monotype, like a lithograph, is all on one surface. The technique is called a monotype because only one impression results from each creation of an image by the artist. Why call it a print if there is only one? It is still a print created indirectly from a plate even though there is only one print made from each painted plate.

There are many ways to create a monotype, but essentially the artist paints or rolls paint onto a flat surface to create the desired image, then a piece of paper is put over the image and pressed to transfer the image. Another paper can be pressed on and a lighter version of the same image called a 'ghost' can be produced, but it is not exactly the same because most of the paint is released on the first print.

Monotypes have been extremely popular in the United States since the 1980s and offer great expressive potential plus the advantages of being an expressive graphic media and an indirect method. After about 15 years of printing collagraphs exclusively, I fell in love with creating monotypes. Perhaps it is my need for instant gratification, an attraction to the freedom from rules or my boredom with making exact duplicates. I doubt that my experience is unique. Monotype printing is close to painting, but you never know exactly what will happen when a monotype is printed. For these reasons, I have found monotypes to be the most enjoyable and successful of all printmaking processes for use in art therapy. The uses of this process for therapeutic purposes are many because it is so flexible and adaptable to many materials and situations. See Chapter 7 for several different variations and applications.

Screen processes: stencil, silk screen

The fourth and last general category of printmaking processes is the stencil and screen process. Paint is pushed through an opening either in a flat piece of paper (stencil) or through a thin film of porous fibers (screen) onto a paper just below the stencil or screen (see Figure 3.3 in next chapter). Origins of the process have been lost, but there are stenciled designs on fabric from China and Japan as early as AD 500 and 1000. The technique traveled to the west probably with the spread of Islam and was used for simple shapes.

In practical terms, the problem with a basic stencil is that it can be used only for a cut-out shape. For example, if you want to print multiple circles you can cut out a circle from a piece of paper, put it down on your surface to be printed and dab paint over the stencil to produce an exact circle. If you want to make an 'O,' a circular shape with no color in the middle, you have to cut a small circle to block the paint and position it by hand in the middle of the cut-out stencil. It is essentially a floating or detached shape. If you have ever tried it, you quickly realize how difficult it is to be consistent; the paint gets on your fingers and under the cut-out shape.

The Japanese perfected a method of holding the inside or floating shapes in place with thin strands of silk or human hair placed every quarter-inch between the outside and the floating shape (Saff and Sacilotto 1978, p.289). We assume that the hairs got closer and closer together to hold the floating shape more securely. Within a few hundred years, the use of thin silk fabric replaced the delicate network of threads. Stiff brushes were used to push the paint through the cross-threads of the silk. Although the Japanese solved this problem long before the famous voyage of Commodore Perry in the 1850s, the western world was introduced to silk-screening only in the nineteenth century in the exchange of trade. After further development, a patent for the process to be used commercially was awarded to Samuel Simson of Manchester, England, in 1907.

The term serigraph comes from the French word for silk, and the term was originally used to describe all processes by which an image is reproduced by means of pushing paint through the printing surface onto another surface. Since the 1950s and the invention of polymers, the silk has been replaced by cheaper, strong polyester fabric; but the term silk screen is still used especially to refer to commercial printing. The more exotic term serigraph is used today mostly to refer to fine art printing.

In the twentieth century, commercial silk screen was used for the burgeoning billboard industry, printing cans and bottles (uneven shapes) and eventually for fine artists. Introduction of new technology and products allowed silk screen to become finely tuned. Images cut from films mimic photographic resolution in detail. The commercial applications are still popular. Fine artists in the 1960s, the 'Pop' artists such as Andy Warhol,

Jasper Johns and Roy Lichtenstein reflected US culture with their bold, colorful silk screens.

The production aspects of stenciling and silk-screening are of great value to art therapists. The process certainly lends itself to personal expression and should be considered for that value alone, but Chapter 9 focuses on the aspect of production for creating products and the use of screening for group projects.

Contemporary processes

A review of this brief history of the development of printmaking through the ages shows a direct correlation between the process and the materials available to create what was needed at the time by each particular civilization or society. Wood was available for early woodcuts, metal was available from the Middle Ages on and was used for intaglio processes. A chemical reaction allowed the fluid gestures of lithographs to be replicated. Polyester replaced silk. As exploration and trade increased contact between cultures of the world, printing processes were adapted to new needs and materials.

The invention of plastic in the 1950s dramatically changed the way several printing processes were done and spawned great adaptations for use by art therapists, specifically collagraphs, drypoint printing on Plexiglass® and silk screens. Development of non-toxic paints, water-based solvents and photographic films has enlarged the possibilities for artistic expression and diminished the dangers involved. To be restricted to having a long list of toxic supplies and specific operating procedure for printmaking is no longer necessary. Students and clients often come up with simpler, more creative ways of using materials than we know of.

This book presents a structure to get you started. By the time it is published, more materials will be on the market; test them, use them, see if they work for you. Experiment to see how you can use these processes with the materials you have available. Use this book as a resource and a repository for new ideas from trade journals, popular magazines, client discoveries. Make it your notebook.

General Information

Creating and holding a place to print

Setting up a printing space

All therapists and teachers are aware that setting up a space that is free from distraction, organized, comfortable and safe is a primary concern. Unfortunately, brief treatment therapy and crowded classrooms are becoming more the norm than the exception, and we often have to make do with less than optimal settings for our work with clients. However, a safe, nurturing space for creative work can be set up in most situations. Setting up for printmaking can involve more supplies than some other artmaking media, but with advanced planning it can become just as easy for you as any other set up.

A well-known cliché in the real estate sales field is 'a house is sold in the first minute.' The first minute that a client enters the art therapy room or classroom is critical also. Your simple welcome and what the client sees are vital first impressions. Having materials out and organized and printing stations already set up encourages clients to sit down and get settled quickly. Whatever the technique you present, there will probably be some unfamiliar materials, such as rollers, tubes of paint, plates. Often different materials intrigue clients and let them know that the session may provide a new experience.

The first and most comforting thing I do is to create a place for everyone. Everyone has his or her own different sense of personal space. In most situations when sitting around a table, a generally comfortable personal space is the area directly in front of the body about as wide as the

arms of an armchair and extending in front as far as the arms can reach. A broadsheet newspaper folded in half then in quarters defines that space. (Think of cartoons in which a person on the subway unthinkingly opens up a newspaper fully and covers up the face of the person sitting next to him.) A folded newspaper usually is space enough for one person.

Fortunately, a newspaper folded in quarters defines an adequately large enough area to provide space for most printmaking activities. The whole area can be used for plate making. When you get to applying paint, use one side of the newspaper as the messy side to put on the paint. If hand printing, move the plate over to the other side to print it. The newspaper is easy, cheap and disposable. However, with just a little extra effort, it is easy to make printing pads that improve the transfer of paint even more.

Making printing pads

1. Cut rectangles of corrugated paper board larger than your paper.

2. Place one or two layers of old toweling on top of the corrugated.

3. Cover towels with a brown paper bag larger than the surface.

4. Tape the paper bag edges to the back of the board.

This printing pad can be reused if wiped off and allowed to dry between printing sessions. It also can be covered with one layer of newspaper or other scrap paper and the soiled paper discarded. Use printing pads especially for stamping, stenciling or screening. Printing pads define about the same amount of space as the folded newspaper.

In an ideal world, every therapist or teacher would be prepared, relaxed and ready for each new group or individual client. When that is not possible, consider using the group time to have participants help get ready to print. If this is the first time you have done printing with them, you will have to guide carefully. If you have a returning group, they will know that the paper needs to be cut, the supplies collected, the tables covered with newspaper, the paper soaked, etc.

Safe materials

Most materials can become dangerous, be ingested or used for harm as well as good. Traditional printmaking uses toxic chemicals and equipment that even if used carefully can be extremely harmful. Those two statements combined might make you wonder why you would consider printmaking at all for art therapy. In this book the materials used for printmaking are the safest possible, but they can be unsafe with inappropriate use or carelessness. Know your clients. Know your materials. Keep your printmaking simple.

Several materials are listed as options in the specific instructions given for each technique. Do not think that you have to use all of them all the time. Be cautious, use only those that you feel you can use safely with clients. The safety ratings on each set of instructions refer to regular usage. If you have a client who is self-harming or puts everything in his or her mouth, be especially vigilant.

One of the decisions that you will have to make with some techniques will be whether to use oil- or water-based paint. In every case where water-based paint is at least as successful as oil-based, I have suggested its use because it is less toxic and easier to clean up. Dried latex paint is just as impossible to remove as oil-based, but in general water-based paint is much better for clinical use because it is easier to clean up.

If you do want to use some of the processes that use oil-based paint, read the directions for clean up carefully and follow them. Do not use lacquer thinners, solvents, kerosene or other noxious cleaners. It is just not necessary or safe. Wiping paint off with rags can clean up even oil paint. Soap and water dissolves most oil-based paints. Lava or any pumice-enhanced soap loosens oil and grease. Lestoil and other cleaners advertised to clean up smudges emulsify the oil so it can be washed off with water. Cooking oil also emulsifies oil-based paint with absolutely no dangerous chemicals. Regular soap removes the oil.

Paint and mess management

Regression in service to the ego does not mean allowing clients to make a mess, to be destructive or to draw excessive attention to him- or herself. A messy table is frustrating, causes confusion and distresses clients. Wet

paint everywhere, glue leaking from bottles or paint all over hands can potentially prevent creative work and could damage or destroy a client's work or that of another. I am not naturally a neat person, but printmaking has taught me that it is to my benefit to create a sense of order and keep mess to a minimum.

Keeping paint in control is the first step in mess management. If you let every client squeeze out paint, use as much as he or she wants or even start everyone out rolling paint at the same time, you are asking for mess. Just as you need to keep an inventory of sharp implements that could be harmful, consider paint monitoring until you know your clients can manage their own mess.

Washing hands between applying paint and wiping a plate helps a lot. Damp sponges in a bucket on the table, paper towels or baby wipes are useful. Keep a messy area for applying paint and a clean area for printing to help create artworks that are free from unwanted globs of paint. Store clean paper separately and designate an area for wetting and blotting paper.

It is difficult to decide whether to clean up or to discuss the artwork first. It is very difficult to get everyone's attention and give enough time to each person if there are materials and the mess made from printing sitting on the table. Using the newspaper pads to work and print makes cleaning a matter of just folding up the newspaper and tossing the whole thing in the trash. I use coffee cans and plastic bags to store rollers, daubers, paint and plates that need to be kept. My art therapy bag is made of cotton and absorbs excess water, so I do not even need to dry off rollers and plates. Between groups I wash and wring out the plastic bag of sponges.

Cleaning up is sometimes the only way to get everyone to stop working. Getting cleaned up clears a space emotionally as well as physically, so the artwork can be viewed and considered with a little more objectivity. Be sure to allow enough time for both cleaning up and discussing the artwork.

Teaching a skill

I remember in my last semester of graduate school hearing Professor Paulo Knill say that we would all be surprised to learn that a large amount of our time as art therapists would be spent teaching. This book is part theory, part teaching and part art because we all are art therapists, teachers and artists.

Learning styles

When teaching any course, I always ask students at the beginning of the semester about their learning style. Some students do not understand what this means but know that they do not understand by reading instructions alone. With more and more comprehensive understanding about learning and learning disabilities, we know that there are several different ways that a person can learn. In simple terms, we are either visual learners and can learn by observing or reading, auditory learners who learn by listening to directions, or tactile learners who learn best when doing something. None of the ways is intellectually superior to another, but traditional North American school learning is mostly done through reading, secondarily through listening.

It is likely that in any given group you will have at least three different learning styles. You may also have clients who have impaired vision or hearing. Frequently clients do not have their glasses. Many clients do not understand your spoken language. Medications often disturb attention span and clear thinking almost as much as the illnesses they are used to treat. Keep this in mind when you are giving directions for the simple steps of a printmaking project. Explain verbally, provide visual instructions and demonstrate the process.

Tasking

All printmaking processes require at least two steps to create an image rather than the immediacy of drawing, painting or modeling clay. Even with the simplest found object, stamp printing requires that the object be dipped in paint then pressed to the paper to transfer. It is extremely helpful to have the process broken down into simple, understandable steps and to have the supplies available for each step. You can instruct your

clients so that they will understand the reason for doing things in a specific order. It is helpful to have one or two examples of making a plate and applying paint as well as finished prints.

This is called tasking and it allows you to assess a client's skills, evaluate progress as well as help both you and your client get organized. Tasking simplifies record keeping for fine motor skills, attention span and sequencing assessment.

Giving directions

When you understand the process and can divide it into simple steps or tasks, you need to teach the process by giving directions. This book should prepare you to do this step. I have found that it works best to verbally give directions, have a chalkboard or written list, samples that show the steps and then give a quick demonstration. This may sound impossible or at least too much, but it is not difficult and will benefit you and your clients immeasurably.

If the group is all together, clearly explain the steps, get out the visual aids then clarify with a simple demonstration. For example, if I am introducing relief printed collagraphs, I have in my bag a plate made with tapes, a similar plate rolled with paint ready to print (and already dried for instructional purposes) and a finished print from that plate. Sometimes I include three signs: 'make plate', 'put paint on plate', 'print.' In total that is two plates, a print and three pieces of paper with simple signs. The papers fold over the two plates, and I carry it around as a 'sandwich sample.'

When working with a group of clients with mixed diagnoses or an open art group, I frequently have one or two individuals start a process while the others observe. These early starters then serve as teachers for their peers. As others join the group, the process is going on in several stages, and I can show them the different steps in progress before they begin.

Letting go or providing technical assistance

Once you have given directions and a quick demonstration clients should be ready to begin. All of the above should not take more than five

minutes. If all supplies are ready, clients will begin and proceed at varying speeds. Your job is to monitor sharps and paint, to stay out of the way and to allow the creative process to unfold. Provide assistance when it is really needed but encourage clients to work independently. The more you know your materials and the possible processes available, the easier it will be for you to stay out of the way.

A common occurrence is that every time I introduce reductive monotypes someone will naturally start painting directly on the plate (an additive monotype.) I do not say, 'Oh, no! Do not add paint! That would be an additive monotype, and we are doing reductive monotypes. Use your brush to take the paint away!' Certainly let your clients explore and respond to the materials in any way that would be suitable. In contrast, some clients will want supervision and be worried that they are not 'doing it right.' Encourage them without doing it for them. You never want to impose your ideas or do the art for someone, but you can not deny needed technical assistance when it is asked for or needed to successfully produce a result.

Archiving: signing and editioning

Archiving refers to the way prints are signed, editioned and stored. Traditional printmaking has had meticulous rules about archiving to protect the artists, his or her work and his or her customers. The artist's signature usually was placed just outside of the plate edge in the lower right-hand corner on the paper margin. The signature was done in pencil because pencil was more stable than ink. If a printing firm (atelier) does the actual reproduction work, the mark of the firm is near the artist's signature. Recently, the title of the work has been written by the artist on the lower left side of the artwork just outside the plate edge on the paper margin. The title is usually surrounded by quotation marks.

Contemporary printmakers usually follow precedence, but prints created as art therapy can be signed anywhere the artist wishes. I do encourage clients to sign their work. Some invent an 'artist' name. Titling an artwork crystallizes a client's perception of the work and is extremely helpful for me as a beginning point for discussion. Titles often surprise me.

When clients produce multiples I have found that they appreciate a simple editioning system and often want to title, sign and put edition numbers on their prints. Traditional editioning rules were devised to inform a purchaser how many prints were pulled from each plate and in which order. The edition is the total number of prints that are printed from one plate that are identical. For example, the first print of 50 is 1/50, the second print is 2/50 and so on. The edition number is usually placed between the title and the artist's name in the paper margin.

The editioning system was invented when etchings and engravings were the norm; all prints were exactly the same and in black ink. It seems that as printmakers invent new processes there are fewer editions exactly alike (except those computer generated) and more confusion about editions. Should an edition in red be different from an edition in blue? Keeping in mind that the reason for the record keeping is to inform a purchaser about how many prints are pulled from one plate, I include all prints pulled from one plate in one edition. The one exception is that monotypes are noted as 1/1, one print of one plate, or the word 'mono-type' is written out.

Professional fine art printing studios (ateliers) are available to print editions for artists. When an artist contracts with an atelier, the artist prepares the original plate and supervises the printing of the edition but does not do the physical work of the printing process. The artist carefully checks each print before editioning and signing it. The atelier adds a stamp to identify itself as the printer of the edition. Chinese artists also employ a stamp, a chop mark, to identify their work, usually stamping in red ink. These two practices suggest the use of personal stamps for identi-fication of client artwork.

Storage of prints depends upon your clinical situation. In some settings all artwork is the property of the client. In other settings all artwork is the property of the institution and a part of a client's clinical record and as such kept for a specific amount of time in secure storage. Find out about the policy of your setting. In some sites art products may be created for sale, so storage must be a part of your plan for production and sale.

There are many issues about displaying client artwork. When you include printmaking, clients will have multiple images and may be more

inclined to want to exhibit their work. Read Spaniol's articles listed under Additional Reading for a good discussion of the issues.

Mixing printmaking and other art media

Printmaking is just another medium available to art therapists. Each medium has its advantages and disadvantages. No one would recommend that you use only markers, use only clay, work only three dimensionally, use only printmaking or any other medium or method. The more you know about different media and the better you understand your clients' needs, the more able you will be to match clients and media. This book is written in the hope that you will consider printmaking. Stember (1977) used printing of found objects to introduce her clients to the artmaking process (see Chapter 4). Printmaking can be used as a warm up, but it can be pretty equipment intensive for that. I have used printing to 'jump start' a client who was regressing, to get him moving and reaching and drawing again instead of closing up (see Chapter 4). I have presented printmaking exclusively in several situations and do so more and more often. The materials used for printmaking can always be used for painting or drawing.

Prints can always be enhanced with handwritten words, colored with markers or pastels, made into books, or anything else as any two- or three-dimensional artwork (see Chapters 7 and 10).

Therapeutic discussion of prints

Prints should be discussed with clients the same way that you process any other artwork. It is always valid to ask a client how he or she felt when she was doing an artwork and especially since this process was probably a new experience. Each therapist has his or her own way of encouraging comment, eliciting responses and supporting insight. Prints are no different than drawings or clay work except that the client may have produced multiples. The multiples can be embellished in different ways and compared and contrasted. The client may have more objectivity about his or her art because printing is such an indirect process and the results probably not what he or she anticipated.

Indirect process

Printmaking not only requires more than one step, but also is an indirect process. That means that the mark made by the artist is not the mark of the resulting artwork. The mark or image of the artist is created on a plate, stamp or screen, then paint is applied to transfer that mark onto a separate piece of paper. The resulting mark is a reproduction of the original but frequently not exactly the same. The paint applied produces not only various colors for one image but also variations depending upon the amount of paint applied. If too much paint is applied, the image has filled in lines. Sometimes the paint spreads where there are no marks making drips or smears. If too little paint is applied, the original marks sometimes do not reproduce at all.

Another reality surprises me even after over 30 years of printmaking. In all relief, intaglio and planographic processes the artist's mark is in reverse, the mirror image, when it is printed. Even viewing an image with a mirror never completely prepares me for the reversed image. Screen processes reproduce images directly without the reversal.

The indirectness of printing can be viewed as distressing or liberating. My experience has been that it is extremely liberating especially for the novice artist, physically impaired or psychologically resistant client. For clients with minimal or negative experience artmaking, printmaking offers something new and less threatening. They get caught up with the process and forget their fear of failure with drawing. There are many techniques described here that literally do not involve drawing at all. You can honestly say, 'You do not need to be able to draw to be able to do this.'

The indirectness and the graphic quality of printmaking also produces amazing results. Ripped pieces of tape and price stickers stuck onto a square of cardboard and rolled with paint become 'Magic' (see Figure 3.1). Stunningly beautiful artworks are created with simple materials and multiple colors.

For physically impaired clients printmaking can provide artistic expression that was never possible before. For someone who has experienced a stroke, brain damage or dementia, printing can provide a mode of expression when former skills and talents are gone. See Chapter 9 for a discussion of the changing needs of elderly people and how printmaking can serve to meet their changing needs and perceptions.

Figure 3.1 'Magic' by MM, simple relief collagraph

Reducing resistance

The indirectness of printmaking can aid with overcoming both conscious and unconscious resistance. The classic triangle representing the therapist, the client and the artwork gives therapeutic distance and enables the client to overcome resistance and develop insight. Printmaking adds another layer and more distance to the triangle. Often hidden issues are revealed by the indirect nature of printmaking that would have remained hidden through years of drawing.

Working with artists

Initially, the experienced artist might be dismayed and annoyed by the introduction of printmaking. I have often had groups where one client very skillfully draws an image while others struggle and can not compete with the 'artist' who gets rave reviews. General disclaimers like 'I am not an artist like So and So' dominate the group. Most experienced artists tend to repeat past successes, however, and often cover therapeutic issues with the execution of a competent often beautiful or startling image. Adolescents often repeat detailed, stereotypical drawings of super heroes, rap stars, cars, science fiction figures. Although these skilled drawings

serve the ego, an art therapist needs to balance this skill with other thera-peutic goals.

Introducing printmaking temporarily interrupts the repetition of artistic success and forces an artist to try a new media. Often the first results from printmaking by an experienced artist are less than satisfac-tory to him or her. Everything is in reverse and perhaps some rethinking will occur. Fortunately most learn quickly and are soon able to use their skills in the new media.

Underestimating artistic potential

As frustrating as it is to overestimate a client, it is also demeaning and frus-trating to underestimate a client's ability or interest. Finding a way for a client to be creative or expressive is your job. Traditional artmaking has been reserved for 'artists.' Very few people have had success as artists but deserve to have the experience of artmaking available to them. I strongly believe that creativity supports health and well being and that opportu-nity should be available to all.

Some of your clients will have been artists but have lost skills due to illness or infirmity. They may not be able to regain previous skills but can be guided into new artistic expressions. Printmaking provides a process that is less direct than drawing or painting. It is less threatening and can produce a sophisticated product with very little artistic talent. Clients who can not draw can create interesting collagraph prints (see Figure 3.2). People who have never done art or who have had negative experi-ences with it, can achieve success with printmaking. Experience with art as therapy sometimes opens up opportunities for continued exploration of art even for experienced artists.

Ratings for techniques

Art therapy serves several functions, the opportunity for clients to express themselves being the most obvious. Art for expression, sublimation or discharging of emotions is a worthy goal but unrealistic and frustrating if the client is unable to use materials successfully due to physical or cognitive limitations. The client may be willing but unable. Sometimes a

client is unwilling but able and printmaking does help in reducing resistance.

Can your client grasp a pencil? Press hard enough to create a depression in a piece of Styrofoam? On plastic? Can the client roll a brayer (roller) back and forth and keep paint on a plate? Does he or she understand that the paint transfers onto the roller? Can the client follow two-step directions? Three steps? Four? Is sequencing a problem? Memory? Ability to concentrate? All these questions can be answered by observing once you begin to work with a client. Reading clinical notes from occupational or physical therapists or other information in a client's chart should be helpful. The more you know, the more appropriate you can make your choice of materials and art interventions. You want to find art methods and materials to allow for maximum success for your clients. For example, if a client can not hold a pencil, he or she may be able to hold a printing block and be able to stamp print.

Figure 3.2 'Joy' two-session collagraph relief print by J

Table 3.1 provides information on all of the techniques described in this book. The following explanations are included for you to make the best use of the table.

Cognitive and physical requirements

The instructions contained in this book are labeled easy, moderate and difficult referring to physical and cognitive ability required.

An easy printing process means:

1. The process can be broken down to two or three simple steps.

2. The hand grasp required is simple or can be assisted.

3. The motor coordination required is minimal.

4. Cognitive understanding is either minimal or not required.

These easy processes can be done hand over hand. If cutting with scissors is not safe or physically manageable, items can be torn.

A moderate printing process means:

1. The process can be broken down into three activities (plate making, applying paint, printing); each may require more than one step.

2. The hand grasp required is at least a tight hold.

3. The motor coordination required is moderate using a variety of motion, extended reach and some strength.

4. Understanding of simple sequencing and cause and effect is required.

These moderate processes are suitable for most clients when they are given clear directions, guidance and encouragement.

A difficult printing process means:

1. The process can be broken down into four activities (plate making, applying paint, wiping plate, printing); each requires several steps.

2. Functional hand grasp or adaptive equipment is needed.

3. The motor coordination required is normal functioning.

4. Cognitive function should be close to normal.

A difficult process can still be done in small steps but tends to be more of a long-term project.

Safety rating

no sharps or glues, washable paint
glue, scissors
glue, scissors, mat knife or utility knife, oil paint, or a press

Time requirements

Time required to complete a task depends upon the abilities of the client, the number of clients, the processing of the artmaking and the clinical reality of the session. The completion of artmaking is always secondary to the emotional needs of clients. No art therapist would encourage a client to finish a project at the expense of talking about its therapeutic benefits or the issues that are presented in the situation. Nevertheless, it is helpful to know how long a project would take under normal circumstances. The rating here is approximately how long it would take a person of normal abilities to create a print following the given directions. The time does not include discussing the artwork, just creating a print.

Style

Some processes are most successful for the reproduction of lines, others reproduce shapes better. A few of these processes reproduce both lines and shapes well or create lines from shapes.

Although line making, scribbling, is introduced by Lowenfeld (1970) as the beginning of development of creative growth, I propose that shape making, stamping, is its predecessor. Hand prints, thumb prints, a baby's messing around with stuff on his or her hands, precedes line making. Shape making and printing is innate and the beginning of creativity. In a workshop about using color in art therapy, Kramer (2001) remarked that line demands intelligence. She said that using a line to make a shape

requires intelligence whereas color is still fascinating and meaningful even to retarded people. Everyone can work in color. It does not require understanding, it requires only response. In a similar way, stamping shapes does not even require a response, the action itself is sometimes enough.

As a child grows and develops skills by manipulating and gaining control of his or her hands and therefore his or her environment, the child's opportunities for creative expression grow and change. Some clients never get a chance to experience this growth and opportunity because of genetic disabilities. Some clients have uneven or arrested development. Others regress from trauma. Most of us regress and experience declining function with advanced age or illness.

Creativity and mental growth is not a linear development for many clients. We should not, therefore, measure artistic development by skillful manipulation of lines to reproduce realism. We should encourage clients at all levels of functioning to express themselves with shapes as well as with lines. There should not be a graduated chart equating shape making with elementary development and line making with artistic skill.

The cover of volume 17, no. 3, of the *Art Therapy: Journal of the American Art Therapy Association*, features 'Buffalo Spring', a monotype and colored pencil artwork that is embellished with stencils (Farrelly 2000). The artwork is inspiring and sophisticated, full of meaning. Emotional, therapeutic, complicated, transformative, sophisticated artwork like Farrelly's can be created using the simplest of materials and processes. The instructions here for stencils are rated easy, ##, 15 minutes, shape. In contrast, dull, unimaginative, boring, simplistic and defensive work can be created with the most difficult and equipment intensive processes. You, the therapist, provide the easiest process that will provide opportunity for your client. Sometimes the indirect nature of printmaking provides the easiest way.

One- or two-sessions projects

Whether a process requires one or two sessions mainly depends upon whether or not glue is used because time is needed to let the glue dry. The time required to create a plate depends upon the clients. In every group there is a client who will finish in two minutes and one who will not be

able to finish even if the session could last all day. Time given is for normal functioning and simple imagery. Even the simplest technique can be stimulating for long-term exploration; this designation refers only to the requirements of creating an image from each technique.

As a teacher, I have always taught a new process by starting with a small plate, suggesting a simple subject and completing the process all the way through rather quickly. When students understand the entire process and have experienced it completely, they are then able to go back and do it again taking more time for their image making. As an art therapist, I have found that this practice works well too but for a different additional reason. In most cases, I have experienced that the more significant imagery produced by clients is in their second artwork. Their first drawings or prints are frequently stereotypical or what I call 'Fake Happy' or 'Shock You' drawings. Frequently, the second images have not only more technical skill but also more power.

Figure 3.3 The four basic printmaking processes

The reason this point is being made is that I have experienced that it is more beneficial therapeutically to choose one technique, a simple one, introduce it and then repeat it over and over. My two personal favorite techniques are relief printed collagraphs and reductive monotypes. These techniques can be classified as short-term projects, they can be done in one session, but they also are strong enough to become long-term projects. I spent about 15 years creating collagraphs as my only personal artmaking; then I discovered monotypes and created mostly monotypes for the next 18 years. The artistic possibilities of each of these techniques are as limitless as any other art medium.

Figure 3.3 is an illustration of the four basic printing processes that serves as an overview for the following instructional chapters that are organized by process. Table 3.1 gives specific information.

Table 3.1 Comparison of specific printing techniques

Technique	Difficulty	Safety	Time	Style	Paint	Session
Relief						
thumb/hand	easy	#	5	shape	water	one
stamp objects	easy	#	5	shape	water	one
potato/erasure	moderate	###	20	shape	water	one
alternative	easy	##	10	shape	water	one
texture block	easy	#	10	shape	water	one
texture block (glue)	easy	##	10	shape	water	two
print balls	easy	#	10	shape	water	one
print balls (glue)	easy	##	10	shape	water	two
Styrofoam	moderate	#	10	line	water	one
simple collagraph	moderate	##	15	shape	water	one
collagraph (glue)	moderate	##	20	shape	water	two

Intaglio						
drypoint*	difficult	###	30	line	oil	two
monoprints	difficult	###	30	line	oil	two
Styrofoam*	moderate	##	20	line	oil/water	one
simple collagraph	moderate	##	25	shape	oil/water	one
collagraph (glue)	moderate	##	25	shape	oil/water	two
glue prints	easy	##	20	line	oil/water	two
Planographic/monotypes						
foldover mono	easy	#	5	shape	water	one
mystery mono	easy	#	10	line	water	one
simple reductive	easy	#	15	line	water	one
additive painterly	moderate	#	20	line	water	one
Monomask	easy	#	15	shape	water	one
multicolor mono	moderate	#	30	line	water	one
watercolor mono	difficult	#	30	line	water	one
Stencil and screen						
stencil	moderate	##	20	shape	water	one
paper screen	moderate	##	20	shape	water	one
shadow screen	easy	#	15	shape	water	one
contact paper screen	moderate	##	20	shape	water	one
painted screen	moderate	#	25	shape	water	two
tin can printing	easy	#	15	shape	water	one

Artists' books						
storyboard	easy	#	20	any	any	one
simple scroll	easy	#	15	any	any	one
traditional scroll	easy	#	20	any	any	one
mobile string book	moderate	##	30	any	any	one
box book	easy	#	15	any	any	one
one sheet foldover	easy	#	10	any	any	one
simple book	easy	##	20	any	any	one
fan book	easy	##	20	any	any	one
accordion	moderate	#	20	any	any	one without a decorative cover
flutter book	moderate	##	20	any	any	one without a decorative cover
triangle fold	moderate	##	20	any	any	one without a decorative cover
single sheet maze	moderate	##	20	any	any	one without a decorative cover
traditional	difficult	###	60	any	any	two
portfolio	easy	#	10	any	any	one

Note: *requires printing press

Relief Printing and Stamping
Focus on the Process

Relief printing: the very beginning

The term 'process' in printmaking is used to describe the way a print is made, the way the plate or original design gets made, how the paint is applied and how it is reproduced. The first process developed historically was relief printing, and it includes some of the simplest techniques presented in this book. Briefly, relief prints result from a raised printing surface. The areas to be printed are raised or the unwanted part cut away; the raised or remaining image is painted and either pressed onto another surface to be printed or paper is put on top and pressed to release an impression (see Figure 3.3 in previous chapter).

Although the historical development of printing is interesting to review, general observation of human behavior makes me surmise that the very first printmakers were probably also just experimenting and noticing the transfer as one shape was dipped into a liquid and the shape transferred onto another surface. Watch any child play in a mud puddle and make hand or foot prints from the mud. Watch an adult experiment with finger paints. The basic concept of cause and effect is discovered. Initial experiments are with hands, then fingers and thumb, perhaps feet or arms. These explorations are pleasurable; our fingers and hands are printmaking 'plates.'

As children develop they gain more control over head, trunk, shoulders then arms and legs and eventually fingers. Developing the

ability to grasp and hold an object is a predictable process and follows normal developmental patterns. A baby has to be able to see before reaching for an object. At about 3½ months, a baby can see clearly, focus and connect the idea of touch. He or she can swipe one arm with closed fist, then do jerky open-handed reaching, trying to grab an object. By 6 months the baby can hold a bottle, rotate his or her wrist, turn and manipulate objects. By the seventh month he or she has some thumb and finger grasp and can hold two objects, one in each hand simultaneously. The baby may bang them together. By the eighth month the thumb, first and second fingers are involved to pinch an object, or the baby uses his or her hand as a rake to retrieve something. By the tenth month, the baby has better retrieval skills and can take apart and put things back together (Caplan 1993).

In normal development, about the eleventh month children can hold a crayon. By about a year old, they are able to hold with one hand, maneuver with the other, point and push. This is early beginning of the scribbling stage (Lowenfeld 1970) or manipulative stage (Hurwitz and Day 1995).

Because it is normal development to learn about mark making first with our own hands, making finger and thumb prints can be a natural introduction to printmaking for many clients. Printing with found objects is an obvious extension of this experimentation and manipulation. Although they are easy and elementary for most clients, these simple printing techniques can be expressive and even artistically challenging. Much of my clinical experience is with clients who do not have the physical ability to make an advanced grasp, severely disabled people and Alzheimer's patients. For them, stamp printing can be a variation of the scribbling or manipulating stage that is available to them when drawing is not physically possible.

When they can not draw

In her article 'Art for children with very special needs,' Gister (1981) says that printmaking is especially helpful for children who do not understand drawing process. She works with them with hand prints to increase their eye–hand coordination and awareness. She uses hand prints to make other recognizable objects that the children would not be able to draw.

These techniques do not need to be limited to use with clients who do not have the physical or cognitive ability to draw. Mental illness frequently renders clients unable to focus or function. Many clients have not had experience or have had negative experience making art and are not interested in drawing or painting. You can honestly say, 'you do not need to draw' when presenting most of the relief processes suggested.

It is helpful to know that many clients who would not ever be able to draw successfully can have artistic satisfaction using relief printing. Stamping is the easiest relief process and comprises Chapter 4. In Chapter 5 there are instructions for collagraphs that can be made by gluing shapes. Glue prints require only squeezing glue.

Simpler than relief printing from found objects or plates is thumb printing. We all have printing plates right at hand: four fingers, a thumb and a palm. No one else has the same mark; like snowflakes, no two fingerprints are made up of the same swirls and lines. We also can make hand prints, footprints, shoe prints, lip prints, body prints. Fingerprints are fascinating enough and can serve as a starting off point for art exploration.

Ed Emberley has a series of books that take you through steps for adding squiggles and lines to fingerprints to make dragons, trains, monsters and whole scenes (see Additional Reading). Fortunately clients instinctively make creatures and people from fingerprints. Consider printing a series of fingerprints then writing a story to accompany them. Make a kinetic family drawing from the prints. Draw several rectangles and make a comic strip with characters made from fingerprints.

Instructions for finger or thumb printing

Supplies: paint, sponge and plate or washable ink stamp pad, paper, pencils or markers

1. Place small amounts of tempera or other water-based paint on a damp sponge on a plate or use a commercially available stamp pad.

2. Touch the paint lightly with a finger and press onto a piece of paper. Repeat using different fingers for different colors.

3. Wash hands while prints dry.

4. Using a marker, pencil or crayons, add eyes, arms, legs, clothes to create people, creatures or objects from the prints.

5. Write words in cartoon bubbles above the creatures or tell a story.

Stamp printing: focus on process

Using objects to stamp an impression is a very natural human development and can be the beginning of artistic development. The motions and steps required for stamping and relief printing led me to subtitle the chapter 'Focus on the process.' Relief is the simplest printing process, and it can be done with the least amount of physical motion, strength or cognitive ability. Conversely, it also can involve many gross and fine motor skills and engage the whole body of the client. The doing of the artmaking is in itself organizing and both stimulating and soothing (see Chapter 8).

When the client is relief printing, it is easy to observe his or her process. The steps are readily measurable, and the client's ability to focus on each task and move through the process is observable. The process itself can be therapeutic and rewarding or challenging and frustrating. A client's ability to organize his or her world, successfully follow directions and complete a task can help to build self-esteem.

If a client is physically or cognitively limited, the content and expressiveness of the artwork is sometimes adjunct to the process of relief printing. With high-functioning clients, the content and expression of relief prints are as meaningful as any other artwork. Observing high-functioning clients in the process of printing is also revealing. Often discussion of how it felt to do the printing, to try something new, is helpful.

In the book *Chuck Close* (Storr 1998), Close talks about his own experience with printmaking, 'Technique has always been the "resistance" of printmaking.' Printmaking was initially intimidating for Close and others. Before beginning printmaking Close was dismayed that viewers got caught up in wondering how an artist produced a print rather than looking at the art. When Close was encouraged to try printmaking he

found that breaking up the project into small, manageable parts that built to a larger whole was very 'comforting' and 'liberating' (pp.71–72).

Sensory stimulation

Sensory stimulation is important for many clients. For elderly, disabled and neglected people, printing found objects to explore their tactile and sensory qualities can be a very therapeutic activity. Found object printing can be part of developing awareness for a child, but it can also be helpful with other clients who respond positively to sensory stimulation. Textures and surfaces of all kinds of objects can be explored then printed. Flat objects are easiest, but after a little practice most people can print an uneven or three-dimensional surface by manipulating the object. For example, a wadded up newspaper dipped into paint and then pressed onto another surface creates fascinating patterns that change as the paper is pushed down and the paint used up.

Printmaking as an introduction to artmaking

Printmaking involves use of an array of objects that may not be familiar to clients as well as familiar ones. The roller, objects to be printed, rolling plates and other supplies may serve to interest and engage clients who are resistant to begin artmaking. An egg carton, a potato masher, a spool of thread may be comforting and reassuring to a client.

Stamp printing is a very good process for doing beginning artmaking; it can be used as a 'precursory activity' (Kramer 1971, p.54) with the process being the therapy and without regard for the product that results. The printmaking process is indirect and less threatening to many because their marks go through several steps before the final product emerges. Found object stamping is the easiest of the printmaking processes because the object can just be pushed onto a pad to apply paint. Consider starting with stamp printing as a warm up or as an introduction to an art therapy group.

Artistic worth

Although my focus is on the process of relief printing, consider using it to produce artworks that are valuable in their own right. These simple processes can be used to create extraordinarily complex and detailed artworks equal to any drawing or painting. Even stamp printing or glue printing can produce very expressive and indeed sophisticated artwork. Stamp printing can become 'formed expression' (Kramer 1971, p.54). Printing can be used in combination with many other media or to make artists' books.

Go to art shows, galleries, fine crafts stores or subscribe to a fine arts magazine as well as expanding your own creative expression. Seeing what others do with simple printmaking is inspiring. Every art therapist must consider materials and present choices for his or her clients. Observe and experiment so you understand what the process of each printmaking technique feel like, what its limitations and advantages are. When you decide to present a printmaking process, you may be limiting your client's choices, so it is essential that you do so understanding the needs and abilities of your clients and the potential of the process.

General set up for stamp printing

The brief history of printmaking in Chapter 2 describes the first stamps or seals then woodcut blocks that were used for printing fabric or paper. People used the materials that were available to make stamps to reproduce images for specific purposes. The need to mark products or property for identification or ownership was probably the first usage for stamps or seals. The following instructions include how to make your own stamps that could be used for similar purposes as well as creative expression.

As with any other artmaking, clients need a clearly defined space to work and a system for executing the project and keeping him- or herself organized enough to allow maximum success of his or her efforts. Use newspaper or printing pads as described in Chapter 3. Each person should have a space to apply paint to objects and a clean space to print. Keeping the two steps separate clearly demonstrates the cause and effect of the printing process.

The simplest way to set up an area for a client to work is with pads of newspaper. Use newspapers folded in quarters; one side makes a nice pad for applying paint, keep the other side clean for printing. As the pad gets messy from applying paint, just fold over the soiled layer and the next clean surface is readily available. This size of approximately 12" x 12" helps keep the mess down and focuses each client on the space directly in front of him or her.

Having a soft, flexible surface to print on delivers clearer prints, especially with found objects, handmade stamps and screen processes. The printing surface is sometimes uneven, so the cushion pushes the paper to meet the stamp or screen. The several layers of newspaper making a pad underneath your paper or a printing pad makes a clearer print than printing on a hard table top because it cushions the surface and allows most of it to transfer better.

Paints of all kinds can be used to print found objects. Easiest clean-up is with water-based paints: tempera, food dyes, watercolor, block printing paint, house paint, acrylics, commercial ink pads (check to see if they are water-based and avoid permanent pigments). Printing with food, pudding for example, is frequently done with clients who put everything in their mouths. Personally, I do not find that beneficial; it sends a mixed message to clients.

The transparency or opaqueness of the paint affects the printing as does the amount of water or fluidity. A paint that is too watery will just make a puddle. A transparent paint will make a delicate contrast with an opaque color. It is imperative that you know your materials and try them out before presenting them to clients. You want them to have success not frustration from their artmaking experiences.

Color is obviously a consideration. Let clients choose colors. You do not have to have every color. If you have yellow, blue, red, black and white you can easily mix any color. Present choices that will create harmonious results if the product is important. (See *Color Choices, Making Sense out of Color Theory* by Quiller (1989) for color-mixing suggestions that include the names of commercially available colors. Many artist paint manufacturers produce color wheels and brochures about their products that help with color mixing.) Visually impaired clients may be able to discern only dark and light contrast or respond to only a few colors. The yellow haze

of cataracts confuses the geriatric client. Experiment and notice your clients' responses to colors. My experience has been that even very severely disabled clients have strong color preferences.

Instructions for stamp printing from found objects

Suggestions for interesting objects to print

Choose objects that are easy to hold onto and have a flat, firm surface if possible (Figure 4.1). Depending upon the manual dexterity of your client, you may need to make adaptations and make holders for objects (see 'Making your own stamps').

Figure 4.1 'Very Mad Man' by LW, kitchen objects stamp print

wrinkled newspaper

spools, buttons, clothespins, bottle caps

sticks, dominoes, paper clips, hair curlers

sponges (cut into shapes or as is)

corks, shells, sticks, sink stoppers, potato mashers

leaves and ferns (sturdy but flexible and flat, apply paint to veined side)

eraser on end of pencil and larger erasers (see 'Making your own stamps' for cutting in a design)

soaps, carved or embossed

lace, string, fabric (especially textured and wrapped around a block of wood or Styrofoam)

wallpaper (textured)

onion bags, aluminum foil

scraps of wood, soak one flat end in water for an hour so the grain swells

egg cartons (cut or whole)

bolts, washers, chain pieces

vegetables: potato, carrot, broccoli, apple, celery, mushrooms, turnip (cut a flat surface and let them dry a few hours)

Clients may want to bring in objects to print. Paint should wash off most objects, but notify client of potential damage. Always check for sharp edges or potential dangers.

Supplies: objects to print, paints, rollers, brushes, Q-tips, spoons for transferring paint, paint containers as needed, paper plates for holding small amount of paint or stamp pads, plain paper (typing, construction, computer), pre-printed paper (wrapping, sheet music, comics, graph, maps), clean-up supplies and newspapers or table protection

Applying paint

1. Set up work stations with newspaper or printing pads.

2. Distribute only a little paint on a plate or bowl or put a thin dampened sponge on the plate to hold the paint and keep it moist. Start off with one color, add an analogous one so that a third lovely color is made when they overlap.

3. Dip object into paint.

4. If item is drippy or messy, press off excess onto newspaper.

Alternative ways to apply paint

1. Use brush or sponge.

2. Roll paint out smoothly on a Plexiglass® plate or plastic tray with a brayer (roller) then roll onto the object to be stamped.

Printing

1. Print by pressing on good, clean paper.

2. If enough paint remains on the object, print it again creating a fainter print.

3. Keep printing by adding additional paint as needed until finished.

4. Hang up to dry or dry flat.

Cleaning up

1. Throw out most vegetables. If you want to keep a vegetable to reprint, wash the surface, dry and store in the refrigerator for a few days.

2. Use damp sponges for hands and table cleaning.

3. Place objects to wash and keep, rollers and brushes in bucket or plastic bag. Wash as soon as possible.

4. Fold up newspaper pads and throw away.

Figure 4.2 'Friends + Photos,' artist's book of stamp prints and photos by MP

Expansion ideas

1. After the prints are dry, use markers, crayons, pencils, chalks, oil pastels, etc. to connect or embellish the printed shapes or add words (Figure 4.2).

2. Additional shapes can be printed on top of dry images. Use lighter (with white) paint if the image is too dark or vice versa.

3. Stamp printing can be done on any surface. Try printing on fabric using any acrylic paint. Walls and inflexible surfaces can be printed with sponge stamps, Styrofoam stamps or soft Flexi-Cut or other adhesive-backed, flexable printing material, cut-outs on handmade stamps as well as some found objects.

4. Finished works can be combined for a group project. A large piece of paper can become a quilt or a window with the addition of many smaller artworks.

5. Several people can work on a larger paper to create a mural.

6. One person can use one stamp and then another person add to the design with the same stamp or another in the traditional round robin style.

7. Junk sculpture could be made with the objects used for printing (after they have dried) and combined with the prints or contrasted to them. Robbins suggests junk sculpture as a way to help a client rediscover what may have seemed unimportant and to find a usefulness as well as an avenue for creativity (Robbins 1994, p.211).

8. Print on different backgrounds: a page from a telephone book, newspaper, comics, over a tissue or magazine collage, marbleized paper.

Ideas for themes

1. Make future robots or machines 'Make a machine that can ...' 'Create a robot who could ...' This would relate to current interest in computers and robotics.

2. Assign members of family to each object and make family 'drawings:' 'The spool of thread is my Mom, the little wood block is my sister ...'

3. Create kinetic family 'drawings.'

4. Use circular paper to develop a Mandala or medicine wheel.

Commercially available stamps

There are commercially available stamps of all kinds. There are stamps with slogans and cute sayings. I have a set of West African Adinkra design stamps. Consider use of such symbols of cultural heritage and let clients develop their own. There are nature stamps replicating real leaves and even plastic stamps that look like real fish to be able to do ancient Japanese gyotaku prints without using an actual dead fish.

Arts and crafts catalogs sell many stamps, stamp pads and even pre-packaged collections of interesting papers that can be stimulating and creative. Arts and crafts stores have aisles of stamping supplies. Stamping with these commercially produced products is a craft with its own value, but it should not be confused with art therapy. If clients insist on using their own commercially made stamps, consider combining them with monotypes or other artmaking.

Instructions for making your own stamps

Once clients have gotten comfortable with printing found objects, it is a logical step to move onto creating their own stamps. Manufactured angels or superheroes are not the same as ones created by your clients. Having clients make their own stamps is very easy, creative and rewarding. There now are commercially available kits for making your own stamps. I have tried most and find that getting them to adhere to a handle or backing is a problem. Most situations do not support waiting for a stamp to dry overnight and frequently they fall apart with rugged use. Flexi-Cut is my favorite substance to cut and then apply to a wood block or plate because it is easy to cut and has an adhesive backing that holds up after repeated use. (See Appendix for suppliers.) You can make your own from the following instructions and readily available materials.

Potato or eraser stamps

Supplies: potato or rectangular erasure, utility knife or paring knife, paper towels, marker, paper

Optional: mirror

1. Cut the potato in half with a large knife to make the surface as flat as possible or use a commercially available eraser. Discount stores sell inexpensive erasers.

2. Let potato dry for about two hours if possible, if not press surface on paper towels to dry.

3. Plan a design. Try drawing a design on paper first. Shapes work better than lines. The image will be reversed, so keep

that in mind if you are going to use letters. Use a mirror to see what the image will be in reverse.

4. Draw the design on the potato with a marker or on an eraser with a pencil.

5. Use utility knife to cut away the part that you do not want to print. Start by using the tip of the knife to cut slowly along the outline of your design. You do not have to cut very deeply, about one-eighth of an inch. Then cut away, starting parallel to the surface from the edge of the potato to the edge of the design. Be careful: always cut away from yourself. Clients may be able to do this or you may have to. Remember to keep designs simple; use shapes.

Alternative materials for stamp making

Carrots, turnips, soap (ivory is best) and blocks of insulating foam work well, too. The vegetables are small but easy to hold onto. The foam that comes cushioning appliances tends to crumble, but it is free. Foam used to insulate houses is expensive but has a smooth surface and is easy to cut or to create a design by pressing with a ballpoint pen or pencil.

For clients with limited grasp try using a long thin potato and cut the end rather than through the middle so there will be an easier to hold handle. To make adapted stamps, observe your client's grasp. Some can grasp but not rotate the wrist, so you must make a stamp that will print on its side. Often I use a sponge brush, pad the handle with foam and then tape so it is fatter and easier to grasp. Then I glue string or thin objects to the foam part of the brush that can be printed sideways. Frequently hand over hand guidance is needed until the client can make the movement and stamp independently.

Magic Stamp™ is a moldable foam material made by PenScore that is expensive but flexible, strong and reusable. The 2" thick blocks work well for all abilities but are especially useful for those with limited hand grasp or only a sideways stroke. The surface of the foam must be heated with a hair dryer then objects can be pressed into the warm foam. Texture can be made with rice grains, shells, netting, jewelry, leaves, pasta, lace, nails and many other objects. The heat required is not dangerous, but using the hair

dryer must be monitored. The foam can be reheated and new impressions can be made. See Figure 4.3 'Screwed Up House' Magic Stamp™ print by LM (see Appendix for suppliers).

Figure 4.3 'Screwed Up House' Magic Stamp™ print by LM

Textured or design stamp blocks

Supplies: blocks of wood or foam, small boxes, string, lace, yarn, glue

Optional: Flexi-Cut, flat pieces from a rubber inner tube, shoe insoles such as Dr. Scholl's© foot pads

1. Find or cut blocks of wood, foam or even small cardboard boxes. One flat surface is necessary. Consider the grasp and manual dexterity of your clients.

2. Glue fabric, lace, shapes of cardboard, string dipped in glue, or anything as thick as a coin or thinner into a design on the flat surface of your block. Use Elmer's Glue or something that is waterproof when dry. Covering the shapes with a coat of house paint helps adhere them and makes the stamp more waterproof and durable.

OR

2. Flexi-Cut is an adhesive plastic that can be cut with scissors (see Appendix for suppliers) and makes great stamps. Craft stores have other adhesive foams. Two advantages to this product are the facts that it can be cut easily with scissors and adheres instantly with no drying time required.

3. Let any glue or paint dry before printing.

Printing rolls or balls

Printing rolls are fun but messy. Rollers are now commercially available with various patterns, but it is more interesting to make your own.

Supplies: paper board tubes or Styrofoam ball and craft stick, glue, string, rickrack or lace

1. Use paper board tubes from paper towels or toilet paper, full tin cans, empty tin cans that have had the top removed and all sharp edges filed down, a damaged roller or an old rolling pin.

OR

1. Use large Styrofoam ball (about 3") and push a craft stick into it and glue to secure. This is like a large lollipop.

2. Dip string, rickrack or lace binding in Elmer's Glue and wrap around the roller in a continuous spiral. If you do not have time to let the glue dry, just wrap the ball tightly and secure the ends tightly.

3. Tape down beginning and ending of string to secure completely. Let dry thoroughly.

4. Roll into paint spread thinly on a plate and transfer to paper.

Instructions for fabric printing

Fabric paints are available for printing (see Appendix) but are expensive and not necessary. Do not use tempera, food coloring or watercolor paint.

They will just wash out because they have no medium to bind the color to fabric. Fortunately, all acrylic paints work well for fabric printing. Artists' acrylics come in tubes or jars and have good, consistent and luscious colors but they are almost as expensive as fabric paints.

As an alternative, latex or acrylic house paints available at hardware or paint stores print beautifully on fabric and are permanent once they dry. Often hardware stores have discounted paint available from quarts or gallons that were inaccurately mixed for a customer or mixed and unclaimed. For my large groups, I buy five quarts of latex gloss or semi-gloss paint: yellow, blue (cyan), red (magenta not stop sign red), white and black. From these colors you can mix all colors.

When printing on fabric, a printing pad works well because the paint needs to be pushed into the fibers of the fabric. Work on just one layer of fabric at a time taking care to protect the fabric that is to stay unprinted. Cover fabric not being printed with a plastic bag. If printing a tee shirt, put newspaper or cardboard inside the shirt to keep the front and back separate.

Artistic and clinical applications

Stamp printing has been used for centuries for identifying property and decorating cloth, and it is currently very popular. Sophisticated use of stamps and relief printing on fabric in mixed media artworks and wearable objects attests to the processes great artistic possibilities. It is a process, however, that is extremely successful with people whose cognitive and physical abilities are limited. The process is easily broken down into measurable steps. The artistic ability required is minimal, results can be dramatic, quick and rewarding and adaptations can be made for almost everyone.

Introducing artmaking: two abused children

Using found objects as stamps to engage a client and to encourage him or her to explore materials is discussed in an art therapy article that combines art therapy and printmaking. In her article 'Printmaking with abused children: a first step in art therapy,' Stember (1977) presents a case study using printmaking to engage her clients, to reduce resistance and to

help them begin the therapeutic process. Stember found that printing with found objects offered a way for her to begin art therapy with an activity that is 'designed to demand little at the start and at the same time to offer pleasure and a chance to earn approval' (p.104).

Stember wanted an activity that would be non-threatening and encourage the child to have success and build trust. She carried a bag of found objects for her clients to rummage through and then engaged them in printing the objects. She found that finding egg cartons and other familiar materials mixed with unfamiliar ones was reassuring to the children. Abused children fear being hurt for 'not doing it right' or for no reason at all, so success without punishment is vitally important. Stember used printmaking as an introduction but says that even when children have moved on into more expressive direct artmaking they often return to what she calls 'the relatively safe and easy haven of printmaking' (p.105).

Stember relates two case studies. The first is of a severely repressed, tearful and frightened boy named Cory. Cory was unable to even consider drawing, so Stember began to engage him by introducing her bag of textured fabrics and objects that could be printed. Cory was able to touch the objects, move them around and play with them to get comfortable. Stember then had Cory dip pieces of texture rug into paint and stamp print with them. Stember used red paint because she sensed Cory could handle only one color and she chose red as a 'stimulus' to help him 'break through the wall he had built around himself' (p.104). I would never have used red with a child who had suffered beatings and neglect and was surprised with this color choice.

Cory began to experiment with the found object printing and later began to draw over his printed shapes. In subsequent art therapy sessions, Cory began to draw objects and then people. During his course of therapy, Cory would return to printmaking, his safe haven, when his images were too frightening.

Stember's second case study was of Guy, another abused child who demonstrated aggressive, uncontrolled behavior instead of Cory's withdrawn, fearful demeanor. Printmaking from Stember's bag of textures and found objects served to organize Guy and help him bring control to the wild disorganized scribbling and drawings that flowed out of him. Guy used printing objects in a random manner at first. With

encouragement from Stember, he began to see some things that looked familiar to him. The first change from his random, uncontrolled scribbling and stamping came when Guy noticed that shapes he had made with an egg carton resembled a house. He used chalk to draw a contour around the house and delineate windows. As Guy used the chalk, he worked more slowly and deliberately but did not speak of the house.

After a month of printmaking, Guy was able to use paint to create age appropriate scribbles, staying on the paper without throwing paint or chaotic repeating. Guy's first haptic person drawing was accompanied by strong spoken comment about his mother, and he started work on a central issue of confusion about his real mother and surrogate mother. In subsequent art therapy sessions, Guy often used printmaking as a start then went on to drawing figures. Sometimes he drew over printed shapes. He eventually asked mostly for paints, and improvements in his emotional stability paralleled his success at controlling the art media.

In Stember's discussion and comparison of the two case studies, she begins by noting that she proceeded slowly with each child, observing for signs of readiness before introducing the next small step. Stember used her bag of objects to engage each child's curiosity. Being abused and deprived of normal sensory experiences, letting these children explore at their own pace is important. Touch is critical; touching these objects provided safe stimulation. Building trust with abused children is very difficult, and Stember used printmaking with found objects as a beginning. Stember also states that Guy and Cory, as well as other children, moved naturally from printmaking into drawing. Some children became more involved with the printmaking process and went on to relief painting, using many of the processes described later in this chapter. Stember's conclusion is that simple printmaking can start the development of artmaking. In addition, it improves behavior and mood because of increased positive self image. Starting with printmaking, the children move quickly through the developmental stages of art expression and enable a clearer assessment of pathological problems and cognitive functioning.

A place for Derrick: a day habilitation program for adults with disabilities

My experience in an adult day habilitation program for persons with severe developmental disabilities has been helpful to see the power of inclusion in printmaking. The program serves 53 clients with functional limitations including inability to communicate effectively with others, difficulty with ambulation or fine motor coordination, inadequate work skills, lack of activities of daily living skills, inappropriate social behaviors, inability to engage in recreational or leisure skills and difficulties managing health care needs. All clients must be over 22 years of age and Medicaid eligible. Several of the clients were formerly patients at a now closed state hospital for the retarded.

My contract was for four hours a week. The challenge was to bring more of the expressive arts to the program. The staff were excellent, knew their clients well and were receptive to suggestions and support. I worked with one or two rooms of six people each week and responded to the needs of each particular group as well as to the interests of the staff. Rooms were organized around ability and considered individuals' need for stimulation or a quiet environment. There was a great deal of interaction throughout the day habilitation program. Since it was a short-term contract, staff training and support were important, and the time was limited.

One of our projects was to make cloth banners to brighten up the halls and replace commercial reproductions that were hung too high for most clients in wheelchairs to see. There were eight different rooms. Some rooms made paintings for their banners, others made collages. Many different media were chosen by clients based on their abilities and comfort level with materials.

I introduced printmaking to two rooms because clients were unable to grasp crayons, regular markers or paint brushes. One room made creative use of large commercially available markers. Large Bingo markers are the right size but they have an alcohol smell and can not be used with clients who put things in their mouths. See Appendix for sources of these water-based large markers. Refillable markers are available also. Each marker was about an inch in diameter and four inches long, so clients were able to hold on to the markers with pincher grasp or a whole hand

grasp. The non-toxic water-based markers have a soft surface that releases the color when pressed.

Clients were mostly able to use the markers to stamp by holding them and banging up and down. Getting each client to focus on the up and down motion, keeping the printing surface in contact with the paper and getting a spread of dots was the main objective. Modifications had to be made to get the fabric we were printing taped to a clipboard and positioned where clients could reach it near an arm that was contracted by spastic muscles. Some clients added marker drawings to their stamping.

The clients in one room especially liked their art sessions because we frequently ended up dancing. Several drew expressively and used the time to 'tell' stories about their home lives. The seriousness of some their home lives was balanced by music, exercising and dancing and their enjoyment of one another's company at this day program. For their banner some chose to draw while others enjoyed stamping or a combination of the two (see Figure 4.4).

Figure 4.4 'Everyone's Banner' by Group 5, stamp prints, markers and painting on fabric

Another room went three-dimensional with their banner. Initially they printed and used markers on fabric squares. The next week when I returned, they had gathered some of the printed fabrics and made them into three-dimensional art with pieces glued to a background and attached with sparkles, ribbons and trims. The staff and clients added and embellished to make a bright colorful banner.

In another room, all of the clients were in wheelchairs, all had cerebral palsy and had severe physical limitations. Some communicated through communication boards. Four of the group had been together at the state hospital. Most chose to paint their fabric squares for their banner. Adapting paintbrushes and arranging a painting surface that could be reached was the main focus. I did not consider printmaking because the gestures made by the brush were very important and expressive, and most clients clearly indicated that they wanted 'to paint.' Since many hands were needed to position the painting surface, hold paints where the client could select a color and add more paint at will and keep the paint mess to a minimum, only one or two clients could paint at a time. The others watched and made sounds showing their involvement. The most dynamic and vocal clients got to paint first and lead the way for the others.

One client, Derrick, is restricted to his wheelchair and has mobility limited to slight movement in one thumb on a good day. Derrick's arm was contracted so that it rests on his chest near his mouth. Including Derrick meant finding something he could do with such limited physical motion but clear intention. Thumb printing proved to be a rewarding alternative. Derrick was able to choose a color by blinking his eyes to indicate preference. With his permission, I put paint on his thumb with a sponge brush. Derrick then created several thumb prints on a fabric piece taped to a cardboard and held close to his hand. He proudly approved of the result which was incorporated into a banner along with other panels by his peers.

The case for repetition

Hurwitz and Day (1995) suggest that vegetable printing is a suitable activity for slow learners because of its repetitive nature and because the steps can be clearly broken down into simple, manageable steps with safe,

simple materials and tools (p. 113). It is helpful for clients to see a finished project and to finish each step before the next one is introduced. Initially limiting color choices may reduce confusion.

The repetitive motion of the stamping may help organize a client or may lead to perseveration. When a client perserverates, I try to encourage increasing the range of motion. 'Can you stretch way up here to print?' Moving the paper sometimes helps.

Robbins (1994) discusses materials and suggests that one of the considerations is a material's movement and rhythm characteristics. Media such as watercolors require a willingness to be fluid, flexible but do not require strength or gross motor movement. Robbins suggests that potato printing demands 'a repetitive motion and gives quick, easy results' (p.209). All stamp printing requires the same, and relief printing does, too, although the rolling of the paint and rubbing of the paper are more complex repetitive motions.

Breaking up old patterns: the challenge with Evan

If a client does not distinguish between applying the paint and then printing, the printing process becomes more like finger painting or painting. The client then just uses the potato or stamp as a brush and moves the paint around with the stamp rather than pressing and making a clear stamping mark. Some clients may not understand the cause and effect of stamp printing and will just play with the objects in the paint at first. Perhaps painting directly or finger painting might be more successful than printmaking for such clients. Nonetheless, I have found it worth pursuing the stamping process to change stuck movement patterns, increase awareness and generally stimulate some clients.

For many years I have worked privately with Evan, a multiply handicapped young man with a chromosome abnormality and severe seizure disorder. His development was always delayed, but he progressed through the scribble stages and for several years was able to form letters and numbers and write part of his name. His interest in artmaking focused on letters and numbers, and he never seemed interested in drawing to create other images. Due to a series of medication changes, poor health and a change in residence and day program, Evan lost his

writing interest and skills and was functioning at a low scribble stage when I thought to try stamp printing with him.

To keep Evan focused on the artwork was a problem. He threw materials and showed little motivation. A recent medication change had him struggling with drowsiness and bursts of aggravation. His initial marks were shaky and minimal. I showed him how to use the large stamper markers. He was able to grasp the fat marker easily, and his attention was engaged with the motion of up and down and the sound of the plastic marker (see Figure 4.5a). Before he got too uncontrolled with his banging the marker, I gave him a regular marker and suggested that he make circles. His large, free circles spontaneously covered the paper. He signed for another color and continued to use the whole paper with his expansive marks (see Figure 4.5b). Then he pushed the table away and ran around the studio. He has showed continued interest in making art since then and shows preference for painting with large brushes and using markers.

Figure 4.5a. 'First Drawing and Stamp Printing' by Evan, b. 'Second Drawing' by Evan

Symbolic language

Derrick and Evan and many others like them who have limited abilities justifiably get bored with the same activities day after day, year after year. Printmaking is a different and stimulating physical gesture. It can be more of a gross motor activity that is helpful when fine motor is limited. A person like Evan who can not form a letter or even a haptic person can bang a marker or a stamp up and down. Some may recognize the result of that action, some may not, but most know that they are creating something. Using printmaking allows people with limited cognitive and physical abilities to create images that they would not normally be able to make.

Although I have worked closely with developmentally delayed clients for over 30 years, I just recently discovered an article by Kläger (1992) that confirms an aspect of my experience. People with severe verbal limitations seem to enjoy artwork immensely and impart great significance to their creations. It is clear that there is meaning but frequently that meaning can not be clearly explained.

In a fascinating article, 'Nonverbal thinking and the problems of decoding exemplified by artwork of people with developmental disabilities,' Kläger explains the brain functioning of people with left brain hemisphere damage. In such cases the right brain sometimes regains its original autonomy which affects verbal expression. Symbols and metaphoric thinking is enhanced although it may appear to be 'wild' (p.41) to the normal listener. I have always found it is very easy to relate in metaphors especially to Down Syndrome people, and now I know why. With active right brain function they have access to emotion, primary process energy and everything is meaningful. If I say, 'Tell me about this,' and point to a line, a circle or a dot, my client usually responds. Often I am not able to understand what is said or the words may not make sense to me, but it is clear that the meaning is clear to the client. Kläger's article discusses case studies where he has decoded the language and metaphors of clients, and I recommend it for further reading.

Using stamp printing will allow people with developmental disabilities to enrich their symbolic, metaphorical art language even more than drawing and painting. With repeated use certain stamps can become

meaningful and facilitate expression similar to other visual communications systems.

Relief Printing Plates

Stamping a found object can be creative in the way a client puts together the images created. Making your own image is even more expressive. Making your own stamps adds creativity to the stamping process. Creating a printing plate also allows a client to make an image and reproduce it in various ways. The following simple instructions for making relief plates can be used in a therapeutic setting for expressive artwork. The relief process requires making a plate then applying paint to the top surface before printing. It is a three-step process. Some plates are made by adding to the surface, others by lowering areas by drawing directly on the plate. The techniques described are easy but allow a complexity for extended use and exploration. Whether a theme is suggested or the clients work freely, the process of printing can be beneficial and the imagery processed as any other artmaking.

Instructions for Styrofoam tray printing: process for line drawings

Styrofoam trays are suitable for a very rewarding relief printing method. There are similar commercially available printing plates that are essentially pieces of the same Styrofoam that is used for grocery meats and vegetables, disposable trays and restaurant take-out containers (see Appendix for sources and the following section for discussion of differences). Certainly try the commercial offerings if your budget allows, but look for free sources.

Styrofoam tray printing is an inexpensive process that is particularly suited to drawing because lines are easy to reproduce. Shapes must be made by drawing them with lines. It is difficult to create shapes without lines in this process except that the entire plate can be cut into a shape or shapes.

This process can be done quickly, with minimal supplies, without sharp cutting tools by anyone who has strength to press a pen into the foam to create a recessed line.

Supplies:

> foam trays from grocery store sales of meat or take-out cartons
>
> pencils or ballpoint pens
>
> scissors
>
> paint (water-based block print, acrylic or house paint)
>
> pieces of Plexiglass® or Masonite to roll paint, or plastic trays or plates just a bit larger than the width of your widest roller
>
> rollers or brayers (one is enough if shared)
>
> paper or fabric to print on
>
> newspapers or printing pads
>
> paper or covering for table
>
> clean-up supplies: a bucket or plastic bag with moist sponges, baby wipes, soap or paper towels

Making plates

1. Clean trays in soapy water to remove food residue, especially oily areas. It is important to clean the trays antiseptically if they were used for meat to avoid possible contamination from bacteria.

2. Cut off raised edges and retain only the flat sections. The Styrofoam can be cut into any shape but needs to be flat to be rolled with paint and printed.

3. Draw into the Styrofoam with pencils, ballpoint pens or an orange stick. It is easiest to use a pen so that the drawing is visible. Lines must be deep and wide enough to create a depression in the Styrofoam that will not fill up with paint. The incised lines should be visible. Often it is necessary to go over the lines and press harder. Usually even if the line goes through and makes a hole in the Styrofoam, the print will work well.

Note: Remember that everything will print in reverse so not only do letters have to be reversed but also the *order* of the letters is reversed.

Applying paint (rolling)

1. Set up a printing area (see Chapter 3) once the plates are complete.

2. Use a Plexiglass® plate or tray to put out a small amount of paint, about half a teaspoon to start.

3. Holding the roller firmly, roll out the paint so that it is thinly and evenly distributed over the roller.

4. On the messy side of your folded newspaper, roll the paint evenly over the entire plate. Go over it so that it is completely covered.

Pulling a print

1. Pick up the wet plate carefully and place face up on clean printing side of newspaper pad or on printing pad.

2. Wash your hands or clean with damp sponges.

3. Place clean paper over plate. Keeping one hand on the paper at all times, start at the center and press outward pressing the paper smoothly onto the plate. You can use your fingers, the back of a spoon, a clean roller, a rolling pin or a dry sponge. The idea is to press evenly without moving the paper. An

alternative method is to place a book over the paper and press firmly.

4. Lift the paper and separate from the plate. You should have a reproduction of the plate, in reverse, as your print.

5. To make another print repeat the process starting with applying more paint. If you want to change colors, either just roll another color over the plate as it is, blending the two colors, or wash the plate, dry it and start all over again.

Problem solving

1. If the paper sticks to the paper, you took too long and the paint dried.

2. If the paint filled in all the lines, you used too much paint. Immediately take another sheet of paper and print again without adding more paint. Use less paint next time.

3. If the print is too faint, use more paint next time or press harder.

4. If you have a double image, try harder to keep the paper from moving as you press. If it continues to be a problem, try placing a towel on top of the paper and then pressing down with a book, or even stepping on the 'sandwich' made by the plate, paper and towel.

5. If you get just one solid plane of paint, the lines are probably not deep enough. Wash the plate before reworking it, then go over the lines to make them deeper.

Reverse writing

Some clients may not have the cognitive ability to do reverse writing but wish to have words, so I write words out in reverse for them to copy or do it for them if requested. I have several unbreakable mirrors with me at all times to check the writing before it is printed.

Alternatives

Try this process using a thick piece of paper instead of a Styrofoam tray. Place the paper on a stack of newspaper, use a ballpoint pen and press firmly so that the lines you draw bite into the paper without tearing it. Apply paint and proceed as for Styrofoam trays.

Expand your idea of the size and shape of an artwork. Because we so frequently use letter-sized paper, legal-sized or 18" x 24" standard drawing paper, we tend to think in rectangles. These Styrofoam plates are very easy to cut into shapes. The edges of meat trays can be used for long, thin plates. The plate itself can be a specific or a free form shape cut out by you or the client. Cut several pieces from one large one to make a jigsaw plate. Put tape or a mark on the underneath side, so they will reassemble easily.

Artistic and clinical considerations

Making a village, developing group cohesion

Once when I had only three hamburger trays for a group of twelve clients, I had to use every available piece of foam including the edges. There were some squares, a few rectangles and many narrow shapes with uneven edges. They reminded me of childhood blocks and how much I enjoyed making houses.

Because the group came from various backgrounds and most were not currently living at childhood homes, a sense of displacement and longing for community was present. The group worked on 'houses or homes' and created prints of their own houses from the Styrofoam plates. Some prints depicted tall apartment buildings, a few were typical bungalows, some were just roofs, another created a barn. After discussing the differences and the various meanings of house and home, the group realized that they could print all the 'houses' together on one large piece of paper to make a city village (Figure 5.1). As with any group, some people would print more quickly and reproduce their houses several times in the city. One person took the concept further and created a book from her collection of houses (see Chapter 10).

a. 'Up on the Rooftop' by JM

b. 'Cityscape' by MM

c. 'The Crib' by SM

d. 'The Blue Uprising' by ML

e. 'Hadley House' by JS

Figure 5.1 'Village' by group F, a. 'Up on the Rooftop' by JM b. 'Cityscape' by MM c. 'The Crib' by SM d. 'The Blue Uprising' by ML e. 'Hadley House' by JS

Commercially available relief plates

There are many commercially made relief printing plates available: 'Score Foam,' Safety-Kut™ Wood Grain Printmaking Blocks, Soft-Cut 'Lino' Block Printing material, Balsa-Foam™, E-Z Cut, Flexi-Cut, Printfoam (with or without adhesive backing), Scratchfoam™,Speedball Flexible Printing Plates. Some are more expensive than others and more successful than other (see Appendix for supplies). Many relief printing plates can be cut with scissors; some have self-adhesive backing and make beautiful stamps and plates. If your budget can afford these materials, they are wonderful to work with. If your clients are able to use carving materials, these new plastic-based materials are soft and cut well with utility knives or wood-cutting gouges if you have access to them. Traditional printmaking books have detailed instructions on the traditional relief techniques of woodcut, wood engraving and linoleum blocks, but I have not included them here because of the danger of cutting tools with these hard plate materials. Flexi-Cut is my personal favorite for ease of use and adhesion.

Instructions for collagraph relief plates

In the 1950s, plastic products were available for commercial use for the first time. Plastic was developed to replace dwindling supplies of ivory for billiard balls but soon was recognized as being valuable for many more uses. In the 1950s in Disneyland in Anaheim, CA, Walt Disney built 'The House of the Future' that was built entirely out of plastic. Plastic is waterproof, durable and chemically can take on many properties and began to be used for many purposes.

Artists started experimenting with plastic polymers, liquid plastic substances, for printmaking. Glen Alps is credited with early experimentation and naming of collagraph printmaking. Alps glued collages on a board and painted or rolled paint over the collage, placed a paper on top of it and pressed to create a transfer print which he called a collagraph. The term comes from the Greek *colla*, which means glue, and the French *coller*, which also means glue, plus the English *graphic*, which means printed matter (Romano 1980, p.12).

Since 1971, I have made collagraph plates for my professional artmaking because the various polymers can create such a wide range of artistic results. Collagraphs can be created to look fluid and painterly or to look crisp and hard edged with a mechanical, graphic look. See Additional Reading for books with contemporary artists examples. I have worked on some plates for months perfecting a particular value or level of detail. Fortunately, I have experimented and simplified the process of plate making to meet the material and time restraints of art therapy. The following variations of this method are many and very useful to art therapists. Try some of these adaptations.

Instructions for simple one-session collagraph relief plates

Supplies: cardboard or Masonite for plates, contact paper, stickers, masking tape, decorative tape, adhesive tape, scissors, water-based block printing or oil paint, roller, paper, printing pad or newspapers, clean-up supplies

Optional: mat or utility knife

Setting up

Set up for plate making by having the plates cut, scissors out and materials to add available. Clean up plate making before proceeding to printing. Set up for printing the same way as for Styrofoam tray printing using a roller and either water-based printing paint or acrylic paint rolled out on a flat surface (piece of Plexiglass®, cardboard, lunch tray, large plate). The paint needs to be rolled evenly and thinly.

Making the plate

1. Cut plates from cardboard, mat board, Masonite, any flat surface that glue will adhere to. Cut squares, rectangles, circles, free form shapes.

2. Create a design or picture on the plate with contact paper and any other self-adhesive papers, tapes (masking, scotch, decorative, not electrical), self-sticking stars, simple shapes stickers (designs on stickers do not transfer only the shapes).

3. If you have used cardboard or any plate that can be incised, you can cut into the plate and the cuts will show up in the print. With corrugated cardboard, you can remove sections of the top paper layer to expose the fluted surface below.

Applying paint

1. Use water-based or oil paint: thick tempera, regular house paint, block printing paint, acrylic from the tube or oil paint.

2. Roll paint thinly onto a separate rolling plate (piece of plexi or a plastic tray) with a roller. The paint should look like silk on the roller, not drippy or in globs.

3. When the paint is distributed smoothly on the roller, apply the paint to the plate in a methodical way. Try to distribute paint evenly over the surface.

Pulling a print

1. When the paint is distributed evenly on the plate, move the plate to the clean surface of your printing pad or newspaper.

2. Clean your hands.

3. Place a clean piece of paper on top of the plate, put your hand on the top and print by pressing the paper into the plate with a clean roller, a spoon, your fingers or a block of wood. Press evenly and smoothly taking care not to move the paper.

4. The first printing will probably be faint because the paint will absorb into the collage. Following prints will probably be better. Repeat the process from the applying paint stage to produce another print.

5. To change colors you must just roll paint over the preceding one or let it dry. There is no good way to get rid of a color once you start. The underlying paint dries in places and the later prints have a combination of colors from previous printings that are very interesting and complex (Figure 5.2).

Figure 5.2 'Starry, Starry Night' by BLB, simple one-session relief collagraph

Instructions for two-session collagraph relief plates

Making the plate

1. Cut plates from cardboard, mat board, Masonite, any flat surface that glue will adhere to. Cut squares, rectangles, circles, free form shapes.

2. Create a design or picture on the plate with anything under a coin thick that you can glue onto the plate: cut or torn shapes from paper, cardboards, tapes, contact paper, fabrics, doilies, laces, rickrack, trims, etc. Everything must be glued down carefully so that it will not lift off when the sticky roller goes over it. Let dry overnight. Press to make sure no glue is lurking under something else waiting to ooze out and ruin the print.

Glue note

Use Elmer's Glue, latex paint, gesso or acrylic polymer thinned in half with water (best). Use anything that dries to be waterproof but avoid airplane glue or glues that give off noxious fumes. Rubber cement usually is not strong enough to withstand the rolling of paint. If you are able to use a press avoid Elmer's Glue; it sticks to the paper even when dry. Use acrylic polymer, gesso or latex paint for collagraphs to be printed on a press.

Proceed as for 'Simple one-session collagraph relief plates' above when plate is dry. Complex and delightful prints will be produced if you have time to try several different rolls of color. You do not need to clean the plate between rolling and pulling prints. Residual color from one print will show up along with additional colors (Figure 5.3).

Figure 5.3 'Image' by AB, two-session relief collagraph

Instructions for glue plates

Making a plate

1. Use a cardboard plate that will accept the glue readily.

2. Make a design (draw) with a glue bottle using the glue line as it emerges from the bottle. Try not to make thick lumps of glue that will be difficult to dry completely.

3. Let dry thoroughly.

4. Apply paint and pull print as above.

Note: Presses are expensive but produce the best results because the pressure reproduces every little variation in the textures. An old wringer washing machine works well if you can find one, a rolling pin works, putting the plate and paper between two packets of newspaper and standing on it can work, too. Intense, steady pressure produces the best prints. If you have a press, using damp, rag paper keeps the paper from creasing and ripping, but it is expensive.

Artistic and clinical considerations

Focus on names

Stamps and relief plates adapt beautifully for making repeated patterns and insignia. Adolescents are often very interested in their names and initials. They can make relief prints or stamps with reversed initials or correctly using mirror writing and use the two to create interesting patterns. Use negative and positive spaces. Be sure to make the letters thick enough to make a good stamp.

Try experimenting with simple initials on a folded square of paper placing them to the edges of the folds so the initials connect and even vanish into one another (Pichini 1994). Make the stamp or plate a triangle and print it in a circle, as a border. Even with a simple initial stamp or plate, clients can make more interesting and abstract designs. A stamp can also be used to mark possessions as they were used in ancient times or as an artist's chop mark (see Chapter 2).

Leveling the playing field

I have found that printmaking is an excellent way to work with a new group of clients because it 'levels the playing field' and allows clients who have had little or no artistic background to successfully create. Clients who have good drawing skills are forced to discover new methods of expression that require new skills. This can be frustrating; often clients have stylized pictures that they repeat with confidence (a particular face, figure, action hero, horse, bouquet of flowers, bucolic scene). Their drawing ability gives them the status of being 'an artist,' but it often discourages others in the group who do not have such drawing skills. Printmaking is usually new to everyone; often the 'best artist' in the group does not create the best print. With technical understanding of the printmaking process, experienced artists quickly become expressive but often want to go back to the process that he or she originally was successful at. Intaglio printing and lithography are printing processes discussed in Chapters 6 and 7 and are richly rewarding for clients who have well developed drawing skills.

Introducing printmaking at a rehab center for women

Bringing creativity into a structured vocational or rehabilitation center can be a challenge. The artistic skill levels are frequently extremely varied and the competition to produce intense. The appropriate focus of such facilities is to develop good work ethic, improve skills and prepare individuals for the beginning or a return to employment. In 1999 I received a call from a rehab facility for women with a history of incarceration, inpatient substance abuse treatment or inpatient psychiatric treatment. Women are employed 30 hours weekly and receive 4 hours of counseling, case management and relapse prevention services as they begin the process of reclaiming their lives. Women remain in the program for 6 to 24 months depending on their circumstances and needs. The facility contracts with area companies to assemble their products and this income pays the women's salaries. They also developed a modest silkscreen business printing tee shirts for small establishments. This venture teaches a marketable manufacturing skill.

The director called me as an artist to ask if I would design some holiday cards for them to screen to sell for fund raising. I refused saying that it would be foolish for me to create the artwork when they had a program full of people who could create much more meaningful images than I could. We talked about the goals of the program, building self-esteem and developing marketing skills. I was convinced that cards created by the women who were printing them would be much easier to market than images from a paid local artist. Customers would buy the cards because they wanted to support women who were trying to become gainfully employed. With great faith, the director agreed to a short series of art sessions.

Six to ten women were available for the hour I was there. The group was called Art Group and substituted for one of their required three hours a week of therapy. I explained their director's phone call to me and announced that I knew that they could design cards that would be wonderful. Most were incredulous. Some had done artwork in the past but had been away from any artmaking for a while. The skeptical group tried to designate one talented young woman as the artist because she loved to draw. I explained that they would all be doing simple printmaking each week and that it did not require drawing skills. At least

I was convinced that the process itself would create interesting effects with simple designs.

We began with 'mystery monotypes'. It was hot in the room. Some women spent too much time on their drawing, and the paper dried and stuck to several plates. Fortunately there were a few interesting prints. One client created a charming, haptic snowman complete with unplanned snow created by the transfer of paint. We moved on to reductive monotypes and had more success.

The second session was devoted to making collagraph plates. The collage pieces were adhered with glue that would have to dry before printing, so we also did some drawing to have some finished pieces from the session. At the third session, the collagraph plates were printed. The results surprised most of the clients. Even the simplest cut-out shapes produced interesting textured prints. A triangle of herringbone textured wallpaper became a holiday tree. Some had used a bottle of glue and written words in reverse. There was time to print in several colors, and those who worked quickly produced several prints.

At the fourth session, we reviewed our images and started writing poetry for the verses. I encouraged them to write more than Merry Christmas or Happy Holidays. We worked as a group when individuals had difficulty thinking of verse for an image. The women and staff were supportive of one another. One woman spoke mostly Spanish and needed translating at times; her card was appropriately written in Spanish. The poetry that emerged to complement the prints contained a mixture of longing for family and traditional associations.

The sessions we had were short. Many clients were so caught up in getting their work done that time out for art seemed unimportant, but part of the training was to help them prioritize and learn to nurture themselves. The commercial screening system at the facility used screens that are prepared photomechanically from camera ready art, so we needed to get the prints and the poetry ready to screen. The last session I had printed out the words of poetry, and the women cut and pasted them to make the cards camera ready. It was a brief series that I hope created an atmosphere that encouraged the clients to explore their own creative process as well as to participate more in the business. See Figure 3.2, 'Joy,'

and Figure 5.4, 'Angel,' for examples of card designs from two of these women.

Figure 5.4 'Angel' two-session collagraph relief print by JD

Intaglio Processes
Focus on Lines

This chapter is devoted to intaglio processes. Intaglio is the term used to describe printing from the crevices or grooves incised into a plate to hold paint (see Figure 3.3). The term intaglio is pronounced in-tal-yo and is a term easy to remember because the image goes into the plate. The word comes from the Italian word *in tagliare*, which means 'to engrave or to cut.' Examples of traditional intaglio printing methods are engraving, etching, aquatint, sugar-lift, soft-ground, mezzotint and drypoint.

The term process refers to the way an image is put onto a plate and the way the paint is applied to create a print or reproduction of the image. Intaglio processes all involve creating an incised or recessed line or area in the surface of the plate to create the image to be reproduced. The incised image is lower than the surface of the plate, paint is pushed into the depressions, the plate surface is wiped clean, and the paint remaining in the incised areas becomes the print. Getting the paint out of the incised areas requires considerable pressure, usually a press.

Intaglio processes are exactly the opposite of relief processes (Chapters 4 and 5) that involve adding to the surface to create the image and rolling paint over the plate to produce a print. Etching, the first and best known intaglio process, developed during the Middle Ages. Armor makers incised designs into their helmets, shields and breastplates and copied the designs for future reference by rubbing pigments into the incised design and transferring them to paper by pressing. Armies, countries and empires were identified by flags, banners and the insignia

incised into suits of armor. This artform was integral to the organization and government of most people during the Middle Ages. All intaglio printing is derived from those early etchers of armor.

Just association with the words, 'incised,' 'cut,' 'armor,' 'pressure' must alert art therapists to wonder if any process associated with such terms could be adaptable for therapeutic uses. Please read all the information here, try this process yourself and consider the needs of your clients. Presenting this chapter second does not imply that it is just a little more difficult than relief process, or that it is more or less applicable.

Although I am presenting processes following historical order of development, each chapter includes several adaptations that provide a wide range of choice in levels of physical difficulty, time needed for completion, number of steps involved and safety considerations. Most of the techniques described here produce the best results with a press, so this chapter will be less helpful to you if you do not have a press. I have not included any of the traditional etching processes (hard or soft ground etching, mezzotint, aquatint) because of the expensive and toxic materials involved. I do not want to use varnish, ferric chloride, Dutch mordant, nitric acid, asphaltum, gum Arabic or rosin.

One traditional intaglio method, drypoint, is described in detail with adaptations available since the development of plastic has made a similar process potentially suitable for use. Drypoint on Plexiglass® is best suited to take advantage of the benefits and eliminate most problems and chemicals. However, one technique that developed in the 1950s, collagraph intaglio, uses the same process but contemporary materials and can produce rewarding results with hand printing and is worth exploring with clients if you do not have a press.

Each of the specific instructions in this book begins with a note about the difficulty and potential dangers of the process. Some processes require scissors, all require some kind of paint that could be ingested, so there are always safety issues to consider. The main intaglio process described here, drypoint on Plexiglass®, is the most difficult in the book and requires a scribing or cutting tool that could be dangerous. Fortunately, Styrofoam tray plates can be incised with a ballpoint pen and inked with the intaglio process. Collagraph intaglio is also included here

as an alternative intaglio process because it does not require sharp tools and can be printed without a press.

Each therapist must carefully weigh benefits and disadvantages of any medium and err on the side of caution with every client. Knowing the process and being comfortable and skilled with all of the materials is vitally important and especially so when using sharps and a press. The sharps required to create drypoints on Plexiglass®, the potential frustration level and potential danger must be seriously weighed for clinical use against the potential for rewarding creative expression. See Figure 6.1 'Carousel Horse,' for an example which includes both. Be sure you are comfortable with these processes and have done enough personal artmaking before you even consider using them with clients.

Focus on lines

The use of this process with specific populations is explored because of the potential for expression especially with clients whose strength is drawing, using lines. The subtitle of the chapter is 'Focus on Lines,' and the reproduction of lines is the main reason for including drypoint on Plexiglass®. Even making a shape on a drypoint plate means drawing that shape and filling in the shape with cross hatching, lines or scraping; it is really drawing. Introducing another way to reproduce lines is valid, and drypoint printing can be rewarding and not too complicated if you understand it and have all tools and equipment ready.

Figure 6.1 'Carousel Horse' by AK, drypoint

Some clients and artists naturally gravitate towards shape making or find success making shapes because they are not able to draw comfortably. Most relief, stencil and screen processes are best suited to shape making (see Chapters 4, 5, 8 and 9).

All intaglio printmaking processes require these steps:

1. The image is incised or scratched into the plate or firmly collaged onto the plate.

2. Paint is pushed into the incised area.

3. The plate is then wiped off, and the plate is polished to remove the paint from the smooth, high areas of the surface but to allow it to remain in the incised or absorbent image areas.

4. Paper is positioned on top of the plate and then pressed into the incised areas to transfer the paint held there. Usually this requires a press.

Note that the third step is additional to and different from relief prints.

Advantages and disadvantages

1. Intaglio printmaking is a four-step process that requires time to complete each step. The plate making may be done separately in one session, but the paint application, wiping and printing must be done together. Breaking down the steps of an art project has obvious advantages and disadvantages. This is a process that is best used with a client that you will see at least twice or for a long session. It is an ideal media for long-term clients with physical dexterity and ability to concentrate on an extended project. It is very rewarding in an educational setting with adolescents. See Figure 6.2, 'Ready to Bloom.'

2. Incising a drypoint plate requires hand strength and agility. Some clients will not have this skill and thus are not good candidates for this process. For clients with adequate hand strength and coordination, focusing energy and skills on plate

making can be beneficial. For clients with limited hand strength or restriction with sharps, collagraph intaglio or Styrofoam plates should be considered.

3. Some kind of cutting tool is required for drypoint on Plexiglass®; this safety issue eliminates some clients. Styrofoam tray printing requires some implement to incise a line, but a pencil or ballpoint pen will work. Consider collagraph intaglio for clients restricted from using sharp implements and just tear pieces of tape. See Figure 6.4 'Chaos 2000.'

4. Mistakes are easy to make and difficult to correct with drypoint on Plexiglass®. The scriber slips and makes unintentional marks. Such marks can be smoothed with care, but it is difficult. This reality can be a frustration or a learning opportunity. Only you can determine if this very real consideration is a problem or opportunity for your client.

5. Specific paints and paper are required. A press is required for drypoint on Plexiglass® and intaglio Styrofoam plates, although collagraphs can be printed as intaglios without a press. There is a lot more equipment and expense than many other art projects. If you have a press, the paper is the major expense. One way to be realistic about time limitations and economize on the expense of supplies is to work on very small plates.

6. Oil paints of all kinds release an odor and are almost impossible to remove when dry. Never use toxic oil-based solvents but clean up with rags or paper towels and then Lestoil or another grease-dissolving cleaner and water. Nevertheless, paint and Lestoil have odors and are chemicals that could cause respiratory problems or skin reactions. They are chemicals and must be treated with caution.

7. Considerable pressure is needed to produce a print. Most intaglio processes require a press of some sort to produce a good print. The major disadvantage to intaglio printmaking is that prints are much better if a press is used. If you are

fortunate to have a printing press or be able to borrow one, this technique and most relief, intaglio and planographic printing is more successful with a press. Most people also are fascinated by a press because it is a machine that they may never have seen before. If you do not have access to a press, you can hand print collagraph intaglio prints. The artistic results are not as successful as using a press but rewarding.

8. It would be very difficult to have more than one person work on making a drypoint plate at the same time. Creating and applying paint to the plate is very individual, but the printing process requires sharing of the press and can be a group activity. Certainly the processing of the artwork produced can be a group experience. See Chapters 8 and 9 for discussion of increasing socialization skills and group process.

9. As with all printmaking media, multiples can be produced and that can be a tremendous advantage or disadvantage.

10. Drypoint is a process of line making, not shape making. Collagraph intaglio is both line and shape supportive.

Equipment and materials

Presses

If you have a printing press, take good care of it. It is a simple machine that just needs basic care: keep it clean and the gears oiled. Remove any paint spills immediately. If the parts are not stainless steel, they will rust if moist blankets are left on the surface or if moisture sits on it. Never leave blankets under the roller under pressure; it will ruin your blankets and may rust the roller. Frequently check to see that the roller is parallel to the press bed and correct the balance if it is uneven. Do not let anyone crank a plate through that is too thick and causes too much pressure; you should not have to use a tremendous amount of effort to print. Some resistance is all right, but do not stress the press. Forced use tears holes in the blankets and could dent the rollers.

The mechanics of an etching press are simple. Every press has a place to put the plate (a bed) and a roller or plate to press down onto the plate.

Etching or roller presses have two rollers, the bed goes between them, and a crank makes the bed advance. Picture an old-time wringer on a washing machine. Actually, an old wringer washing machine works well if you can find one. If you do, a piece of Masonite works well as a bed to hold the plate as it is pulled through the wringer.

Another kind of press is a lithography press that has a top plate to press down onto the bed. Picture standing on a stack of books. If you do not have access to a press, hand printing is more like a lithography press in that you have to press the paper onto the plate with as much pressure as needed to produce a print. The artist sets up and becomes the press. To hand print, you will need either a clean roller, a rolling pin, a large spoon or your fingers to press the paper into the plate as firmly as possible.

Second-hand presses are sometimes available. The mechanics of a printing press are so simple that not much could be wrong with a used press. You might be able to borrow one from a nearby school or an artist who is not using it.

Safety note

Obviously, if there is enough pressure to press paper into shallow incisions on a plate, that same pressure can really crush fingers that could be caught. Vigilance is important to keep fingers, long hair and clothing away from the rollers or press bed. Do not leave the press unattended or unsupervised with clients.

Blankets

Some kind of blanket or cushioning between the paper getting printed and the roller is essential in making a good print. Printing presses have felt blankets, but they are very expensive. If you have them be grateful and careful not to get them soiled by messy hands or paint oozing out from printing plates. Do not let anyone run a plate through the press without clean hands; use unprinted newsprint above and below each plate.

If printing blankets are not available, use pieces of old wool blankets cut to the size of the press bed to cushion the plate and paper. Usually two will suffice. Felt works well also.

Protective paper

For the press: the plate rests on the bed of a press and often leaves a residue of paint if there is any on the underside of the plate, so use plain newsprint or recyclable paper under the plate. Rescue the paper to be recycled from a copy machine, use paper towels or use junk mail. Printed newspaper is messy because the print offsets onto everything and is best avoided in an ideal setting.

For applying paint and printing without a press: use newspaper as described in Chapter 3. This makes a cushion where paint can be applied to the plate and wiped. When the top layer of newspaper gets soiled with paint, it is easily turned to the back and another clean sheet is available. This newspaper pad defines a work space for each client and helps organize the space. Even the used wiping cloths can be folded up and thrown away in the newspaper when the session is over.

Drypoint plates

Plexiglass® (or any other plastic sheet thick enough to withstand a scratched-in line) works well for drypoint. You will need a Plexiglass® cutter and a metal straight edge with a cork or foam back to cut a large piece of Plexiglass® into smaller plates. Cutting Plexiglass® is like cutting glass but easier and safer. Because of the nature of this process and current trends toward short-term therapy, use small plates. A 2" x 2" plate seems small, but this is a linear process that is most successful done with short, small strokes. When introducing any new process, it is best to start with a small plate so clients can experience the process without becoming over-whelmed.

Cutting Plexiglass®

Cutting Plexiglass® is not difficult and is a good skill to have. To cut Plexiglass®, firmly hold a straight edge over the large section of Plexi-glass® and isolate the surface you intend to cut. Draw a light guide line with a marker, then use the cutter to lightly and smoothly draw the cutting blade close along the straight edge. Use the straight edge to steady your hand. Make several strokes, each in the same groove, getting deeper each time until you have a clean groove cut into the Plexiglass®.

The smell of plastic lets you know that you are doing it properly; the sound is unpleasantly similar to chalk on chalkboard. Now extend the piece over the edge of the table and whap it sharply with your hand. It should pop off and along the cut edge. If it does not work, carefully reposition your straight edge and repeat your cuts until you have penetrated the Plexiglass® deeply enough have it snap off easily with your hand slap.

If you bevel the edges of the plate with a file or rasp, the plate will go through the press more smoothly, the edge is less likely to cause injury, and the paper will be less likely to crease. Hold the plate at the edge of a table and draw the file or rasp along the edge and away from you. A 45-degree bevel is best. Sometimes this beveling of the edges can be done by the client, but it takes time and dexterity.

Note: Most hardware and building supply stores will have long thin strips of Plexiglass® that remain from customers' orders, and most are willing to donate these strips to teachers and therapists. If you do not want to cut the Plexiglass® yourself, ask the hardware store to do it for you. If you are flexible about the size of the plates, you can use up scraps that the store will probably not be able to sell. They may charge you but maybe not much.

Collagraph intaglio plates

Use mat board, Masonite, cardboard or any other surface that will allow glue to adhere and remain stiff enough to withstand wiping and running it through the press.

Scribers

Artists' etching tools are available through catalogs (see Appendix) but hardware stores carry scribers designed to put social security numbers into possessions for identification purposes. They are relatively inexpensive and easy to use. Scribers can also be made from broken dental tools, old compasses and large nails. Wrap lots of masking tape around handmade tools to provide a cushion for fingers and make the tool easier to grasp and more comfortable for extended use.

Printing paper

The best paper gets the best results: 100 per cent rag paper is very expensive but wonderful. Best results are produced with a press and dampened, soft paper (Arches, Rives BFK, Somerset, Lenox, Folio, etc.: see Appendix for suppliers). However, you can use typewriter, computer or any kind of smooth surfaced paper if you have to, especially to proof a plate. The sizing in most papers makes it stiff and thus inflexible, so it is difficult to get it to press into the crevices without creasing. If you can afford only plain paper try construction paper because it is soft and picks up the paint easily. Colored construction paper quickly fades with age, but the white and manila paper is adequate.

System for wetting paper

Printing papers are made with high rag content and have less sizing than commercial papers, but even most printing papers are best when soaked in water before using to remove the sizing. Use a dish-washing tub, photographic developing tray, a cement mixing tub or even a bathtub for large papers and fill with water to cover the paper. Place pieces into the water one by one and let them soak 20 minutes.

As an alternative and space saver, use a spray bottle of water to spray both sides of the paper. Place the wet paper in a stack and put the stack into a plastic bags and close up for 20 minutes. If you are limited in time or space, it may be easiest to precut and presoak the paper and bring it to the session in a plastic bag. Do not leave paper soaking or in a plastic bag too long because it will mold or mildew.

If you are using computer, typing or any other regular paper, you only need to wet the paper on both sides just before using. Use a spray bottle with water or run each side under a faucet quickly. Soaking will make regular paper disintegrate.

Note: If you have a paper-making plant or office supply store nearby, ask if they have any paper that they would donate to your good cause.

Blotters

After soaking the printing paper or wetting the regular paper, blot off excess water between two towels or clean blotters. The paper should be damp but not dripping with water. If the paper looks shiny and wet, blot out more moisture. The paper will be fragile without the sizing to stiffen it and hold it together, so handle it carefully.

After prints are pulled they should be dried slowly between dry blotters to prevent the paper from curling or rippling.

Paint or ink

For the best drypoint prints, oil-based etching inks are ideal. They are very dense pigments that need to be mixed with plate oil and are available through art supply stores and catalogs (see Appendix). Fortunately for therapeutic use, regular oil paints can also be used successfully. Using oil-based paints allows plenty of time to work, damp softened paper can be pushed into the crevices to pull out the paint, and you get the best prints. It is definitely better to use oil paint if your clients can tolerate the smell, and if you clean up as suggested.

If you must use water-based paints, try block printing paint and work very quickly because the paint will dry in the crevices and on the smooth surfaces of the plate. Use damp, blotted paper which should transfer the dried paint. Very little paint is needed for each print, but paint management is always necessary to consider (see Chapter 3).

Daubers

You need to get the paint into the crevices and then wipe it off the smooth surfaces. Cut 2" x 10" (approximately) strips of soft cloth (wool, any knit fabric, old tee shirts, anything soft and smooth) and roll them up and fasten them with masking tape to make daubers. The soft cloth does not scratch the Plexiglass® as any paper does, and it is an easy way to put paint where it is needed in the crevices. Daubers also make applying paint to collagraphs easier. For extended use, when the end that was covered with paint dries, cut it off with scissors and use the new surface. Another way of getting the paint onto a plate is to use a soft rag, but that is messier.

An option is to use small pieces of cardboard or mat board to smooth the paint on and into the crevices. The paper tends to make undesirable scratches in the Plexiglass®, and it wears off the plastic burrs that hold onto the paint on a drypoint plate, but it is neater. This system works well with Styrofoam plates. Weigh the advantages and disadvantages with the needs of your clients.

Wipers

A wiping pad helps wipe evenly and smoothly and keeps hands cleaner. Make a wad of cloth about the size of a baking potato, tape it together. Cut soft squares of cloth to cover the wiping pad, lots of them. Tee shirts are great. Put a square of cloth over the pad to wipe the plate. Change cloths frequently to wipe the surface areas clean, but retain the wiping pad to cover with a clean square of cloth.

For collagraph intaglio use a combination of soft wipes and small pieces of newspaper.

Gloves

To keep hands clean when applying paint, consider purchasing gloves that can be used and reused. Any type of glove would help protect hands, but they are awkward and many artists eschew wearing them. Hardware stores carry black cotton gloves that are inexpensive, soak up the paint and dry out quickly. I have reused several pairs for years. Plastic or latex disposable gloves are expensive and leave paint prints everywhere, but some people use them. Plastic gloves are usually available in hospitals and healthcare settings. If a client is allergic to latex, using any chemical is probably ill advised. If a client is uncomfortable getting messy, consider using another neater media.

Cleaning supplies

No toxic solvents are necessary to clean up oil paint. Please do not use turpentine, lacquer thinner or paint solvent with clients or for yourself. Use soft towels or rags to wipe excess oil paint off plates and hard surfaces. Paper towels will scratch the soft plastic surface of drypoint plates. Throw

away used rags and paint covered newspapers safely where there is no danger of their being ignited. Let the paint dry on the daubers until it has hardened, then cut off the dry paint and use the fabric remaining for another time.

For cleaning hands, wipe off paint with soft rags as thoroughly as possible then try Lava soap or any gritty mechanic's soap and water. There are several waterless hand cleaners available now at hardware and building supply stores that originally were manufactured for auto mechanics. They have a pleasant smell and claim to be good for the skin as well as efficient cleaners. Baby wipes work well also if a sink is not available, but they leave an oily residue.

Try Lestoil for cleaning plates or any paint spills that do not clean up with soap and water. Use minimal chemicals, even Lestoil, by wiping up messes first. Be sure to monitor the use of the Lestoil so that it is not abused. For no chemical problem, rub on cooking oil to remove the oil paint and then regular soap to emulsify the cooking oil.

If there is limited time to clean up, first have clients clean their hands. Oil paint takes a long time to dry, so you can clean the plates up later if necessary.

Extra plastic or paper bags and empty coffee cans are useful for storing or cleaning up.

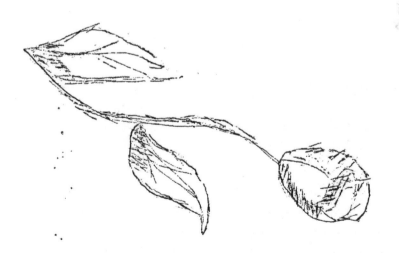

Figure 6.2 'Ready to Bloom' by MP, drypoint

Instructions for drypoint printing on Plexiglass®

Making plates

1. Assemble supplies: pieces of transparent Plexiglass®, pencils, scribers, tape, paper for drawing image to be transferred or for under plate.

2. Cut a piece of paper the size of the plate.

3. Draw an image or design as a guide. Remember that the print will be the mirror image or reverse of your drawing. Hold the drawing up to a mirror to see what it will look like once it is printed. Tape the drawing to the underside of the Plexiglass® so it is visible and can be used as a guide to incise the plastic.

OR

3. If a client wants to work directly on the plate without a preplanned image, place a clean piece of paper beneath the plate so the client will not be distracted by the table or the newspaper covering the table beneath it.

4. Place the plate flat in front of you on the table and steady it with your other hand while holding the scriber. Press the scriber and pull it along the surface of the plastic to scratch a line. Either trace your drawing or work freely directly on the surface of the Plexiglass®. Use short, controlled strokes to press into the plastic and scrap a line into the surface.

5. A burr will be created on one or both sides of the scribed line. The burr of plastic should be left there to hold paint and produce a soft characteristically velvety line. The angle you hold the scriber determines the burr. These burrs break down, so treat the work gently. Press firmly into the plastic, but you do not need to make a deep crevice, just enough to hold paint.

6. Try lines, dots, crosshatching (making lines go one way then at an angle to create shading), scratching back and forth. It is difficult to draw curved lines, but straight lines can be made by using a ruler. Be careful not to cut your other hand and

stay in control of your marks. Turn the plastic as you work and as you find which way it is easiest to incise lines.

7. Hold the plate up to the light or place it on a dark piece of paper to see the incised lines more clearly. If the lines are etched deeply enough, you will be able to feel them if you brush your finger gently across the surface. The lines you see should be the lines that will print once the plate has paint on it.

Setting up

Get everything ready to print before putting paint on the plate:

1. If using a press, arrange the blankets and paper to protect the press bed and blankets.

2. Ready paper to print on: cut paper, set up tub for soaking, towels or blotters to soak up excess water before printing. Position paper in a clean place nearby but away from the paint mess if possible.

3. Cover the work table first, then designate for each person an area to apply paint to the plate and a clean area to put the plate down.

4. Set up hand-cleaning area: paper towels or rags and soap or hand cleaner to clean hands after putting paint on the plate and before printing it.

Applying paint to the plate

1. Collect daubers, wiping pads, extra square wipe cloths, paint (and spoon or roller if hand printing).

2. Put on gloves if available.

3. Squeeze a small amount of paint (about ¼" to ½" from a tube) on the dauber. Gently but evenly rub the paint across the plate from top to bottom with the dauber. Turn the plate a quarter turn and repeat, turn and repeat, turn and repeat, so that you

have pushed the paint into the crevices in all four directions. You should be able to see the paint filling the cracks. There is no need to put paint on the areas that are not incised unless you want a soft trace of color left all over.

4. Look carefully to see if there is paint everywhere you have incised lines or images. Add more paint to the dauber if necessary.

Wiping the plate

Wiping the plate is critical.

1. Place a clean square of cloth over the wiping pad. Using the pad, smoothly and evenly wipe the excess paint off the surface of the plate. Press lightly at first. Initially the plate will be tacky, and the paint will come off on your rag.

2. Turn the plate to wipe evenly from all sides being careful not to take the paint out of the lines or crevices.

3. When the cloth covering the wiping pad gets full of paint, exchange it for a clean one. When most of the paint is off the surface, the wiping should be smooth and easy, like polishing. If you are using water-based paint, work as quickly as possible because the paint dries. The water-based paint will leave a thin film of paint even on the uncut surfaces, and it will print as a lighter tone of the incised lines. If you are using oil paint, you have plenty of time.

4. If you put the plate down onto a clean white piece of paper, you should be able to see where the paint is and where it needs to be wiped some more.

5. Carefully wipe the paint off the edges of the plate.

Printing on a press

1. Place the plate face up on a piece of cover paper on the press bed.

2. Clean hands.

3. Cover the plate with the paper you wish to print on.

4. Place a protective paper over the printing paper then arrange the press blankets on top of that.

5. Rotate the press wheel to direct the plate, paper and blankets under the roller and out the other side.

6. Before you remove your print, lift the blankets carefully and check to see if you have adequate pressure. You should be able to see the embossed imprint of your plate evenly all around when you look at the paper on top of the plate. If you are not sure you have enough pressure, carefully put your hand on your print, lift up the paper and peek at the image. If you need more pressure, let us hope that you have not moved the paper and can put it back down and through the press again with increased tension.

7. If the pressure was correct, you can lift off your print and with luck have a faithful reproduction of your image.

Note: This actual process of printing is often an opportunity for group cooperation and division of labor. If a client is uninterested, unwilling or unable to create a plate, he or she may be able to be the 'press operator,' maintaining the blankets, helping to keep clean paper on the press bed, cleaning the press and assisting others in setting up their plates to run through the press. My experience has been that most clients want to crank the press to run their own plates through. Some do not have the strength required, some are shy about it, but most get a great feeling of accomplishment and power running the press.

Pulling a print

1. The event of lifting off the paper to reveal a print is always a dramatic moment and sometimes a nerve-racking one. Frequently a print is not what the artist expects, sometimes it is much more wonderful, sometimes not, but almost always a surprise. Of course, the image is the reverse of the plate.

Knowing that intellectually and seeing the printed image is different.

2. Insist on no negative remarks and that everyone takes responsibility for his or her own remarks about another's artwork. This is an excellent time to do some processing and allow some positive affirming. It is also an excellent opportunity to discuss the difference between expectation and reality.

Changing a plate

1. At any time add more scratching, more lines, more detail to the plate. The opportunity to add to the artwork has great advantages for longer-term therapeutic settings.

2. If you want a solid dark area, try using sandpaper to rough up an area that will hold the paint. Sand or Carborundum grit can be added to acrylic polymer and painted onto the plate to create a gritty mid-tone area.

3. Removing an unwanted line is practically impossible. Try incorporating that line into additional design or ornamentation. If the line absolutely must go, try smoothing it to remove all the burrs and use a Q-tip to remove all paint from that line after paint is applied and wiped from the rest of the plate. Before printing, place a patch of clean paper over the line before placing the printing paper over the plate to print.

Problem solving

1. Usually the artist gets only one good print per application of paint, but if you can see paint in the crevices, try printing a 'ghost' print which is a second print from the same printing (it will be fainter, more ghostly).

2. If you had too much paint the first time, wipe it carefully and try printing again.

3. If the print is too faint, reapply paint and leave more paint in the crevices.

4. Change colors. If a completely different color is wanted, clean the plate first (see 'Clean up'). If the plate is not cleaned, the second color will mix with the first making a third mixed color.

5. Try to isolate different colors in different areas of the plate to have multiple colors.

6. Leave some paint on the areas of the plate that have no lines. Create tones or even images. This is a monoprint. See Figure 6.3, 'Healthy- Confused' a monoprint that uses smudges and extra paint to be very revealing.

Clean up

1. To clean a drypoint plate to change colors or to store it, pour a small amount of Lestoil onto the surface of the plate and gently rub it all over and especially into the crevices. Let it sit for a few minutes, then gently rub it with a soft cloth and rinse under warm water. The paint should come off easily; if not, repeat the process until the plate looks like it did before you put paint on it. Do not leave paint in the crevices if you want to print again. Collagraph plates should be wiped with a cloth or paper towel and allowed to dry.

2. Throw away wipers with paint, any used rags and newspaper in a covered fireproof container or in a bag that you will dispose of properly as soon as possible.

3. Collect wiping pads and store in plastic bag or coffee can. Collect daubers and store in a separate bag or coffee can where they can dry out before next use.

4. Place soft cloth between plates for storage or at least stack them carefully to avoid scratches.

5. Remove blankets from under press roller to dry.

6. Empty soaking tub, hang up towels or blotters to dry.

Storing

1. Dry plates with a soft cloth; if you have a lot of plates, a dish-drying rack works well for storage and drying. Never use paper or scratchy materials to clean or dry Plexiglass®.

2. Use a piece of tape to write the artist's name on the underside of the plate.

3. Plexiglass® is scratched very easily, so avoid carrying drypoint plates around or storing them unprotected. If you need to stack or transport drypoint plates, place soft tissues or cloth between them or wrap each carefully in paper.

4. If it is appropriate for a client to take home a drypoint plate or if the plates are to be displayed, a dark piece of paper cut to the same size and adhered to the back of the Plexiglass® enhances the incised image. An interesting variation is to cover the edges of the plate in black tape, make a hanger at one corner and hang the plate as a sun catcher. If a plate is not going to be reprinted, leave the paint in the crevices.

OR

4. Collagraph plates are often artworks in themselves. They can be mounted, framed or displayed as any other artwork.

5. After printing on heavy printmaking paper, allow intaglio prints to dry slowly between dry blotters or clean paper weighted down with books. Drying them flat under pressure will prevent the paper from buckling and rippling from the pressure of the press and embossing.

Instructions for monoprints

Monoprints are a combination of a drypoint and a monotype (see Chapter 7 for instructions for monotypes). It is called 'monoprint'

because even though you can repeat the same print (the drypoint part) the monotype part will be different each time (the monotype part).

1. Follow steps for 'Drypoint printing on Plexiglass®' about making a plate, applying paint and the first part of wiping it.

2. Try leaving some of the original paint on the smooth surfaces when doing the intaglio wiping to create shading or texture.

OR

2. Complete a regular intaglio wiping and when the plate is ready to print, use a brush or Q-tip to add details, shapes or textures to the plate with additional paint. Make an additive monotype (see Chapter 7) with the drypoint image (See Figure 6.3).

Variations: jigsaw or group plates

Make a group print by combining several separate drypoint plates together as one artwork on one piece of paper (Figure 6.3). The plates could be cut as a jigsaw puzzle, each piece worked on by a different person and then all pieces reassembled. If you do this be sure to put tape on the back of all the pieces before handing them out.

Instructions for intaglio Styrofoam tray printing

Hand printing is not sufficient to press the paper into the indented design to pull out the paint, so you must use a press. The foam is obviously compacted by the press, so only a few prints can be pulled before the pressing eliminates the difference in levels needed to produce a print. The disadvantage of fewer prints is to be weighed against the ease of creating them, however. Styrofoam plates can be printed either as a relief or as intaglio if you have a press, but only hand printed as a relief print.

Supplies: foam meat trays, pencils or ballpoint pens, scissors, water-based or oil paint, paper, paper for covering table, small pieces of cardboard for applying paint (with one straight edge), clean-up supplies

Figure 6.3 'Fantasy,' 'Healthy,' 'Evil,' and 'Confused' by WB, monoprints

Making plates

1. Clean trays in soapy water to remove food residue, especially oily areas. Clean antiseptically if they were used for meat to avoid possible contamination from bacteria.

2. Cut off raised edges and retain only flat sections.

3. Draw into the Styrofoam with pencil or ballpoint pen. Lines must be deep and wide enough to create a depression that will hold the paint. The lines should be visible, but be careful not to push so hard that you poke holes through the Styrofoam.

Applying paint

1. Collect pieces of cardboard for spreading paint, wipe cloths, paint.

2. Put on gloves if available.

3. Squeeze a small amount of paint (about ¼" to ½" from a tube) on the plate. Gently but evenly spread the paint across the plate from top to bottom with the piece of cardboard. Turn the plate a quarter-turn and repeat, turn and repeat, turn and repeat, so that you have pushed the paint into the indented image in all four directions. You should be able to see the paint filling the cracks. There is no need to put paint on the areas that are not incised unless you want a soft trace of color left all over.

4. Look carefully to see if there is paint everywhere you have incised lines or images. Add more paint if necessary.

Wiping the plate

Wiping the plate is easy.

1. Using a rag or paper towel, smoothly and evenly wipe the excess paint off the surface of the plate. Press lightly at first. The plate will be tacky at first, and the paint will come off on your rag.

2. Turn the plate to wipe evenly from all sides being careful not to take the paint out of the lines or crevices.

3. If you are using water-based paint, work as quickly as possible because the paint dries. The water-based paint will leave a thin film of paint even on the shiny surfaces, and it will print as a lighter tone of the incised lines. If you are using oil paint, you have plenty of time.

4. Carefully wipe the paint off the edges of the plate.

Printing on a press

1. Place the plate face up on a piece of cover paper on the press bed.

2. Clean hands.

3. Cover the plate with the paper you wish to print on.

4. Place a protective paper over the printing paper then arrange the press blankets on top of that.

5. Rotate the press wheel to direct the plate, paper and blankets under the roller and out the other side.

6. Before you remove your print, lift the blankets carefully and check to see if you have adequate pressure. If you are not sure you have enough pressure, carefully put your hand on your print, lift up the paper and peek at the image. If you need more pressure, let's hope that you have not moved the paper and can put it back down and through the press again with increased tension.

7. If the pressure was correct, you can lift off your print and with luck have a faithful reproduction of your image. See 'Hand printing' below.

Instructions for simple one-session collagraph intaglio plates

1. Use cardboard, mat board, Masonite, any flat surface for a plate.

2. Cut or rip contact paper, any self-adhesive papers, tapes (masking, scotch, decorative, not electrical), self-sticking stars or stickers and stick onto plate to form design. Use a mat knife or utility knife to 'draw' making incised lines into the plate. Try pressing very hard with a ballpoint pen especially if your plate is cardboard.

3. Apply paint as a drypoint, using a dauber, making sure to push the paint into all crevices and shapes. (see 'Applying paint' and 'Wiping the plate')

4. Wiping is important: use soft (cloth) wipes alternating with folded newspaper (hard) wipes. The porous and recessed

surfaces retain the paint, and the shiny or raised surfaces release the paint in the wiping process.

5. If you can afford good paper that can be soaked to remove sizing and use a press to print, the paper will emboss (i.e. take on the shape of the objects on the plate) as well as transfer the colors of the paint. Blot the excess water from the paper.

If you do not have printing paper, try Japanese rice paper, construction paper or the strongest paper you can afford. Spray the paper on both sides and blot. Proceed to print on press (see drypoint instructions) or hand print.

1. Place the plate face up on the clean side of the pad of newspaper.

2. Clean your hands.

3. Place a good piece of paper on top of the plate.

4. Use a clean roller to press smoothly and with as much weight as possible on the blanket. Start in the middle of the plate and press out to the edge. Hold your hand on the top to avoid repositioning the paper; return to the middle and press outward in another direction.

OR

4. Use your fingers or the back of a spoon to press directly on the back of the printing paper to press it into the incised areas. This method works best if you use oil based paints and wet the paper.

Note: the instructions for making a collagraph plate for relief printing are the same as for intaglio printing. Only the way the paint is applied to the plate is different. For rich, complex, multicolored collagraph prints, first apply paint as for intaglio printing and wipe carefully. Before printing, roll another color over the plate as in relief printing then run through the press or hand print.

Instructions for two-session collagraph intaglio plates

1. Cut plates from any flat surface that glue will adhere to.

2. Use anything as thick as a coin or thinner that you can glue onto the plate: cut or torn shapes from paper, cardboard, textured wallpaper (see Figure 6.4), coins, contact paper, fabrics, doilies, laces, rickrack, trims, etc. Everything must be glued down carefully so that it will not lift off when intaglio printed. If you have used cardboard or any plate that can be incised, you can cut into the plate and the lines will take the paint just like lines on a Plexiglass® plate. To make it easier to wipe paint off for an intaglio print, coat the entire plate with latex or acrylic paint, polymer or gesso. Let dry overnight or several hours.

3. If you are coating the whole plate with latex, do any cutting in after the coating has dried.

4. When the plate has dried, check for loose edges and hidden pockets of wet glue before printing.

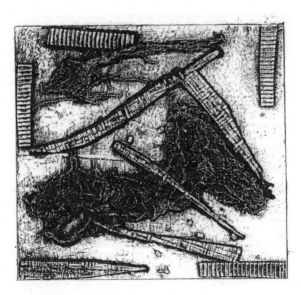

Figure 6.4 'Chaos 2000' collagraph intaglio by MM

5. Apply paint the same way as for 'Simple one-session collagraph intaglio plates' and proceed as above. Wiping will be more difficult because of the many surfaces; be sure to turn the plate around as you wipe and get off all excess paint.

Instructions for glue prints

An easy alternative plate can be constructed by drawing a design with a glue bottle using the glue line as it emerges from the bottle. Let dry thoroughly. Before printing, check to make sure there is no wet glue that would ruin the print. Print as an intaglio or relief or combine both ways to apply paint beginning with intaglio then relief rolling.

Artistic and clinical considerations

Many of the disadvantages of traditional intaglio printing can be modified by creating drypoint prints on Plexiglass®, making it a process suitable for some clients. It is included here because the process can be very compelling and satisfying just as a process, and the artistic products can be helpful, expressive and stunningly beautiful. Instructions for Styrofoam tray intaglio printing are included because they require less equipment and fewer sharps but need a press to print. Collagraph intaglio is the most suitable technique for clinical use because plates can be printed without a press and even without sharps.

Fascination with drawing

One advantage of this process is the fact that it is basically a linear method. In drypoint printing, lines create the best designs. It is very difficult to create solid shapes; the design relies on lines incised into the plate. Most clients have had experience drawing from an early age. Artistic development begins with scribbled lines, filling in develops secondarily. Children love to draw and developmentally go through stages that involve experimentation and control of their line making to create shapes. Older children usually go through the schematic stages with little self-criticism of their own line and shape making.

As a child approaches adolescence, he or she begins to be self-critical and reject their drawing if it is not equal to replicating reality as he or she sees it. Nevertheless, many adolescents spend a lot of time drawing even if it is superheroes, cars, stylized figures or faces. Adolescent preoccupation with body image and general fascination with faces makes Plexiglass® drypoint an excellent media for exploration. Very few adults draw comfortably, but this process would be very effective for clients who like to draw (see Figure 6.5).

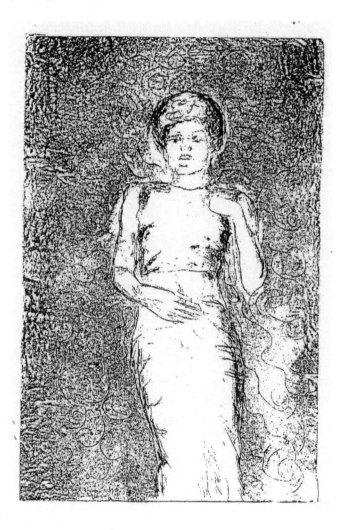

Figure 6.5 'Untitled' by SM, drypoint

Many clients are self-conscious about their drawing ability or have had negative experiences with their creative process. Being able to tape a drawing under a Plexiglass® plate and then trying to trace the drawing may give some clients confidence if they can find a drawing that they wish to copy. Is this artmaking? You must judge the value of this activity for your client. In groups where there is a great deal of peer pressure, perhaps allowing a client to start from classic drawing or a magazine would have its benefits. Of course the resulting print will have variations and marks of the artist and is unlikely to be just like the underlying drawing, but it is still not the same as creating from an original drawing or working freely directly on the plate. Each art therapist must consider whether the product or the process is more important.

Desperate Printmakers: an after school art club

An exemplary after school program was started by art teacher Harrison Miller at the Morton McMichael Elementary School in Mantua, West Philadelphia, an inner city, poverty level community (Raunft 1981, pp.18–22). Miller shared his printmaking skills and his etching press with third and fourth graders and created a program worthy of discussion in this intaglio chapter.

Although not an art therapist, Miller was well aware of the power of art to focus and direct the energies of children with little to do after school and few successes in their lives. He knew he would have to provide a challenge but one that could be met by these young students. In spite of Lowenfeld's warning on etching, 'needless to say, a procedure such as this would be too complex for children' (Lowenfeld 1970, p.83), Miller trusted his knowledge and the energy and perseverance of his students and proceeded. He taught traditional etching, using acids, stop outs and all the other necessary equipment required for this demanding, complex process.

Because Miller used toxic materials and because he was a good teacher and recognized the value of providing a safe and organized space for the children, his space was clearly laid out for maximum order, safety and success for printmaking. Desks were set together for working. The etching press, inking table and storage for paints, roller and wiping supplies were put together. There was a place to store works in progress, a

place for aprons or old shirts to protect clothing. Clean paper and a soaking tray were on the same table. There was a place for everything, and everyone knew where things were stored, and they were expected to return items to their places.

Even though etching seemed to be too complex for this age group, Miller broke down the process into manageable steps. Occupational therapists know the value of 'tasking' or breaking down the steps of any task into small, manageable steps, and tasking is appropriate for art therapists as well. Miller knew he had to teach a complex process to young children in simple steps. Many art therapy clients have trouble functioning due to developmental delays, medication or mental illness, so it is very appropriate to present artmaking in small steps especially for clients with special needs. Miller used only one process and repeated it so the children learned and grew with the process.

The Morton McMichael Elementary School Art Club made a difference in the lives of many children. As the children developed in their skills, each was able to develop his own complex personal imagery. Miller claims that the printmaking process slows the children down and gives them more time to think and explore their ideas. They use popular images from their culture and other graphic media and integrate them into personal interpretations.

The title of Raunft's article, 'The desperate printmakers,' comes from an incident that occurred with Miller and one of his students. Often Miller had to help with the reverse writing required by printmaking, writing out letters reverse and in reverse order. He also helped with spelling. One day, a little girl, one of his printmakers, asked Miller how to spell 'desperate.' It turns out that she was just trying to think of a title for her artwork and was desperate, but the adjective was incorporated as the title of the article.

Miller was able to focus the considerable energy of his young artists. When you have tried drypoint printing you will understand how difficult it is to wipe the plate enough but not too much. Once Miller and his student Theresa pulled a print that was only barely visible. The little girl had worked so hard wiping the plate that she had assiduously wiped the paint even out of the cracks. She was a desperate printmaker; the art club supplied a need, a desperate need, in the lives of these inner city children.

These children did much more than anyone ever expected they could. The children developed confidence and learned discipline. Miller was able to sell some of his students' artwork, which was a great incentive and tenable reward for their efforts and talents. Their printmaking activities at the art club ultimately influenced the lives of their families and community.

The culmination of each year's art club was an art exhibit open to the community and attended by officials of the regional school board. It is important to make a connection with the community for several reasons, not the least of which is a thank you if you have asked for donations of supplies as Miller had. Manufacturers and stores are willing to make donations and investments in their communities, and they deserve to be acknowledged.

Miller's art club could be a model for after school programs or an open studio. Unlike other programs, the center of this program is a press. I would substitute other non-toxic processes but would still focus on processes that benefit directly from the pressure of the press, especially intaglio, monotype, collagraph processes.

Graphic sophistication

A comment often heard at the beginning of an art therapy session from uncomfortable or resistant clients is 'This is kid's stuff!' or 'That is babyish!' Indeed, crayons, markers and even watercolor paint boxes may remind adults of childhood art classes where they might have had unpleasant experiences. Young adolescents are particularly sensitive to childlike materials that suggest regression when they are struggling towards adult-like behaviors.

Printmaking usually involves new materials and experiences that can spark interest in reluctant clients. The use of the press is exciting, and the resulting prints from even a very simple few lines on a drypoint plate are very sophisticated.

Printmaking and particularly drypoint printing is a sophisticated process that provides a framework for creative self-expression (Roberts 1989, p.20). The containment of the small plastic plate is reassuring. The size is non-threatening. Even a few lines, a sample plate, become transformed when paint is applied and wiped and run through the press. For

one thing everything is reversed and looks different just because of that. The plate edge clearly defines the print and gives it a graphic quality that is rarely achieved in simple drawing. There will probably be a wide range of talent in every group. Drypoint printing will stimulate those who love to draw or have special talent, but it should be rewarding for others also (see Figure 6.5).

Drypoint is particularly suited for long-term clients. They can learn the process on a small, simple plate and add onto that plate with subsequent sessions. Their confidence will build with their mastery of the process. Many sessions can be devoted to reworking and then proofing one plate; the prints can be hand colored, reworked, used for bookmaking, or written upon.

Some clients can benefit from drypoint printmaking because it focuses attention, requires following multiple directional steps and contributes to a sense of well-being and accomplishment when the product is completed. The plate can be augmented, and many artists spend a lot of time completely engaged in incising the plate. Many people get compulsive about scratching the plate; some artists get blisters from hours of work scratching on a drypoint plate. The potentially compulsive nature of this plate making must be considered.

Drawing and addressing violent imagery

In his article 'The art of emotionally disturbed adolescents: designing a drawing program to address violent imagery,' Graham (1994) describes his art program and draws a few conclusions that may transfer to the printmaking process. Graham is an art teacher, not an art therapist, and he carefully refers all therapeutic processing to his students' therapists. He works with students who are emotionally disturbed and use violent imagery in their artmaking. Almost every teacher working today has to face psychopathology in the classroom. Certainly those working with any special needs, emotionally disturbed or learning disabled students will have noticed an increase of violent images.

Graham knows that his students deal with their past and try to integrate past violence in their lives through their artmaking. The sublimation of trauma is discussed further by Stronach-Buschel (1990), and Graham cites their work for his understanding of what goes on in his

classroom. He sees that the management of drawing, slowly making thumbnail sketches then developing imagery in an artistic way helps his students to manage their imagery. The objectivity of setting the image into a scene, using perspective, adding details, using other students as models, essentially the many techniques of teaching drawing, composition and development of an artwork slow down the violence and help his students defuse their aggression and create powerful imagery. An additional benefit is that his students learn to appreciate not only art but others who are also struggling (Graham 1994, p.117).

In Graham's article he remains a teacher. In searching journals for mention of art therapy and printmaking and finding so little I have looked beyond and have had to expand my definitions and look at larger concepts. Much of art therapy is teaching; we need to teach artmaking skills to give our clients tools to express themselves. The printmaking process slows down the expressive process and can give clients a way to integrate imagery, violent or non-violent. Since drypoint printing on Plexiglass® is such a linear process and one that adolescents would be attracted to, I have included mention of this article. I hope that teachers and art studio directors will be looking at this book for guidance.

CHAPTER 7

Planographic Process
The Magic of Monotypes

Planographic process

The third basic process of printmaking is called planographic because all the paint is on one flat plane unlike relief printing where the paint goes on the raised surfaces or intaglio where the paint goes into the recessed areas (see Figure 3.3). The best known planographic process, lithography, was invented in 1798 and sparked a great change in the way information became more available and artistic expression loosened up.

The original lithographic process requires a heavy, three inch thick limestone plate that has a smooth, flat surface on which the artist can draw with a greasy crayon. The Greek word *litto* means stone writing. There is no carving, cutting or building up on the surface, consequently the artist can be fluid and work spontaneously. The concept that oil and water do not mix, a chemical reaction, makes the print possible because the greasy crayon drawing is flooded with chemically treated water then oily paint rolled over the whole stone. The water resists the paint on the roller, but the paint is attracted only to the greasy marks. The water dries, but the oily paint stays wet long enough to transfer to a paper placed on top of it. It sounds messy, and it is. Nevertheless, in the nineteenth century, lithography was very innovative and much quicker than traditional relief and intaglio processes. Because of its speed, lithography achieved enormous commercial success.

Lithography was used for playbills, advertising and posters initially but became a popular fine art medium in its own right. Each of the primary colors is printed with a separate plate, one color on top of the other, so that every possible color is produced. The system was quickly mechanized and became the basis of commercial printing as it is still done today. Today the stones have been replaced with flexible metal plates on which the image is imprinted from a computer scan. The colors are separated by computer, and the plates are wrapped on large cylinders and run through the presses, each color at rapid speed.

Lithograph on heavy limestones or commercial presses is still taught at many art schools. Fine artists use stones or zinc plates with lithographic or etching presses. Most importantly for art therapists, lithography encourages fluid individual, artistic expression.

Litho Sketch®: the legacy of lithography

Traditional and commercial lithography are obviously inappropriate for use in art therapy because of the equipment, but there is a product available through school supply catalogs called Litho Sketch® that could be used with high-functioning clients. (See Appendix for lists of suppliers.)

Litho Sketch® is a clay-treated paper that acts like a limestone. Regular crayons or a product called tusche can be used to draw on the paper plate. A non-toxic water solution is spread on the plate, and a special oil-based paint is rolled over to produce prints. Litho Sketch® requires several steps to complete including a slow build up of paint before a strong print is produced. Clean up can be done with Lestoil© or any other grease-dissolving household cleaner.

Clear directions for Litho Sketch® are included with the supplies, so they are not repeated here. It is a tricky process, however, and can be frustrating. This particular process could be extremely satisfying or intolerably frustrating depending on your client and your problem-solving skills to teach the process successfully. As with any new technique, if you are going to use it with clients, practice first until you are comfortable with the process.

Monotypes: the painterly print

Fortunately, there is a planographic process that embraces the fluidity available with lithographs without the expensive, specialized equipment. Monotypes evolved in Europe during the seventeenth century. Two centuries later, Degas found full expression with the same simple monotype processes; he created over 300 monotypes (Saff and Sacilotto 1978, p.348). I saw an exhibit of Degas's prints at the Museum of Modern Art in Boston and was fascinated with subtle variations of his monotypes. The prints I remember clearly were all of the same scene, a woman stepping out of a bathtub.

Monotypes have been very popular in the United States since the printmaking revival peaked in the 1970s. Artists combined techniques and experimented with a break from the tradition of printmaking that focused on accuracy of technique and careful editioning of prints. Monotypes fit perfectly with the wave of enthusiasm for creating non-traditional artworks, and many artists combined techniques to create large, enthusiastic prints (Preble and Preble 1994, p.169).

Monotypes are prints because there is a plate involved. A monotype is a graphic expression that sometimes looks like a painting yet has a plate mark and the smooth finish of a print. As the name implies, a monotype produces only one print at a time. It is almost impossible to make an exact duplicate. It is possible to continue printing after pulling one print and to add to the plate to create even more interesting prints as you continue to work.

Preble and Preble (1994) call monotype 'a non-traditional, process-oriented practice' (p.169), a description that should catch the attention of art therapists. Clinically, I have found monotypes to be useful in many situations because the process captures the imagination of the artist and allows a freedom of expression that is often elusive with other printmaking processes. Clients are fascinated with the process and give up some of their fears as they participate in the process of artmaking.

There are many different ways to create monotypes. Water-based or oil paints can be used with specific modifications. The following instructions are presented in order of difficulty beginning with a very easy technique. Success for a client does require a certain amount of technical competence, however; so it is important that you understand the process

and variations to be able to guide with confidence. If you understand each of the ways to create a monotype, you will have choices to present to a client if he or she is having trouble with the process or needs containment or expansion.

Monotypes are nearest to painting of all printmaking processes and provide the most flexibility for clinical use. There is a plate which can provide the structure and containment often needed by clients, but the image can be created with great flexibility and freedom, as freely as any painting. The artist can use multiple colors, create with lines or shapes, add and remove paint and change the image easily.

The mechanics of printing often change the created image (as well as print it in reverse) which can be frustrating or liberating as all printmaking can be. No two prints are exactly alike. Creating a second image after the first is quick, more complex and usually more rewarding. It is an intensely free process that still affords containment and structure.

From a practical point of view, the supplies needed are the most minimal of any of the suggested processes, especially in the simplest techniques. The range for creative expression is limitless. The skill needed is minimal, but the process engages the most sophisticated and accomplished artists.

I have artistically been captivated by monotypes since the 1980s. Monotypes are the most rewarding way for me as an artist to sustain a vision by working sequentially with a monotype and the ghosts that follow. This chapter may prove to be most valuable for you as an artist and an art therapist. The process is easy and the different techniques are suitable for realistic or abstract images and linear or shaped expression.

Eliciting images: structure for intense affect and content

The process of printing often provides the structure and the main focus of an art therapy session and requires much of the time. It is your choice how you incorporate content into the session. Many art therapists work in settings where they are providing cognitive therapy or directed sessions. In such a setting, the topic of discussion can be discussed first then moved into the artmaking. I have always found that if I begin with the artmaking, the work of the session happens in the process or in conversation as clients work. Certainly processing after the prints are created is a

good time for the verbal therapy part, but printing provides the therapist with time to observe and guide just as any other artmaking does.

Printmaking is indirect compared to drawing or painting directly, but the task and distance from the image reveals a great deal of information for the client and the therapist. The distance also give the client often needed separation as well as an artwork for projection. The image created is in reverse and often the paint moves and smudges. The print does not look like what the artist anticipates. This can be frustrating or illuminating and adds to the therapeutic opportunity.

The monotype process supplies structure but a very wide range of expressive possibilities that can be focused on issues and content. It reduces resistance but sublimates intense feelings so that clients can focus on their presenting problems (see Figure 7.1).

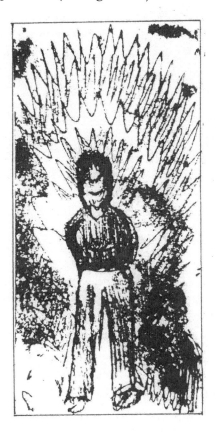

Figure 7.1 'Untitled' by BS, mystery monotype

Competency and mastery of feelings through artistic expression

In his chapter 'The struggle towards an identity as art therapist' Robbins (1994) discusses his personal artistic and theoretical conflicts as he developed as a therapist. He explored many art media and investigated theorists, particularly Margaret Naumburg and Edith Kramer. It was Kramer's *Childhood and Art Therapy: Notes on Theory and Application* (1979) that initially resonated strongly with Robbins and with me especially as I look at using monotypes for expression. As artists we get wonderful feelings of mastery and 'an exquisite sense of wholeness' (Robbins 1994, p.70) when creating art. I see Kramer's ideas of sublimation of intense feelings through art enacted when clients are pulling monotypes, and I am amazed at the expressiveness of the process. So many emotions are contained on one small Plexiglass® plate.

Robbins continued his theoretical exploration after finding Kramer's theories not enough because he experienced so many clients who were not able to sublimate their emotions through artwork. His own theories evolved after much searching and thinking. He emphasized having a variety of modalities to choose from and a flexible theoretical framework for therapy. I have rarely had trouble engaging a client in artmaking perhaps because I do have so many modalities to offer. I feel, however, that making the creation of art central to art therapy and using the power of the process to sublimate powerful and unacceptable feelings is justification enough for suggesting monotype printing.

Reflecting group process

Yalom's classic book *The Theory and Practice of Group Psychotherapy* (1985) provided therapists with a basic understanding of the group process. All the stages of group therapy get played out in a session, often several stages are happening at once with different participants. This is especially true in brief treatment. Printmaking requires a firm, organized structure to be successful; group therapy requires the same: firm boundaries, regular meeting time, confidentiality, predictable agenda, a group task. In brief therapy all of that has to happen in one session.

In her article 'Brief inpatient groups: a conceptual design for art therapists,' Sprayregen (1989) proposed that brief therapy has to be problem

based and that the group provides much of the help in recognizing problem behaviors. When the whole group is doing something like a monotype that no one has done before, each person's problem-solving skills and presenting problem will be manifested. Printing is like any other artmaking in this aspect. Because printmaking is usually a new experience, behaviors tend to be less guarded and more problem-solving skills, or lack of problem-solving skills, emerge.

The simple structure required to create monotypes creates an ideal structure for brief therapy. The process is almost as easy and quick as stamp printing, but it does not allow repetition. Monotypes allow a wider range of artistic expression than relief printing because the artist works quickly with either lines or shapes.

Monotypes can be reworked before printing. Starting over is usually just a matter of rolling over an image, rinsing or wiping off the plate and starting again. Because monotypes can be produced so quickly, the process allows for changing images. This flexibility can be a useful thera-peutic advantage particularly in brief treatment therapy when a client must focus on his or her presenting problem and what can and can not be changed. A ghost print changes some parts but retains some of the original image depending upon the amount of paint that remains on the plate.

In clinical reality, often skills, abilities and willingness to participate vary greatly in a given group. If you divide some of the printmaking steps, give each person a job to do, you can engage clients who are not willing to 'do art.' Keep in mind that the two- or three-part process of monotype making or any other printmaking requires cognitive ability to understand but not to do it. It is an intriguing process which may seem magical to some and not understandable to others. Be sensitive to cognitive under-standing of your clients, assessing their cognitive skills fairly.

Basic monotype supplies

1. A plate: a piece of Plexiglass®, plastic tray, table top, cookie sheet, any non-absorbent, flat, hard surface

2. Paint: best is block print paint in water or oil base, oil paint, tempera, finger paint

3. Rollers, brayers or brushes to apply the paint

4. Pencils, sticks, Q-tips, rags to remove paint

5. Paper to print on

6. Paper to protect table

7. Rollers, a press, spoons or finger to press the paper to print

8. Clean-up supplies: for water-based paints use sponges in plastic bags, for oil-based paints use Lestoil© or another grease-dissolving water-based cleaner, plenty of paper towels or rags.

My printing bag holds two 4" x 6" Plexiglass® plates, a tube of block printing paint (usually just one color at a time), computer paper, a plastic bag with damp sponges, pencils, paper towels and newspaper.

Water or oil paint?

Water-based paints, obviously, clean up with water or damped sponges stored in a plastic bag. Acrylic paints have plastic polymers in them and dry very rapidly into an insolvable film that will not print once it is dry. Dry acrylic paint is difficult to remove from a plate but can be peeled off. It dries on fabric and is permanent. If you use acrylic paint, work quickly and print while the paint is wet. I avoid using acrylic paint clinically if possible.

Water-based block printing paint also dries quickly but it can be transferred if your paper is damp even if the paint has dried. It goes on smoothly with a roller or brushes. Finger paints and tempera paint transfer well but tend to bubble, and it is harder to get a smooth plane of paint. To correct this problem consider using Formula for Base in the section 'Instructions for watercolor monotypes.' Using damp paper transfers water-based paint that is dry, but most successful transfers are with wet water-based paint.

Creatix™ makes a product specifically manufactured for monotypes (see Appendix for suppliers). It is a water-based paint. It is expensive and comes with a separate monotype base that is applied to the plate first then dried before the paint is applied. The base allows for an excellent transfer

of paint when used to print on damp paper. Although the directions specify damp paper and dry paint, Creatix™ works with dry paper and wet paint and all possible combinations. It transfers by hand printing and with a press. The base also works well with tempera paints because it allows the paint to spread smoothly without beading up on the plastic plate. It is a wonderful product specialized to make monotype printing successful with water-based paints.

There is a formula for making a watercolor monotype base similar to Creatix™ Monotype Base that you can make at home if you want to get the very best results making water-based monotypes. See 'Instructions for watercolor monotypes' for the formula.

Max© is one of several oil-based paints that can be dissolved in water. It is chemically between water- and oil-based paint. If you use Max© paints use dry paper or slightly damp paper.

Oil paints dry very slowly and can be manipulated more. They transfer with dry or damp paper and are less frustrating because of the extended drying time. They can be cleaned by wiping with rags then any residue dissolved with Lestoil or Murphy's Oil Soap© and damp sponges. Prices for oil paints vary with the brand name, the amount of pigment versus oil in the formula and according to color.

I much prefer working with oil paints if possible, but more frequently choose water-based block printing paint for clinical use. Tempera is the cheapest and most readily available paint but does not work anywhere near as well as block printing paint. Most paints have some odor and many are toxic if ingested. Read labels and experiment before you use with clients.

The instructions that follow for different monotype techniques work well enough with block printing paint or oil paints.

Damp or dry paper?

The object of monotype printing is to transfer the image in paint onto paper. The questions of whether to dampen the paper or not depends upon the paint and the paper. Wet paint transfers best, absorbent paper absorbs best, dampness makes paper more absorbent because it loosens the sizing that holds paper together (and weakens it). Dry paint transfers only to dampened paper (unless it is acrylic which will not transfer when

dry). Pay attention to your client's artwork; if it is dry offer dampened paper.

Dampening regular paper is as simple as running it quickly under a faucet or spraying with a spray bottle of water. Blot the paper with a towel if it is drippy. If damp paper is too much to deal with, do the best you can with dry paper and encourage clients to work quickly with water-based paints or use oil paint.

Instructions for simple foldover (inkblot) monotypes

Supplies: poster paint or any paint, paper to print on and paper to protect table, spoons, brushes or some way to get paint out of container onto paper (squeeze bottles for paint can be great or become dangerous and messy), clean-up supplies.

Optional: string

1. Fold paper in half then open up.

2. On one side place dots or images of paint.

3. Fold clean side onto wet paint and rub gently.

4. Open paper to reveal print.

Variations

Put string(s) down with the paint, fold over the paper, pull the string(s) as you put pressure on the paper to blend the colors. Open up the print.

Problem solving

1. It will be a mess if you use too much paint.

2. The paper will stick together if you let the paint dry before pressing.

3. If you use two analogous colors, a third clear color will result; if you use two complementary colors you will get brown or gray where they mix. See Quiller's *Color Choices: Making Color*

Sense out of Color Theory (1989) for an excellent understanding and examples of how to mix colors including common names for manufactured colors.

Instructions for mystery monotypes

Supplies: block print paint or oil paint, plate, paper, pencils, paper to protect table, clean-up supplies

1. Put a small amount of paint on a plate and roll it out to a thin coating all over the plate evenly distributed. It should look like a piece of silk.

2. Move the plate to a clean surface (wet side up) and place a piece of paper directly on top of the plate.

3. Use a pencil to draw on top of the paper. Do not lean heavily on the paper but keep it from shifting.

4. Lift up the paper. The pressure of the pencil will have picked up the paint from the plate. There will be an overall lighter pattern of paint where you did not draw with the pencil. See Figures 7.1 and 7.2.

Problem solving and expansion ideas

1. If it is just one dark solid transfer, you used too much paint.

2. If nothing transfers, the paint dried before you began.

3. If the paper sticks to the plate, the paint dried as you were working; you must work more quickly.

4. Roll more than one color on the plate in rainbow fashion to create an interesting effect.

5. If you are just about ready to pull another type of monotype print, peek at the print before lifting off the paper. If there is a light area that you think would benefit from some line work, put the paper back over the plate and draw on the back to create lines in this mystery monotype fashion.

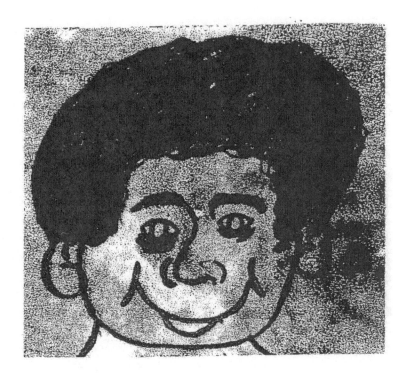

Figure 7.2 Self-portrait by JT, mystery monotype

Instructions for simple reductive monotypes

Supplies: block print paint or oil paint (one dark color), plate, roller, paper, sticks, paintbrushes or Q-tips to remove paint from plate, paper to protect table, clean-up supplies

1. Roll a thin, even coat of paint onto the plate.

2. Use brush, stick, Q-tip to remove paint from plate to create an image. Make lines, shapes, textures. If using water-based paint, work quickly so that the paint does not dry.

3. Remove finished image on plate to a clean area, place a piece of paper on top and smooth lightly with hand to let the paint hold onto the paper.

4. Print the image by using a press (see Chapter 6) or hand print by pressing firmly with fingers or a roller from the center outward.

5. Lift off a corner to see if the image is transferred; if the print is coming out nicely remove the paper. If the image is too faint, apply more pressure.

Instructions for additive monotypes: the painterly print

Supplies: block print paint or oil paint (several colors), plate, roller, paper, sticks, paintbrushes, Q-tips to add paint to plate, paper to protect table, clean-up supplies

1. Use brush, stick, Q-tip to add paint to the plate to create an image. You can make lines, shapes, textures. Paint as you would a painting but try to keep paint smooth. Globs of paint will smudge and run (which is not a bad thing but unpredictable). If using water-based paint, work quickly so that the paint does not dry.

2. Remove finished image and plate to a clean area, place a piece of paper on top and smooth lightly.

3. Print the image by using a press (see Chapter 6) or hand print.

4. Lift off a corner to see if the image is transferred; if the print clearly transferred remove the paper. If the image is too faint, apply more pressure.

Variations

You can start with a thin layer of paint on the plate and just add other color and images to the plate mixing colors as you go. If you do not want the base color to mix in, use a rag to remove paint from an area and add color directly onto the plate. Combine with drawing in some lines as in simple reductive monotypes.

Instructions for monomask monotypes

These monotypes are characterized by strong negative and positive shapes. They are easy and effective in one color but several colors can be used. Begin simply with one, dark color.

Supplies: block print paint or oil paint (dark colors), plate or smooth surface, roller, paper, paper to protect table, clean-up supplies

Optional: scissors, sticks, paintbrushes, Q-tips, textured paper, strings, doilies, anything flat and thin (that is expendable or washable)

1. Tear or cut out shapes or images from the paper or select flat objects to mask out.

2. Roll paint onto plate or flat surface. Place cut-outs or other objects flat on the plate on top of the paint.

3. Remove finished image and plate to a clean area, place a piece of paper on top and smooth lightly with hand to let the paint hold onto the paper. It may be lumpy but try to keep the paper from moving.

4. Print the image in a press or by hand. If hand printing, keep one hand on the paper at all times to prevent the image from double printing.

Variations

1. After the first printing, carefully remove the pieces. Color remains beneath the pieces that were directly on the plate. Flip them over and rearrange and try a ghost print.

2. Try putting paint on the shapes before putting them on the plate and printing.

3. The initial print can be printed on a piece of newspaper, sheet music, magazine page, wallpaper, wrapping paper. The masked-out areas will reveal the paper underneath, and the paint will cover the rest.

Ghost prints: reprinting

Often enough paint remains on the plate to be able to produce a second, or ghost, print. Use a second piece of paper and perhaps a little more pressure and repeat the printing process.

It is also interesting to use what is left and create another print by adding to the ghost of the first print using the technique called additive monotypes. This process can be repeated many times.

After the first monomask monotype, lift off the cut-out shapes, turn over the shapes and position them elsewhere on the plate. A shadow of paint will remain under the original placement and the cut-outs will release more paint if they are printed upside down.

Instructions for multiprint monotypes

You can make a print applying separate colors in stages, printing repeatedly one time after another. The paper must be registered or placed in the same place each time.

Supplies: paint, plate (transparent), brushes or rollers, paper, tape, paper to protect table, clean-up supplies

1. Use a transparent plate. Put a sketch underneath for a guide (if you want to work from a sketch). Make pencil marks to show the position of the plate on the sketch so you can replace if it moves.

2. Position paper to be printed over the plate. Tape it from the top to the table or sketch below to make a hinge. Lift paper up before applying the first color to the plate.

OR

2. Place the upper right-hand corner of the paper on the upper right-hand corner of the plate each time you print to register.

3. Apply one color with brush or roller in any technique using the sketch below the plate if desired.

4. Lower paper and press to transfer the image. Lift paper up carefully and fold back on the hinge if used.

5. Wipe the plate clean, add another color, put the paper down and press again.

6. Repeat for as many colors as you wish. The colors will blend and offset, but the results may be very interesting.

Instructions for watercolor monotypes

Supplies: Watercolor Formula for Base, plate, brushes, watercolors, water-based block printing paint or tempera, Formula 409 or other all-purpose cleaner, tissue, paper, paper to protect table

Optional: hair dryer, craft squirt bottle, watercolor crayons

Formula for Base

3 tablespoons cornstarch

1 cup water

⅓ cup glycerine

⅓ cup honey

(Glycerine is inexpensive and available in most drug stores)

1. Measure out the glycerine and honey and set aside.

2. Place cornstarch in saucepan and blend slowly with the cup of water stirring all the time.

3. Place on stove at medium heat. Keep stirring until it bubbles and thickens.

4. Remove from the heat.

5. Immediately add the glycerine and honey; stir thoroughly.

6. Pour into a container with a cover and store in refrigerator.

This will keep for months, and you can take a little out at a time as you need it.

Preparing the Plexiglass® printing plate

1. Wash plate with soap and water. Dry.

2. Spray the printing surface with Formula 409. Wipe off gently with face tissue leaving a very fine film, and let dry (or use hair dryer to dry).

3. Spread a thin coat of the above Watercolor Base Formula on the printing surface with soft watercolor brush. Let dry or dry with hair dryer. It will be sticky from the honey but the drying removes the moisture.

Painting a watercolor monotype

1. Paint directly on the plate with watercolor or dip a brush in the Base Formula and add watercolor.

2. Draw into the watercolor with a stick or watercolor crayons. Use tempera or other water-based paint.

3. Try squirting watercolor and water from a small craft bottle. Use hair dryer to mix and dry.

Printing

1. Place plate on clean sheet of scrap paper image side up.

2. Place dampened paper on top of image; cover with another protective sheet of paper.

3. Press firmly with fingers, spoon, roller or press.

4. Lift off carefully to reveal print.

Problem solving

If using water-based paint and the paint dries too quickly, either work more quickly or use a spray bottle filled with water to lightly sprinkle the plate with water and reroll. If it really dries, wash off the plate and start over again.

If you get too much paint on a plate to work with it, place a paper towel or newspaper over it and lightly smooth it to remove some of the paint.

If the impression is too faint either there is not enough paint, the paint dried or more pressure needs to be applied.

To cut down on mess and disorganization, consider doing all the plate preparation and handing out prepared plates with Watercolor Base Formula already applied and dried. Sometimes one member of the group is able to take over as the plate preparer.

Combination monotypes and embellishing

I usually introduce only one of the above described methods during a session, but if clients are having difficulty I may suggest another. All of the above variations may be combined in any way; each experience will be different. Try rolling paint over part of the plate and adding paint to other parts with a brush. Then use a stick and draw into the plate as you would for a reductive monotype. Paint flat found objects and place them on a background of rolled paint. Pull a print then do it again after moving the objects around.

After a print has dried, turn it around, upside down, look at it from across the room to see it in a different way. Do you see images? Suggestions? Use paints, colored pencils, chalks, craypas, collage elements to add to the image. Experiment with collage by tearing up prints or adding magazine images or textured paper. Make a book from your prints (see Chapter 10).

Artistic and clinical considerations

Projection

Simple foldover prints produce Rorschach-like abstract images, excellent for projection. In Malchiodi's *The Art Therapy Sourcebook* (1998b), she devotes a chapter to 'Spontaneous art: drawing out imagery.' She refers to Margaret Naumburg's work with patients' spontaneous art expression and her belief that they are immediate and uncensored releases of uncon-

scious conflicts in visual form (Malchiodi 1998b, p.104). Naumburg used spontaneous artmaking to develop creativity, especially for the non-artist.

One of the exercises in Malchiodi's book is 'Paint blots' (Malchiodi 1998b, pp.111–116) done with watercolors which are similar to foldover monotypes. She suggests doing three at a time and says that she is interested in images as they evolve over time. The spontaneity is freeing, creative and relaxing for many people. Non-artists are often surprised at their creativity, whereas studio-trained artists may find it difficult to work without rules and expectations.

Malchiodi suggests titling and dating each spontaneous artwork, perhaps writing comments about it. She also encourages returning to such work later and writing more about it, seeing it in a new light, maybe even writing a story or poem. See Chapter 10 for making books from foldover prints. Malchiodi suggests to her clients having an intention before doing such spontaneous artwork and looking for a response in the artwork.

Malchiodi also presents other techniques for creating spontaneous art and suggests using a circular format which could be used effectively with these foldover inkblots. The circular paper can be folded in half or in quarters.

It is also stimulating to see the incredible variety of images and shapes that can be created from this process, even before they are manipulated or enhanced in any way. I encourage clients to share their foldover monotypes and see others' work. As always, it is important to remind clients that their remarks about others' artwork is their projection, and I encourage them to express their responses and take responsibility for their own feelings.

Mystery and reality: clinical observations from brief treatment in an inpatient psychiatric hospital

For several years I worked at a local inpatient psychiatric hospital providing art therapy group sessions on weekends. One of the units I served was a general psychiatric unit comprised of acute short stay private patients whose diagnoses ranged from depression to psychotic mania. Most patients were pharmacologically stabilized in the ten days allowed

by their healthcare policies. There was frequent recidivism and a caring but overworked staff. It was supposed to be an adult unit, but there frequently were one or two adolescent clients.

The only space available for groups was the unit kitchen where the coffee pot, sink and refrigerator for client use were located. The kitchen had no closable doors but two open arches to the nurses' station and the lounge. Fortunately there were round tables and plenty of chairs.

On Saturday and Sunday mornings, I would attend the morning meeting and announce the time of the open art group. Clients were free to attend for whatever time they wished. Because the group was elective and it was the weekend, attendance was never predictable.

After trying many other media, I tried printmaking. Printmaking reduces resistance. Most clients are curious, maybe somewhat intimidated, when exposed to new materials, but a simple demonstration can engage even the most reluctant person. The materials are not 'babyish' and even a minimal effort produces results. The process is quick especially if water-based paint is used.

I brought supplies for simple printmaking projects and had interesting results from mystery monotypes. I started by rolling out paint for the first participants and demonstrated the process. I usually started with a mystery monotype because it is so easy, the client just draws on the back of the printing paper. Then I rolled plates for them, placing each rolled plate on a fourfold newspaper and covered with a piece of paper. Most of the time I did all of the rolling and was able to keep the mess to a minimum as people came in and out. They produced many prints.

I called the process 'mysterious' originally to engage the interest of reluctant clients. Adolescents were fascinated by the reverse writing required. Beginning with names also helped me learn names and relate to a new group each day. Many clients relaxed with the simple request to produce their names.

One Saturday session I remember vividly. I was introducing mystery monotypes. Hector came to a group with a mixture of curiosity and confusion. He was struggling with a change in medication, some withdrawal symptoms and sadness. Hector began drawing on the plate covered with paper that I handed him. He worked intently with colored pencils then asked for watercolor. I lifted up the corner of the paper to

show him the print that was emerging underneath, but he was not inter-
ested. He insisted on completing his watercolor and with a mixture of
signing and my limited Spanish told me that he was missing his pregnant
daughter who lived in the Islands. He showed me the house up on stilts
and his daughter in the open doorway. When we lifted off the print to
reveal the image produced in Figure 7.3, he turned it over, back to his
watercolor. He was not interested in the mystery of the monotype; he was
only concerned with his own reality.

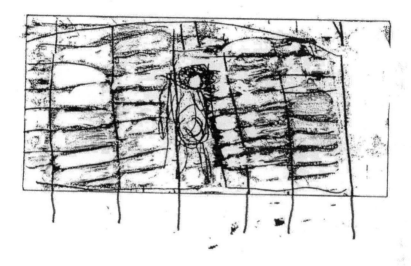

Figure 7.3 'Untitled' mystery monotype by Hector

This experience with Hector and many others remind me that it is the
client's need, not mine that is paramount. As much as I love introducing
printmaking, I try not to impose any materials or process upon a client.
With the supplies needed for printmaking, clients should be free to draw,
paint or create a construction if that is what they wish to do. Printmaking
like any other media should always be a suggestion, an introduction or
one of many possibilities.

Body image and monotype printing with adolescents with distorted body image

Using monotypes to work with clients about distortions of body image would be helpful because such images can be produced quickly, the paint rolled onto the plate and redrawn or the prints themselves can be reworked.

A graphic representation of distortion could be produced by having a client place a photo or magazine picture under the Plexiglass® plate, roll a thin layer of a transparent paint and proceed to create a reductive monotype from the image. Creating a monotype by the additive process using the same image under the Plexiglass® would also be an informative process. Either way, any distortion from the photo would be obvious. Of course, clients working from their own created images or photos would be helpful also.

Conroy (1986) in an article for the *British Journal of Occupational Therapy* reported on an inpatient program for clients with anorexia nervosa that found the 'process of painting' to be much more successful than an assigned themes approach (p.322). The painterly print, monotype, may be very suitable here. The difficulty in treating this population is well documented, and frequently art therapy has been found to be successful.

'Enhancement of body-image: a structures art therapy group with adolescents' (Schneider, Ostroff and Legow 1990) is an article that presents a program developed and used at the Summit Institute, a psychiatric residential treatment facility for emotionally disturbed adolescents and young adults in Jerusalem, Israel. Art therapy has been successful with this population as they struggle with their self-perceptions and those of others.

The seven session group is structured on the subject of the human figure with the hope of encouraging 'a more positive, healthy and integrated body image' (p.135). The art materials provide the media for exploration both symbolically and metaphorically. The clients 'can begin to cognitively, tangibly and emotionally work-through distortions, anxieties, confusion and conflictual issues relating to their own body images and identity' (p.7).

Schneider *et al.* (1990) use the group as an important part of the therapeutic process because body image is directly related to feedback. They state that although artwork is perceived as an extension of self, it is still less threatening to facilitate communication and to receive feedback from the group especially on so sensitive a subject. I propose that the indirectness of printmaking adds distance and allows more to be processed in an even less threatening way than the collage, sculpture and drawing used in this program.

Adolescents with distorted body image are so narcissistic and preoccupied with their own body image that they are often not aware of perceivable differences in other people. Confronted with artwork of others' faces, bodies and emotions forces a confrontation of differences which is neither good nor bad, just different.

The range of activities for the Summit Institute program builds on itself starting with collage of the figure, then a clay figure, two portraits in color expressing feeling, sketching group members, a picture of the human figure in color, a picture of an interaction between two people in color and ending with a life-sized color picture of a human figure.

I suggest that a monotype process would be very rewarding for some sessions. The sessions that suggests two portraits in color representing feelings emphasizes the expressive quality of a portrait and could be done as an additive monotype or even as a foldover inkblot. Sketching group members could be done with the reductive monotype process especially if oil-based paint is used. The paint stays workable and functions as a drawing tablet; the whole plate or parts of it can be rerolled to correct mistakes, but the whole image prints in reverse (see Figure 7.4).

The pictures of a human figure in color and picture of an interaction between two people could be additive monotypes. It might be helpful to use the process described above and put a photo of each client under Plexiglass® and proceed with a reductive monotype from the photo.

My suggestions are based on my work with adolescents in brief inpatient treatment hospitals and Skophammer's (1994) article 'Art with an attitude' about creating monotype self-portraits with adolescent students. My suggestion for printmaking does not imply abandoning drawing and painting. It is a suggestion that might be useful especially if there is resistance, feigned or actual boredom or an especially uneven

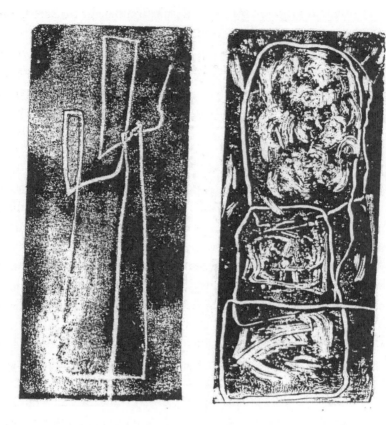

Figure 7.4 'Outside' and 'Inside' reductive monotypes by AB

balance of ability within the group. The printing process not only offers more distance from the image but also puts everyone into the same place as beginners with a new project.

Art of one's own: nurturing the nurturer

A classic comment from art therapists and art teachers is, 'I never get to do my own work.' Balancing a career in any helping profession and personal artmaking is always difficult, yet we know that it is beneficial. Many art therapists get supervision from another art therapist and have time to create artwork that is usually in service to their professional work.

Personal artmaking is often relegated to vacation time or treasured, long periods of time that are set aside for making art.

Doing a little bit of art but doing so frequently is something I would recommend. Usually that translates into keeping a small notebook and a few colored pencils for sketching between appointments or waiting somewhere. Doodles while telephoning are as valuable as sketches while waiting for an Internet connection. The supplies need to be few, and the size usually small.

The equipment needed for printmaking usually excludes it from frequent inclusion in artmaking unless you have a studio and all supplies readily available. I have such a studio and still find it difficult to print regularly. What I do, however, works well for me and might for you. When I do have the time, I make many monotypes on large sheets of paper. I mix the techniques described above and work quickly and freely painting with a roller, applying paint to multiple objects and moving them around. I use my time to do the printing and think of the process as a beginning. I clean up and let the prints dry.

I hang a dry print somewhere where I can see it during my daily activities or clip it to a board. Sometimes I carry it around in a cardboard tube. Whenever I have a moment, I work on it with water-soluble colored pencils. I refine a shape, pull up a form, color in an uneven area. It is slow, meditative work that soothes and comforts me. It is rather mindless; I do not plan ahead but respond to a small section at a time. It is like knitting but more creative and constantly stimulating yet soothing.

Collagraphs and monotypes have captivated my creative energies for over 30 years. The possibilities are limitless artistically, and the process is challenging and comforting. Perhaps printmaking will satisfy and nurture you, too. I hope so.

Stencil Process
Focus on Products

The fourth basic printmaking process that has been used for centuries is screen printing. Screen and stencil printing is different from the other three processes because the print is not taken from direct contact with the plate but pushed through an intermediary surface, the screen mesh or the stencil (see Figure 3.3, a drawing of the four processes in Chapter 3). In all stencil and screen printing, paint is pushed through certain areas and masked from others. Usually the areas that are not to be printed are masked. Because the paint goes directly through onto the surface beneath, the image produced is not in reverse but is exactly as designed. This directness of screen printing is very advantageous and has uses in an art therapy setting worth exploring.

Stencil and screen processes

The simplest form of screen printing is the stencil. Stencils are easy but have many artistic and therapeutic applications. Stencils are particularly useful in long-term settings or where creating a product is a component of meeting treatment goals. Craft stores sell precut stencils, but directions for making your own are included here.

Art therapists' assessment of the needs of his or her clients must take into account many factors. Creative, expressive personal artmaking using these methods is of primary importance, but I have chosen to emphasize product making and community building benefits of screen and stencil

printing. The settings where screening might be most beneficial serve clients whose need is long term or vocational. Populations include physically and mentally disabled people, medical and vocational rehabilitation clients and many geriatric populations. Art workshops and open studios also frequently employ screen processes. Theoretical aspects to consider are purposefulness, repetition, psychic organization, the distinction between art and craft, physical integration, practicality, developing social skills and group cohesiveness as well as the relative value of products and production.

Purposeful activity

Art therapists and occupational therapists often have different clinical goals and reasons for deciding to use a particular art method and/or materials. In most cases, however, it is of value to present purposeful activity. Studies of motivation document that clients doing purposeful activity perform better (Steinbeck 1986). This is an intrinsically important aspect of occupational therapy assessment and activity. It is also compelling to art therapists in a rehabilitation or vocational training setting. Why would a client engage in any activity that seemed purposeless? Every client deserves a reasonable answer to the question, 'Why should I do this?' Learning to express oneself is purposeful. Learning how to make greeting cards is also purposeful and increases self-esteem; distributing cards builds socialization strengths and helps develop group cohesiveness.

Repetition of images

When is repeating an image of benefit? When is repetition a reflection of being stuck and uncreative? Kramer (1971), in her classic *Art as Therapy with Children*, refers to repetition that is 'alive and productive' (p.127) as prints can very well be. The key is the creation of the image in the first place, which is a sorting out of information and distilling through the individual creative process. Rather than thinking of this stage as a holding pattern for future more creative work, Kramer reminds us that 'we also must not underestimate the stabilizing and reassuring function of repetition' (p.128). In an April 2001 workshop at Springfield College,

Springfield, MA, Kramer reiterated the need for a lot of repetition before expecting change.

The schematic stage of children's art development is the period when a child repeats the same images over and over again. Besides this normal developmental stage of artmaking, other clients may repeat images for various reasons including trauma. Malchoidi's *Understanding Children's Drawings* (1998a) discusses specific examples of repetition induced by trauma (pp.138–142) and the self-soothing quality of repetition often associated with dissociative stages (pp.141, 151).

There is a difference between repeating an image or scene in drawings or paintings and making repeated, printed images from one screen or plate. Perhaps the ease with which the client is able to quickly repeat his or her image by just filling in a stencil can be even more stabilizing and satisfying than starting all over again with another rendering of the same image. Is this a mechanized version of the schematic stage of normal children's art development? An opportunity to order his or her world, repeat the image and feel stabilized is an appropriate reason to suggest that printmaking and the screen process is a good choice in many situations.

There is, additionally, refinement in each repetition which can lead to great satisfaction and artistic achievement. The subtle differences in each print may be defects in a work situation but can be appreciated and even enhanced in the art therapy or occupational therapy setting. See Chapter 10 for suggestions for using repeated images to make artists' books.

Physical integration

The physical demands of stencil and screen printing can increase mobility, extend range of motion and encourage physical integration. Printmaking can be broken down into small, measurable steps; the process of creating art can be observed and documented to assess and develop physical skills. Most screening activities require two hands and a range of motion greater than drawing or writing. Adaptive measures need to be taken for clients with physical limitations, but clients constantly surprise me with abilities and interest beyond their normal patterns.

The printing process requires repetitious motions in a certain sequence. Once this pattern is established, a great many prints can be

pulled in a short time. This predictable forward and back or up and down motion can be very soothing and at the same time be very stimulating. Think of a rocking chair or of rolling a pie crust.

The physical movement required for stenciling and screen printing is often a key factor ignored by art therapists and of primary importance to an occupational therapist. As art therapists we need not feel helpless if a client is physically stiff and unresponsive. Before working with multiply handicapped or geriatric clients, I always check in with the occupational therapist or physical therapist and ask her what her movement goals are for each client. If increasing range of motion is a goal, perhaps the stretch of pulling a squeegee across a screen would be helpful. If a more open, flexible grasp would help a client with activities of daily living, consider stenciling and the repetitive up and down motion and accuracy of fine motor coordination required.

Expanding a client's range of motion expands awareness. Many clients benefit from any activity that causes them to cross their midline. Crossing midline helps integrate brain functions (Sietsema 1993). Gross motor moving is often the beginning of increased fine motor skills.

The physical differences between repeating a 1" x 4" drawing and screening, stenciling or rolling to apply paint to a plate should be considered. Most printmaking involves repetitive motions to apply paint and pull a print. There are more steps to screen and stencil printmaking, but most are not directly involved with the image making. There is a lot of reaching, pulling, pushing, pressing, stretching and lifting. All of these motions can be beneficial to increase range of motion, manual dexterity, upper body strength and movements which cross the midline. The variety of movement helps as much as the repetition. When working with elderly or physically disabled clients, I frequently start a printmaking session with a stretching musical 'workout' to wake up clients, get them engaged and moving.

Psychic organization

If used effectively, printmaking can be a 'means of supporting the ego, fostering the development of a sense of identity, and promoting maturation in general [and] contribute[s] to the development of psychic organization' (Kramer 1971, p.xiii). These concepts Kramer attributes to

artmaking in general, but I apply to screen printing especially when it is used with elderly or disabled people. Printmaking is a form of artmaking that does not depend on skilled image making; it is easily broken down into small manageable steps and involves the body in repetitive motion. It is satisfying and integrating especially to those who benefit from sensory stimulation and movement.

In *Expressive Therapy with Elders and the Disabled: Touching the Heart of Life*, Weiss (1984) writes about two groups of people who have similar needs to organize and recreate their lives to include meaning and alternative ways of relating to themselves and others. Elderly clients need to find meaning in living in an institution that is very different from their previous lives. There is often a preoccupation with past experiences but a need to adjust to new physical, cognitive and social limitations. Expressive therapy and activities that focus on sensory stimulation help these people find enjoyment and meaning in activities and creative experiences that balance all aspects of their lives.

It is not surprising that disabled elders and pervasive developmentally disordered (PDD) clients are often served in the same institutions because their needs are similar. In assessing the efficacy of programs to meet the needs of PDD clients, Linderman and Stewart (1999) note that a consistent program of sensory interactive occupational therapy improved participants social interaction, approach to new activities, response to interactions and decreased targeted aggressive and disruptive behaviors (pp.207–13).

Art or craft?

Because it is so process based, printmaking often falls into the category of craft. Kramer's (1975) distinction between art and craft is that art transforms 'amorphous, malleable material' (p.106) into something symbolic that conveys expression and experience whereas craft transforms raw material into something useful (and attractive) in a logical understandable process. Kramer cautions that even if a client would benefit from an activity more like a craft because of illness or limited energy or fear, the project still must be something that is logical and something the client can accomplish (p.107). Craft kits are only assembled and are not art

therapy; they only serve to help clients follow directions and keep him or her occupied.

In the crafts, the measure of accomplishment is the completion of a project and increased self-esteem. The steps are small and measurable in simple printmaking projects, and the completion is an accomplishment. Adding personal imagery to a craft activity adds meaning as well as accomplishment. Creating products from craft projects, Kramer maintains, can 'build self-esteem in persons who reject their art work because it contains too much evidence of pathology, or in persons who cannot endure regression and relaxation of compulsive defenses, which are inseparable from art' (p.33). She adds that 'obsessive perfectionism that is a hindrance in art can be an asset in the crafts' (p.34).

Craft projects provide several benefits that unstructured art does not. Crafts have clearer parameters and accepted boundaries. There is a comfortable safety in the repetition, of doing something that has been done before by many others. Crafts are also socially acceptable and more common as well as usually focused on making a useful product. The expectations of a craft project are those of following directions and getting something made and do not threaten to expose personal pathology.

Because of those same steps and materials, printmaking is less formidable than traditional artmaking. Being presented with a blank sheet of paper is very intimidating to some clients. The ability to cut that paper to create a stencil or a screen dilutes the confrontation and often the anxiety or resistance.

The art therapist who uses printmaking knowing these advantages must realize that the client will need to be able to handle the materials and develop skill in order to feel accomplished with this process. The therapist can combine artmaking with craft and use the best qualities of each (see Figure 8.1).

Practicality

After the initial small investment, stenciling can be very economical and artistically satisfying in a rehabilitation or vocational setting. Cut from a plastic-coated material such as E-Z Cut, a stencil can be cleaned and reused for a long time. The same client can reuse it, or different people can

Figure 8.1 'Uncertain,' stencil by SM

use the same stencil. Commercially purchased silk screens can be reused countless times. When the fabric gets torn, it can be replaced. The simple screens described in Chapter 9 are even more economical. With careful, economical use of stencils and screens, the major expense is paint and paper.

Developing social skills and group cohesion

The creation of an image, the actual printing, the drying, storing and organizing of resulting images or products and the process of showing or selling products are all facets of this process that can involve many people. Tasks can be divided and shared to involve the entire group. For example, if your group has varying ability and interest, one person could design a stencil, another cut it out and still another print it. After printing, the prints need to be spread out to dry. The steps are easily divided and process shared. Stencils from different people can be combined for interactive sessions. The process can be used at any stage of group development.

Production and products

The potential for artistically satisfying and practical, attractive products is an advantage with stencil and screen printing. Creating a product that is useful and visually interesting is very satisfying to most clients. Some clients have few possessions of their own or have seldom created something worth keeping. Screening a tee shirt or stenciling a jacket can be very positive. Stencils can be used to identify possessions, to create a logo for an organization or to decorate the surrounding walls, curtains, tables and chairs for monthly holiday celebrations, special occasions or general use.

Making holiday cards or a birthday card for a friend is empowering and contributes to altruism and gratitude. Whether I worked at psychiatric hospitals or a nursing home, clients were always grateful to be able to make cards to send home. Clients appreciate increasing their skills and creating for themselves and others. Most home decorating and women's craft magazines feature articles on stenciling, and it is a commonly accepted decorative element. Probably more people feel comfortable stenciling than they do painting. Many cultures have traditional designs that have been stenciled on furniture, clothing and even homes.

Using stencils also adds a continuing element to sustain a vision for an artist's book. See Figure 8.2 'Hands of Time' an accordion fold book that combines a life-sized screen of a hand, smaller hand stencils and family photographs.

Funding

The practical consideration of funding a program or funding an art therapist is unfortunately now an issue facing many of us. I am currently working with Cancer Connection Inc. on a contract basis to offer art therapy sessions to survivors of cancer. Each series has to be privately funded. I have used cards adorned with clients' artwork to write thank you notes to sponsors, who greatly appreciated the acknowledgement, but our funding is always in jeopardy. At the last session of the group, members earnestly wanted to continue meeting. We decided to begin making cards to sell in the organization's office and in local gift stores to raise funds to continue the program.

Figure 8.2 'Hands of Time,' artist's book by PH

Many workshops and day treatment facilities have pre-vocational components or the possibility of creating products for local gift shops or craft fairs. Creating products with silk-screened or stenciled designs can be a significant contribution to the program's financial status and sense of self-worth of clients (see Chapter 9 for examples). All aspects of such a project must be considered, but consider stenciling or screening becoming a major component.

Instructions for stenciling

Stenciling requires a stiff material from which a shape can be cut to produce an image. It is best to have water-resistant material (see Appendix for suppliers). The cut stencil is placed on top of the surface to be printed and a brush is used to apply paint through the cut-out area. The major limitation of stenciling is that shapes need to be complete, i.e. the letters C, E, F, etc. can be cut out easily, but the interior parts of A, B, O, etc. will all be solid; the O will just be a solid circle. Stencils do not work very well if the image has thin sections that are not supported well by the stencil material. See Figure 8.3 'Sisters Singing;' the thin sections between the feet were difficult to keep clean. This limits other designs as well. Simple designs work the best by far.

The stenciling process can be messy and requires some skill in applying the paint. Start with just a little paint and build up.

Figure 8.3 'Sisters Singing' stencil on wrapping paper by LM

Supplies

1. To make a regular lift-off stencil: stiff, thin paper or board such as oak tag, cover stock, plastic treated paper, vinyl or commercial stencil material such as Wax-O™ or E-Z Cut.

OR

1. To make a sticky stencil: contact paper can be used to make a few images. It helps keep the paint from sliding under the stencil when adhered, but it is best used to print fabric or a shiny surface. Reynolds freezer paper works well too. Trace your design on the dull side, cut out and then iron onto fabric. It makes several prints before the sticky stuff wears off. Requires an iron.

2. Paint: thickly mixed tempera, acrylic, watercolor, fabric paint, latex house paint, water-based silk-screen paint.

3. Stiff brush or foam brush for applying paint.

4. Paper, fabric, wall or other surface to print.

5. Masking tape to tape stencil to paper, or hinge stencil on one side to a backing board in order to slide in each paper.

6. Clean-up supplies.

Printing stencils

1. Cut out shape(s) to be printed. Cut out what prints, no need for reversing image. Start interiors cuts with hole punch or X made with a utility knife. Be sure to leave enough space around the shapes to hold onto the stencil and provide stability.

2. Place cut stencil on top of paper or surface to be printed.

3. Tape edges of stencil to keep it from moving around.

4. Apply paint with brush or roller by stippling, lightly tapping up and down starting at the edge of the stencil and working into the middle. Be careful to start with less paint and apply with an up and down motion not from side to side. Up and down motion keeps paint from going under the edge of the stencil.

5. Carefully lift up stencil to reveal image. If paint gets on the back side of the stencil, clean with damp sponge and dry before next use.

6. Allow image to dry before stenciling again on the same paper.

Artistic and clinical considerations

Print light colors first.

Repeat patterns: overlap, print part off the page, turn the stencil, print in a circle.

Grade the color: put one color on one side of the stencil and another on the other and let them blend in the middle.

Combine stencils with other artmaking. Try stenciling over paintings, over monotypes.

Print on various textures, colored paper, textiles.

Printing on fabric and other surfaces

Stencils are almost as easy to use to print fabric, furniture and walls as stamps. Your main concern will be to keep the areas that are not to be printed clean and protected from drips. Use plastic bags, newspapers and masking tape to protect such areas and keep a damp sponge handy for cleaning up.

Adhering the stencil to a chair leg, tee shirt or wall usually is easy with masking tape. Be careful when stenciling repeatedly to allow time for images to dry if there is any overlapping. Clean the back of the stencil each time it is used.

When stenciling garments or any fabric that is thin, place newspapers, cardboard or an expendable towel underneath the surface to be printed to protect the area behind it and to keep paint from collecting underneath the fabric. If it gets soiled, be sure to replace with clean protection or the fabric will be covered with paint on both sides.

Use only acrylic, fabric or house paint for permanent stencils on fabric, furniture or walls. After it is dry, ironing the back of a garment with a warm iron sets the paint, but it is not necessary.

Stencils printed over patterned wallpaper, sheet music, telephone book pages, newspaper, gift wrap and magazine pictures produce fascinating images (see Figure 8.3).

Social interaction: a quilt mural in an Alzheimer's unit

Introducing printmaking in an Alzheimer's unit illustrated to me the profound effect of the physical demands upon clients. The loss of physical skills especially the fine motor ones required for tasks such as buttoning and holding a pencil was particularly sad and frustrating for me and for clients when we did any art. Clients were always ready to sing

and dance but were reluctant to draw or paint. Initially I introduced printmaking because although many clients remained verbal and interacted socially, many had lost fine motor skills and were unable to grasp a pencil, crayon or brush.

Art Group included a group of four clients who would be seated around a circular table in the clients' kitchen. There were two clients who came to most sessions but about five others who would be alternately included according to their abilities on a given day. Starting with their interest and strengths, I began most sessions with singing and hand stretches. We used our hands to clap and act out words or ideas from the songs. Then I introduced an art or printmaking activity and showed them the supplies.

I had to start out working hand over hand. Using a pencil, marker or brush proved particularly difficult to manage for most. I introduced printmaking out of mutual frustration. Amazingly, using a roller to apply paint to a simple relief plate (see Chapter 5) or a squeegee to pull paint across a screen seemed to awakened forgotten body memories. I had no way of knowing that many of the women were former mill workers. The repetitive motions tapped long forgotten physical memories of operating the looms. Faces brightened, energy increased. Emma spoke for the first time in months.

Clinical goals for the clients were to increase their social interaction, interest in their environment and fine motor skills, and these very simple printing activities did so. The products ended up not being very important. We hung them up mostly for family to see, but the clients usually forgot what they did.

One permanent exception to the fleeting small successes of my art group was a mural created by almost everyone on the unit. I would probably not have undertaken this project if it had not been for the success of the printmaking activities. The enthusiastic activity director asked me to do a mural on the cement block wall across from the nurses' station. It was a well-traveled area, rather dark and distinctly ugly. There was constant traffic because of the many pacing or wandering clients and activity of the staff. There was room for me to stand with one ambulatory client and one in a wheelchair.

I prepared the area for the mural by measuring then marking a grid of 12-inch squares with masking tape. We called it a quilt from then on to help clients associate the image and squares with a familiar, comforting object. I bought a large, 3"x 6" x 2" industrial sponge about the size of a house-brick and found a small stiff plastic tray just large enough to hold the sponge and a thin layer of paint. I stored the soft peach colored latex paint we used in a jar with a screw-on top and added to the tray as the paint was used up.

The background of our mural was done almost exclusively by Ramonna, a tall beautifully groomed woman who loved to sing but was rapidly losing fine motor skills and experiencing emotional mood swings. I approached Ramonna with an offer to sing with her and asked her if she would help me with a project. We sang almost constantly as Ramonna dipped the sponge into the tray, reached and pressed the sponge against the wall to make a textured print, two in each square. It was simple stamp printing.

I had mixed a dark peach with white paint to make the background color. I purposefully did not mix it up completely so the sponge created a variegated pattern of peach and white. The surface was uneven cement blocks, so some of the wall color showed through if Ramonna did not press very hard or if there was not much paint on the sponge. It took Ramonna at least two or three days to complete the background for the quilt. I took that time as an opportunity to explain to clients and staff passing by what we were going to do with the quilt when the background was complete. I could have painted the wall myself, but I wanted the clients to do as much as they could.

When the background was complete, clients started painting individual squares. I had four colors of latex paint in small jars that could be held in one hand and a short foam brush for each. Each client chose one color at a time and painted what she wished. One man who had never been interested in Art Group wheeled by and asked to paint. He quickly painted a shaky sail boat, saluted then wheeled away singing 'Anchors Away!'

Martha had trouble grasping a brush, so we danced in front of the quilt. I put a brush in her hand, and she brushed strokes across a square to produce what we called a 'dance painting.' The project took several

weeks, but we managed to get most squares painted and were able to include everyone who was able to get to the area. Reserving the lower two rows of squares for those in wheelchairs took some management, but we were able to include everyone with at least one square and the more active clients filled in where needed. Loretta, a non-Alzheimer stroke victim from the long-term care unit, was our star painter and would fill in any place she could reach from her wheelchair. Every day she came to note the progress and critique the newest additions. One woman, Desiree, who rarely came out of her room, ventured out to paint a square with the group.

I left that facility shortly after the Quilt Mural Project, but I have been told that Desiree subsequently attended social events and groups. Unfortunately the Quilt Mural was painted over by a new management company that bought the facility, but the activity director photographed it. See Figure 8.4, 'Quilt Project,' stamp printing, stencils and painting by Group A.

Figure 8.4 'Quilt Project' by group A, stamps, stencils and paintings

Simple Screen Processes

Silk-screening is more complicated than stenciling but can create a more complex image and faster reproduction. The term 'silk screen' is still used although most screens are now actually made of polyester. 'Serigraph' is also used but mostly to describe strictly fine art screen printing. Serigraph combines the French words for silk and graphic.

Screen printing has historically been used for commercial purposes, first for printing fabric then for paper. For contemporary commercial screen printing, the image is photomechanically reproduced. Colors are separated by a computer, and the image is printed by high-speed, high-resolution machines. Screened images are everywhere. In most groups you will find a screened image on someone's tee shirt, sweatshirt or notebook cover.

Some clinical settings such as work release centers, sheltered workshops, vocational support settings and hospitals have silk screens, computers and various equipment to fix an image on the screen. This book does not cover these processes because the directions are so specific to the equipment involved. If you are fortunate enough to have access to silk-screen supplies, directions for applying and removing images should be with the chemicals; if not, you can call the manufacturer.

Simple screens

Many screen films are intended for oil-based inks and require toxic solvents to remove. You do not need to use toxic chemicals. If you inherit just the screens and want to order supplies to create and fix images, see

Appendix for suggestions of good water-based chemicals and suppliers. The large Dick Blick Art Supplies catalog has a comparison chart of all their available screen inks including clean-up requirements. Every process is different and requires specific information. Fortunately, screening concepts are the same no matter what chemicals you use. This chapter presents alternative techniques to adapt basic silk-screening to clinical settings using equipment available at low cost through hardware, craft or fabric stores.

Silk screen frames and equipment for expressive or therapeutic use are available from art stores and catalogs. Traditional frames can be made and specific directions are available in other books (see Additional Reading). The directions for various products used to adhere an image to the screen are always included with supplies and are not described here except for one. I have included a simple, water-based system that is non-toxic and fluid for use in creating expressive silk-screen images. The screen techniques described here are successful when used with commercially made screens as well as the simple embroidery hoop handmade screens suggested. These simple, direct methods for screening use inexpensive, available materials that allow the artist to be directly involved in the creative process.

The techniques described here are adequate for simple designs and do not demand exact registration for complex, multicolored reproduction. They are intended for use in the art therapy setting for creative artmaking and have the potential for use in making products. If the facility is set up for vocational training, the equipment will be more sophisticated and accurate, and you will have to learn how to run it for production. Concentrate on creative image making using the tools you have.

Basic supplies

1. Embroidery hoops from a craft store; use plastic or wood if possible but get ones with some adjustment to tighten the outer hoop to the inner one. Certainly use a silk screen frame if you have one.

2. Cotton organdy enough to cover each screen and leave about 1" to 2" extra to pull to tighten. Or order polyester screen mesh; 6XX is adequate.

3. Silk-screen paint or tempera paint for paper, acrylic for fabric (use latex house paint or artists' acrylic diluted to the consistency of house paint). Note that latex, fabric or acrylic paints are required for fabric printing if you intend to wear or wash the fabric.

4. Spoons or squeeze bottles to get the paint in controlled amounts from the paint containers to the screens.

5. Squeegees: use a piece of mat board or cardboard smaller than the diameter of the hoop by 2"or 3". Or use small window-washing squeegees or order ones from an art supply store. They must be smaller than the inside of the screens.

6. A printing pad for underneath the paper or fabric to be printed. For a small project see 'Printing pad' in Chapter 3. For a large piece of fabric, cover table with newspaper over towels. Spread fabric on the newspaper and tape all outside edges to the table. If printing tee shirts, cut cardboard large enough to put inside the shirt to protect the part not being printed and smoothly stretch the area to be printed. Cut a piece of old towel or soft blanket to cover the board.

7. Paper or fabric to print.

8. Clean, damp sponges and liquid soap to clean up any spills and the underneath side of the screen. The pores of the organdy get filled as the paint dries but can be rinsed out to unclog them. A sink and running water helps.

Note: One disadvantage with traditional silk-screening equipment is the storage and cleaning of screens. They need to be carefully washed and dried for future use then stored where they will not be damaged. If you use embroidery hoops and keep your projects simple and small, the light-weight hoops can be hung on a hook and the organdy dried from a clothes pin.

Instructions for cut or torn paper screens

Supplies: Embroidery hoop, organdy or polyester screen fabric, newsprint paper, paint, spoon, squeegee, fabric or paper to print on, paper to cover table, printing pad, running water

1. Make screens by cutting organdy about 1" to 2" larger than the embroidery hoop. Separate the two parts of the hoop, put the organdy over the smaller hoop; place the larger hoop on top and push it over the small one. Tighten the larger hoop and pull the organdy taut like a drum to form a screen.

2. Cut a circle of newsprint slightly larger than the hoop. Cut out the desired shape or design from the newsprint. Remember to keep shapes simple (see Figure 9.1).

Figure 9.1 a. 'Sighlent House' b. 'I was Once' c. 'Doubled Over' by JS, cut paper screens

3. Place paper or fabric to be printed on the printing pad, position the newsprint stencil where desired and then place the hoop over the stencil with the organdy side down on the stencil, hoop edges up.

4. Carefully spoon a spoonful of paint onto the top edge of the hoop just inside the hoop. Hold down the hoop firmly with one hand.

5. Use a piece of cardboard or squeegee and smoothly and steadily spread the paint across the screen/hoop to the other side covering the entire surface. Move quickly and steadily but do not move the hoop. The stencil will stick to the hoop with the paint. You will have excess paint collected on one side of the hoop.

6. Gently lift up the hoop and the newsprint stencil leaving the screened image on the paper. Keep the hoop and the newsprint stencil together.

7. Remove the screened image and put down a clean piece of paper. Repeat the process with another piece of paper as often the stencil holds up but work quickly because water-based paints dry and will seal up the pores in the organdy. Just spread the paint across the hoop making sure to go over all areas that need to print.

8. If you want to change colors, just mix them on the screen. If you want a completely new color, you must start all over again and wash out the organdy, dry it and cut another stencil.

9. To clean up, remove stencil and wash out organdy. The organdy is reusable when dry. The stencil is not reusable.

Instructions for shadow screens

Supplies: embroidery hoop, organdy or polyester screen fabric, flat items (leaves, doilies, paper cut-outs), paint, spoon, squeegee, fabric or paper to print on, paper to cover table, printing pad, running water

1. Make a screen from organdy and an embroidery hoop as in instructions for 'Cut or torn paper screens.'

2. Place a piece of paper larger than the hoop on the printing pad. Place leaves, a piece of lace, a doily, talcum powder, anything flat with an interesting shape on top of the paper. Do not use anything sharp or anything indispensable.

3. Place the screen over the object and hold it down firmly as you put paint into the screen.

4. Spread paint across and over the object below with a squeegee. The paint should cover everything including the object and create an image or shadow of that object when it is lifted off the paper.

Instructions for contact paper screens

As an alternative to the cut or torn paper screen, use contact paper instead of paper to cut out your stencil as in step 2. Cut a circle slightly larger than the hoop. Adhere it to the top side of the screen folding up the edges onto the sides of the hoop so that the paint will not seep out along the hoop edge. Scratch-Art® Mask-Ease® is also available through art supply stores. The product has an extra layer (and requires an additional step) to help in the transfer of small floating parts, but you will have to decide if the additional cost is worth the benefits. My personal decision is to use the contact paper and remember that the simplest shapes are the most successful. Proceed with steps 4–9.

Instructions for painted screens

Another choice is to make the screen from the embroidery hoop then paint directly onto the organdy with acrylic paint. Wherever the paint dries and seals up the pores of the organdy it will not print; therefore, what you wish to have as an image must be left unpainted. This works only with cotton organdy fabric. The organdy can not be reused for another image, but the organdy can be washed and reprinted many times.

It is a permanent screen and much cheaper than commercially prepared ones or ones made from other products. The process may not be suitable for some clients however because you must paint to mask out the areas you do not want printed. This is the most successful of these simple screen techniques.

Supplies: embroidery hoop, organdy, acrylic or latex paint for making screen; screen printing, tempera or any thick water-based paint to print, spoon, squeegee, fabric or paper to print on, paper to cover table, printing pad, running water, clean-up supplies

1. Make screens by cutting organdy about 1" to 2" larger than the embroidery hoop. Separate the two parts of the hoop, put the organdy over the smaller hoop; place the larger hoop on top and push it over the small one. Tighten the larger hoop and pull the organdy taut to form a screen.

2. Paint directly onto the screen with acrylics or latex paint. Paint only the areas that you do not want to print. Paint several coats. Hold screen up to a light to see that you have masked all the little holes in the fabric. Let dry completely.

3. Print as for simple screen.

4. Wash out paint used for printing. The dried image will remain and can be reprinted. If you noticed small holes in the painted areas that let paint through, you can add more paint to fill them when the screen is cleaned and dry. Store the painted screens either flat or in the hoops.

Instructions for non-toxic screen printing using commercially available supplies

Supplies: Speedball Drawing Fluid and Screen filler, silk-screen frame, squeegee, water soluble silk-screen paint, brush, Wisk detergent, paper, cold and hot running water, hair dryer (optional)

1. Apply the blue Drawing Fluid to screen with a brush to create a positive image. What you create will ultimately print. Let it dry. Use a hair dryer carefully to hasten drying.

2. With a squeegee, spread the brown Screen Filler over the entire bottom side of the screen; the edges of the frame are facing up. You will cover up the blue image. Let dry.

3. Spray cold water onto the top of the screen to wash out the areas covered by Drawing Fluid. Direct the spray to the blue areas to be cleared. Dry.

4. Place clean paper under the screen. Print with water-based paint by placing paint at the top of the screen and pulling the paint firmly across the screen with the squeegee.

5. To clean off paint that dries in the screen where you do not want it or to clean the screen to store the image on the screen, wash with cold water. To clean the screen completely and remove the image, dissolve the filler with a spray of hot water. If the filler is difficult to remove, soak first with a layer of Wisk detergent and use a screen brush to loosen the filler with hot water.

Alternative, easier technique

1. Eliminate the Drawing Fluid and paint directly on the screen with the Screen Filler. You will be painting areas that will block the paint, so you are painting a negative image, but it eliminates a step and considerable time but still produces good results.

2. Let the Filler dry and proceed to screen print as in step 4. Clean as in step 5.

Instructions for tin can printing

'Canning' is a process of applying textile dye to fabric to produce a fluid linear design. The following instructions have adapted this textile design process to a simple technique that is a lot of fun and is especially suitable developing group cohesiveness. This technique works best using a large

piece of fabric or heavy paper. It can be messy but some beautiful artworks are possible.

Supplies: tightly woven fabric with some natural fiber: cotton, duck, muslin or heavy paper; jelly thick paint: tempera, acrylic, house paint; metal cans of various sizes with one end removed; beer can opener or nail and hammer; a printing pad or table covered with newspapers or towels; tape

Optional: contact paper

1. Cover table with several layers of newspaper or towels that will have to be washed.

2. Spread fabric over pad or table and tape all outside edges to the table.

3. Mix paints to a jelly-like consistently and start with the lightest color.

4. Punch one or more holes into the remaining end of a metal can with the beer can opener or nail and hammer. Prepare several cans with a variety of holes and sizes of holes.

5. Cut shapes from the contact paper, pull off the sticky back and press securely onto the fabric. Do not do this step on paper.

6. Place a can on the fabric, pour a small amount of paint into the can, enough to cover all holes but only as much as you can use. While pressing firmly, move the can across the fabric to create a pattern keeping the can in contact with the fabric at all times. The paint will flow out onto the fabric and be smoothed by the can. Continue until the paint is used up, or pull the can off the fabric onto a piece of stiff paper. Keep the can in contact with the fabric or paper at all times or the paint will just pour out of the hole in the can all over the place.

7. Continue with other colors, building color over color, blending and covering the contact paper shapes.

8. Clean up excess paint.

9. Let the paint dry and pull off the contact paper shapes to reveal unpainted fabric.

10. Embellish as desired with other art media. Use as a banner or a table cover. Cut into sections. Use as a background for other printmaking or drawing.

Note: this can be done on paper without the contact paper cut-outs. The contact paper is too difficult to remove from paper covered with paint and may tear the paper.

Artistic and clinical considerations

Ideas for products

Prints can be made on a variety of surfaces: paper, fabric, walls, furniture. Check the properties of different paints to be sure that the print will be permanent where needed. What products might be made? Cards, place mats, handbags, gift bags, wrapping paper, gift tags, tee shirts, clothing decoration, curtains, aprons, furniture, wooden boxes, book covers. Print calendars: a computer can print out the grid of the dates and screen prints can be added for each month.

Research the history of a school or treatment facility and make a booklet illustrated with screen prints of the building or clients' impressions. Create a family journal or story from one of the many book forms described in Chapter 10. See Figure 8.2 'Hands of Time' as an illustration of an artist's book using screens and photos. Develop a foldout autobiography using stencil of self, screened on each page and embellished. Use each client's image of self to stencil belongings.

Have clients develop a logo for site, make it into a screen and use it throughout the building as well as on tee shirts, curtains or jackets.

Long-term settings

In general, silk-screening lends itself to long-term goals and settings because it is a process that can be learned using the simple techniques described here then expanded to involve a group over an extended period

of time. With these simple methods, design possibilities are limited to simple shapes, but even the simplest of shapes can produce attractive products. As skills increase, more sophisticated screens and materials to adhere images to the screen can be investigated (Figure 9.2). Because the equipment can be reused, often the investment in silk-screening equipment can be justified.

Figure 9.2 'Abyss' by MP, painted screen

New products and ways to create screens that are non-toxic and connected to computers are being developed every year. Some settings have screens and printing setups but have their screens made commercially. A client's design can be commercially cut into a screen, then it is just the mechanical process of printing that is done on site. The simple process can grow into a small business or workshop. See 'Introducing printmaking to a rehab center for women,' an example in Chapter 5.

Group process

Projects like tin can printing on a large piece of fabric can be an especially graphic representation of the group's level of development and interaction. The position of each contact cut-out becomes covered up during the canning, but when the fabric is dry and the contact paper removed, the negative shapes are in sharp contrast to the painted fabric. The stenciling or screening process can also be used to create personal symbols. Combine the images on large pieces of paper or fabric. Or have each client make a screen or stencil with a personal symbol and print the images together in a Mandala form.

If this type of activity is done at the beginning of a group the relationship of the symbols will be different from when it is done at the end of the group. One large art piece can be created at different times. If the group is ending, perhaps each person could have his or her own piece of fabric as well as his or her own symbol. Everyone could make his or her own banner and have representation from everyone else in the group. Consider making each a tee shirt, pillow case or laundry bag depending on the group.

All of these screening processes end up being a group production because the actual screening takes very little time and there is a great deal of production to get things ready then all of a sudden a lot of wet printed images being produced in a short time. There are many jobs for you as the facilitator or other people in the group besides that of doing the actual printing. Screen printing always reminds me of volunteering in a church kitchen for a pancake breakfast. It reminds many of factory work. There is a bustle of activity, a lot of interaction and a sense of group cohesiveness especially when things are going well.

Community involvement

How could these techniques be used as a base to set up a project that would involve the community with a therapeutic setting? How would others be involved in the process of creating with stencils or screens? How could others be involved with the product making? How could others benefit from the products created? What would be the benefits?

Problems? Even with the simplest of screening processes described here, how could this be done?

On an individual basis, volunteers from the community can be enlisted to be helpers with printmaking projects at many settings. Often volunteers do not know what to do and may be hesitant with clients until they get to know them. There are many small parts to the printing process that would be a lot easier with another pair of hands. Art therapy, occupational therapy, rehabilitation and teaching interns can get started with a printmaking session.

Products made from stenciling or screening can be made for family members, friends and other clients. Items can be donated to other facilities. Your clients can make cards for people in nursing homes, Ronald McDonald Houses near most medical centers, homeless shelters, anyone in need of a personal expression of care.

Some sheltered workshops have small retail outlets where clients learn sales skills. A way to ease into retail sales is to rent a table at a local arts and crafts fair for your group. Besides creating the printed cards, place mats or mouse pads, clients can be involved in packaging, labeling

Figure 9.3 'Thinking' by CF, screen print

and pricing before the fair. At the fair they can practice social skills and assist in sales. As an alternative, ask local businesses if they would sell your products and provide accurate inventories and an easy set up to be paid.

ArtStreet in Albuquerque is a successful public program set up originally to serve the areas' homeless population. It provides a space to create and sell art; it does not claim to provide art therapy. ArtStreet is 'a group of artists, art therapists and interested community members who want to use art to build community and increase personal self-esteem, self-sufficiency, and hope among individuals and families who are dealing with hopelessness' (Timm-Bottos 1995, p.184). Printmaking is a part of their program. In 1998 'The Prints of Albuquerque' was a popular citywide project. They do not have a press but used a large, heavy roll of paper as a press and called it the Flintstone Press.

A creative art center for people with disabilities

In *Art and Disabilities: Establishing the Creative Art Center for People with Disabilities*, Ludins-Katz and Katz (1990) describe a prototype center that includes creative art, art therapy, art in recreation and art education. The first center was started in 1974, and many others including the National Institute of Art and Disabilities evolved from this model. The book is helpful to anyone considering any type of open studio approach and can be useful with any population with modifications.

One distinction of this prototype is that there is no age limit, so there are many clients who are older mixed with younger clients. As the general population ages, so do persons with developmental disabilities. Very few agencies are prepared to for this change in demographics in spite of the available statistics. An intergenerational approach benefits everyone, but the specific needs of elderly people need to be considered.

The art center has a large open studio where adults with disabilities paint, sculpt, make prints and engage in crafts. Additionally there is an art gallery for showing the work produced. The book explains the philosophy, the mechanics of setting up a center, includes adaptions for people with disabilities, a personnel manual, job descriptions and legal documents.

The model includes printmaking and stresses that a good press is worth buying. The brief descriptions of the printmaking techniques mention many of those presented here. Their selection of techniques supports my experience.

I was delighted to read about a young man with severe cerebral palsy who was painting while in his wheelchair. The staff took him out of the wheelchair so he could paint on the floor. Paint got all over but when a staff member went to get a mop the client signaled for a piece of paper first. He put the paper over the spilled paint to make a monotype. Before pulling the print he stopped and pulled his wheelchair over the paper back and forth (like a mystery monotype) and created a 'wondrous print' (Ludins-Katz and Katz 1990, p.152).

In a related article for *Activities, Adaption and Aging*, Katz (1993) briefly reviewed a case study of a man of 69 who came to one of the centers after being in a state institution most of his life. Beverley's greatest joy was making prints on the press. He worked effortlessly and without direction to produce effective prints and collages. His work was abstract and colorful with an 'unerring sense of design' (Katz 1993, p.14). His life expanded and was documented with the printmaking. He was acknowledged and active in the world.

Open studios

In 1995, an issue of the *Art Therapy: Journal of the American Art Therapy Association* was devoted to the value of studio spaces for artmaking as an adjunct or in response to frustration with short-term institutional treatment based art therapy. In her editorial, Malchoidi (1995, p.154) states that much attention has been given to the process and product of art therapy but 'crucial to what comprises therapy is how art therapists bring people together within a space'. Studios provide longer, unstructured time periods to make art. Most often each artist is self-directed although there may be time to discuss artworks and a relationship with the art therapist or artist running the studio. Boundaries are less clear, confidentiality and privacy may be compromised, funding is probably private or corporate sponsorship. Many different issues present to an art therapist in a studio setting, but often the studio approach provides a therapeutic, rich atmosphere for artmaking.

The Art Studio at MetroHealth Medical Center in Cleveland, OH, is a studio model serving medically ill and physically disabled people within a traditional setting. The program was founded in 1967 and is funded separately by a non-profit organization in coordination with hospital funds for staffing and space. Other staff salaries and expenses come from the Art Studio Board and are raised through contributions, fees and 'wearable art T-shirts, socks, and aprons created by "painting" with wheelchair tires' (McGraw 1995, p.167). At the time of this article the complex funding, coordination and support was very impressive.

The philosophy of the Art Studio's program is to provide a studio space for people to rediscover themselves through art. The focus is on the process, not the words, the 'non-verbal, image-producing qualities of artmaking as central to therapeutic gain' (p.174).

In Chicago, the Open Studio Project provides a space for people to discover their personal meanings in the creative process. Allen (1995) describes the project in an article, 'Coyote comes in from the cold: the evolution of the open studio concept,' that stresses the questions and differences of this approach from traditional clinical art therapy. Allen's conclusions about artmaking are that whether creating art for therapy or a gallery exhibition the essence is the same: 'self-expression, communication, feelings of wholeness, suspension of time, entry into a different realm or state of grace' (p.163). She further concludes that 'consciousness' is the difference art therapy can add. 'By adding intention, the clear desire to know something through art, and attention, the honest consideration of meaning in the image, we experience artmaking as creating or deepening consciousness' (p.163).

'The primary attribute to an open studio is energy,' says Allen (p.164). At the Open Studio Project the art therapists work alongside clients. They offer workshops, intensives, drop in times and involve people from all parts of the community. One of their workshops is Printmaking. She mentions that they offer instruction in simple collagraphs, but many of the techniques in this book would be appropriate because the intention is 'on simple and direct methods of producing multiple images using printing plate ... as a way to enlarge one's repertoire' (p.165).

In McNiff's (1995) article 'Keeping the studio,' he begins with the 'participation mystique' (pp.179–80) that describes the images and

energy that can be created in the art therapy studio or any artmaking experience. The reason that this aspect is important here is my belief that printmaking and especially the screen processes can involve many people in the creative process that might not be willing to paint or draw as individual artists. The difference between the wonderful community building experience of making a meal as a group and creating artwork as a group is the presence of the images. The images emerge and solidify the community. These articles remind me that focus on products and production never should take precedence over image making and expression. My experience has been that the images emerge and the energy of the group enlivens them and becomes a community expression. McNiff says 'the group-mind is more intelligent, creative, and resourceful than any one of us' (p.182), and that has been my experience especially with a studio filled with people making art.

In my hometown, Northampton, MA, Anchor House supplies mentally ill artists with a working studio and separate exhibit space in the center of town. There are many open studios and art centers providing studio and exhibit space, and printmaking is one of many art media available.

Preserving cultural heritage

The Art and Cultural Project of the Northern Cape of Africa was founded in the 1990s as a non-directed art workshop and community self-help project for San women (Kasfir 1999). It now has several subdivisions including a silk-screen fabric printing workshop and a painting and printmaking group. It is a well-run program that has tapped the extraordinary creativity of its participants. Some of the artists work in a style similar to the rock painting that is a traditional practice. The objects in the prints appear in an apparently random relationship to one another and seem to float in space (pp.60–61). The distinctive work from this project is shown in museums world wide.

The !Xu and Khwe Cultural project at Kuru in the Northern Cape is a different story. It serves men and women, families of ex-soldiers and trackers who were resettled at a South African army camp. In this resettlement camp, the artmaking is 'a kind of therapy to counteract alcoholism and hopelessness as well as a community development strategy' (Kasfir

1999, pp.62–63). In a descriptive example of artwork, artists Julieta Calimbwe and Zurietta Dala created 'Nests, Land mines and Plants' (1995). A graphic print by Thaula Bernardo Rumao called 'Tent Town' shows an attacker and victim in an X-ray style familiar to most art therapists.

Kasfir, the author of *Contemporary African Art*, brings up a major issue about cultural identity as a basis for these community-based workshops. The organizers, who are white, try to protect their artists from unscrupulous outsiders, but they also tend to construct an identity for their artists which brings them back to a tribal culture that many may not have experienced. This cultural identity gives the art 'a pedigree which spectators will recognize as authentic' (Kasfir 1999, p.47). This has been done all over South Africa for the tourism industry. The workshops, thus, produce not only art but also Bushman culture through the reproduction of cultural artifacts.

I have found that there is a wide divergence in the symbols that clients and students create in response to a suggestion of cultural identity. In some cases, identification with one's cultural background is powerful and helpful. In other situations, a client is working with issues of personal, individual identity and cultural issues are secondary. Kasfir's point about resurrecting a culture for displaced people reminds me to be clear about priorities. Is this project serving a therapeutic or commercial goal? What is your role and what is best for your client? Do not assume that making a living is secondary to understanding one's psychological issues.

Additionally, there is always a dichotomy between art which is not utilitarian and utilitarian crafts as well as a difference between art and commercial commodities. Whenever considering artwork in such a similar workshop situation, be sure to understand these distinctions and the role of art as therapy or art for production.

Putting it Together
Artists' Books, Sustaining a Vision

History of books

In spite of all of our technological advances, today's books are products of a long tradition. For five millennia 'the entity of a book has remained the same – a collection of surfaces to receive writing for the purpose of communicating ideas' (Avrin 1991, p.1). The history of the book parallels the history of printmaking in many ways and is influenced by the same factors. Civilizations of the past communicated their ideas on various surfaces based on their needs and the materials available.

Books were made up of a collection of surfaces and covered for protection. Paper was used as a surface by the second century BC in China and by the eighth century in the Near East. Paper was not available in Europe until the Middle Ages. Animal skins were cleaned, pounded flat and used as a writing surface in Egypt by 2500 BC, then later in Europe. Paper made from papyrus was perfected in the Mediterranean. Assyrians and Romans wrote on waxed tablets.

Most people have seen pictures of Egyptian hieroglyphics, Mayan symbols and picture writing from other ancient civilizations. We know that writing evolved from picture symbols. By the time books were bound, they were predominantly words, however illustrations are found in books as early as Mesopotamia civilization. The author's portrait was painted on the text for identification. In a reflection of this ancient

custom, modern authors are pictured on the back jacket cover of a book (Avrin 1991, p.6).

Historically, covers were made of common materials that were often quite heavy. The wax tablets of the Assyrians and Romans were hinged and fan folded and protected by wood or ivory frames. Egyptian and Hebrew scrolls were contained in ceramic jars or cylinders of wood or leather. Roman scrolls had fabric jackets. Medieval European parchments were laced to heavy wooden boards. As more and more books were made and civilizations produced more goods, lighter weight materials such as fabrics and leathers were used as covers.

The form for the most modern western books came from the Roman codex. Roman tablets were fastened together at the inner edges like most commercially produced books today. The term codex is still used to refer to pages folded and fastened together on the inner edge. In following another tradition established centuries ago, most books still are taller than they are wide because the pages originally used came from animal skins, and animals are usually oblong in shape (de Hamel 1992, pp.19–20).

The most popular existing book forms from the East are fan fold and accordion fold books. Scrolls are still a form used especially for religious books. The early Muslim Qur'an had a horizontal format imitating a scroll although it was composed of codices (Avrin 1991, p.267).

The most consistent form of a specific book that has survived is the Jewish Torah. The scroll and cover of the Torah is still produced with very specific directions for materials to be used and how it is to be reproduced. 'No book of any other culture has survived with the same physical form or textural stability for so long a time as has the Jewish Torah' (Avrin 1991, p.101). Avrin asserts that the stable manufacture of the Torah balanced the mobility of its followers. This and other meaningful traditions served to keep the Jewish people together when dispersed.

Historical reference to the Torah and the long tradition of creating books for communicating ideas suggests that making books is an expressive media as well as an appropriate holding technique for art therapy. See 'Making books in therapy' for more explanation.

Artists' books

In reviewing printmaking history, it is interesting to note that early printmaking processes were introduced as mechanical means for reproducing information and served practical purposes. Those same processes are now used for expressive purposes and designated as fine art processes while newer mechanical methods take on the jobs of communication and reproduction. An etching was originally regarded as a reproduction, now etching is called fine art and a computer generated Giclee print is called a reproduction.

Artists' books are now a popular fine art form for the same reasons (Drucher 1995, p.328). The 'artist's book is the quintessential 20th-century artform' states Drucher in *The Century of Artists' Books* (1995, p.1). The phenomenon of artists' books began in the 1940s and did not exist in this form before. Some artists' books are printed in the same way as most commercially produced books but are produced in limited numbers. Some artists' books are made entirely by the hand of the artist, and these are the focus of reference here.

Drucher, herself a book artist, maintains that artists' books will continue to be dominant in the twenty-first century. At a time when whispers of the end of books and print culture abound on the Internet, more books and certainly more artists' books are being produced than ever before. 'The culture of the book is our future, our continued work on a legacy across time and space, a continuation of an ongoing tradition' (Drucher 1995, p.364). The potential of the book form for creative exploration is without limits, and its use as a form for sustaining a vision is very powerful.

What is a book?

Although the history of the book has seen changes in materials and form, most readers will still associate the word 'book' with a rectangular object, a lot of written pages, bound with a cover and related to reading. To most literate people the direct link is to learning and information. You did not think about the concept of 'book' when you picked up this object to read, did you? To me books are a delight and often one of my favorite pleasures. My home and office are filled with books; I love looking at

them, reading them and owning them. To many people, however, the word 'book' holds a different meaning.

First of all, books, reading and traditional learning tools are often frightening, disheartening or disastrous for some clients. Anything associated with school recalls failure and humiliation to many. Mentioning 'making a book' might seem an impossible, loathsome chore. Anything to do with reading or writing may bring up discomfort and questioning of self-worth. This aversion is common not only for people with learning disabilities and illiterate people but also for countless others. Many clients are uncomfortable with written words because of their mystery, inaccessibility or just because they are so permanent and powerful. In many cultures books are reserved for religious or exclusive use of the learned. Some cultures think books are only 'for girls,' others only 'for scholars.' The relief of being able to express oneself with art in previous art therapy sessions may seem threatened by the introduction of the idea of making a book. Be aware of this and discuss the idea of making a book with your client to dispel these fears.

Titling this chapter presented problems. 'Making books'? 'Book making'? 'How to make a book from prints'? What seemed obvious became more complex as I thought about the subtleties and effects of words upon readers and clients. Being 'booked' is recording charges on a police record just as making 'prints' may translate into being finger-printed.

Working with clients in a prison setting should sensitize a therapist to terms related to forensic vocabulary, but most people would think of the term 'book' in multiple ways. Do we use the slang 'throw the book at him' to place as many charges as possible against someone? Is the term 'bookie' still used for placing a bet on the horses, football game or cock fight? 'Booked' implies recording, keeping accounts, and usually in a negative way even if it is not involving the legal system or underground culture.

In a less dramatic way, a book is a number of tricks used in scoring bridge. The libretto of an opera is called a book. We use books of matches. Even bookkeeping has connotations that may affect how a client responds when 'making a book' is suggested. Do we sometimes do things 'by the book'? Do we know a loved one 'like a book'? Now that is

'one for the books'! These colloquial and slang terms bring to awareness the power of a word and its multiple meanings. We must discuss the concept of making a book and the ideas a client may have of what a book is or could be.

Even when we get past the slang and inferences of the word 'book,' a book like a dictionary or novel comes to mind. The idea of writing a book is overwhelming to most. The idea of creating an artist's book primarily of images is a relatively new concept and usually reserved for contemporary artists. What kind of book could a client make? What about words? How would the client put pages together? What could the cover be made from? Does it need a cover? Will it take forever? If your idea of making a book is limited, that limitation will restrict the client.

I teach printmaking for art therapists in graduate schools. My students' final project is to use prints created or techniques learned during the semester to create 'a book.' I give no directions, guidance or restrictions but say, 'Anything you want to call a book is a book.' The stretch and initial frustration of this freedom gives graduate students a challenge not unlike that of your clients. Students have produced more amazing, meaningful and unique books than I ever imagined were possible. I am indebted to them for many of the suggestions included in this book.

An open-ended approach may not be enough support for your clients however. You might have one or two of the many book forms in this chapter in mind when you suggest this project for a client so that you will have necessary supplies on hand. Be open to allowing your clients to create what they need to 'put it together.'

It is also important that you are clear about your intentions when suggesting to clients that they put images together in some form. As tempting as it may be to want a client to produce an item of beauty or to organize his or her work into some form, keep in mind the therapeutic reasons for doing such an activity.

The popular interest in artists' books and the quality of the books created by art therapy graduate students tempted me to name this chapter artists' books. I usually refer to my clients as artists. I truly believe that they are, all of them. I work frequently with people with very limited cognitive and physical ability, and they are artists. Unfortunately, supporting your clients' sense of self-worth and innate understanding of

themselves as artists is often a slow process. I do not want this process of creating a book from images to be restrictive or limited in any way, so I chose the title 'Putting it together' because it has the greatest general sense and implies creating an order or structure.

Putting it together is very simply the reason I feel book arts should be in your therapeutic repertoire. The process of folding, sorting, ordering, sequencing and selecting to produce a book is a perfect metaphor for the therapeutic process. A client puts it together artistically, constantly making decisions and getting images to fit so that there is some reason for the compilation. Images relate, the client writes over a shape, chooses a cover of a certain color, a particular material, embellishes with ribbons, ties the whole thing up with a whole yard of twine. The client ties up loose ends, makes associations, relates seemingly unrelated projects from different sessions and creates a different whole from parts. Any book is greater than the sum of its individual parts, just as an individual is not just his or her presenting problems. Drucher (1995) reminds us that when we look at artists' books there is an 'obvious but profound realization that the book should be thought of as a whole' (p.122) just as we regard each client.

The client's work in the process of creating a book is vital, and the client's insight or vision of him- or herself after sustaining such a vision can be enormously healing. A painting, print or drawing can be a vision. An artist's book becomes a sustained vision. In working on a book, the vision is clarified and organized. Most books have a beginning, middle and end. Even the books with no beginning, middle and end have a form that becomes a therapeutic structure or container (Figure 10.1). Review the forms presented in the section 'Book forms' for suggestions.

Making books in therapy

Often linked with independent presses and social activism, artists' books 'express aspects of mainstream art which were not able to find expression in the form of wall pieces, performances, or sculpture' (Drucher 1995, p.9). Drucher borrows the term 'intermedia' that Dick Higgins invented to describe the blend of expressive arts in artists' books, and I think it is a useful term in considering client made books in art therapy.

Figure 10.1 'Humming with Purple Love' triangle fold artist's book from monotype by LMW

The difference between the craft of making a book and making an artist's book is similar to the difference between any craft making and the creation of artwork for therapy. It is a distinction that is particularly applicable to this presentation of printmaking for therapeutic purposes. The rigid demands of cutting precisely, gluing cleanly, lining up pages, organizing in a specific pattern to make a book are not necessary or helpful when introducing the book or printmaking for our clients.

It is the potential for expression and structure that is important, and that is what is different about artists' books. The artist's book is different; it has to have 'some conviction, some soul, some reason to be/ and to be a book in order to succeed' (Drucher 1995, pp.10–11). It is not the craft of bookmaking that is the focus, but the craft is a loose structure to promote the expression. Drucher's definition is enough and a clear way to decide if creating an artist's book will succeed for your clients.

Twentieth-century artists' books fall into two categories. Some artists' books are mechanically produced by independent publishers and available in editions or unlimited production. As varied and fascinating as these books are, they are not the model for use in therapy except as they

reflect social commentary. They should be considered when using art history in a therapeutic situation. Photos of artists' books can be shown or examples found at local art exhibits.

Some artists' books are created by artists by hand and are available in small editions or most often as unique artworks. For purposes of this book, the unique artists' books hold powerful properties. Such books are often described as auratic objects having 'power, attraction, uniqueness' (Drucher 1995, p.93). Some such books are like private archives, and the viewer becomes a voyeur into the artist's life. The book is 'a glimpse of the expression of another's person's experience suddenly revealed, communicated, across the space of time' and sometimes is the only proof of existence (Drucher 1995, p.358). Does that sound like art therapy?

Drucher states that books make art tactile and spatial in a way that no other art form does. Creating sculpture certainly has both those qualities but once the sculpture is completed it is usually not handled the way a book is. With an artist's book, the form of a book is integral to its message. Following in this chapter are many choices of forms for books to suit various messages of your clients.

The artist's book uses form, function, sequence and stability to provide access to its contents. The codex form Drucher equates with bringing order to chaos (p.123), but working with the codex form is too complex and frustrating for inclusion here. Instructions for many simpler books forms are included.

A book is a spatial experience. 'Enclosure and intimacy are two familiar features of this spatial embrace' (Drucher 1995, p.360) and make up the attraction of the book form for therapeutic use.

Starting with the form

Suggesting to a client that he or she create a book may be a way to provide an immediate container or holding place for his or her artwork that is comforting and organizing. Starting with the safety of a place to put 'things' is the concept of making boxes or other symbolic containers in therapy. Waller (1993) refers to the containment of the art object as it holds strong and unacceptable emotions for the individual or group (pp.16–18). She borrows terms like 'net' and 'frame' from other art therapists, so I extrapolated that a book also makes a suitable container.

The obvious association with making a book and then putting in images or writing is to writing in a journal. Journal writing has its own therapeutic value. Making an artist's book is journal writing with images if the book is used to add onto in an ongoing way. I have used this approach with clients in inpatient psychiatric settings for them to record their feelings on a daily basis. One severely depressed patient was able to draw only one faint line the first day, a stronger line the second, a wavy line the third day and so on. This is a valid option but does not lend itself to using printmaking particularly.

If making a book is a project with a beginning and end, it serves the client by being a container where he or she can sustain a vision or at least put a collection of images together. Creating a book form, even a simple one, may be a way to engage a client and provide the safety of a structure to begin artmaking. If making a book form does not seem to be a useful project, just start with a loose leaf binder and add pages or use a purchased notebook with blank paper. Whether the client makes the book form or you provide it, the book may be a useful way to start artmaking (see Figure 10.2).

If using printmaking methods, stamping is the most useful technique for printing in a book because it is the simplest. Most other methods need to be done on a sheet of paper that can be manipulated to pull the print, and the structure of most books would make that difficult. Use artmaking methods such as drawing or painting if you are going to start with making the book and then plan to add the artwork. Or create prints on separate papers and glue them into the book. See 'Technical skills' for help.

One example in my experience of a very satisfying book project was done by a nursing student struggling with her studies and goals. She made a very simple foldover book with pages stitched together through two holes. Then she made a simple stamp to resemble the symbol of the American Red Cross. She stamped the red cross on each of the pages and then drew in stick figures to remind herself of her role models, Clara Barton, the founder of the American Nursing Organization, an aunt who had been a nurse and on the last, fourth page a photo of herself working in the rural countryside as a visiting nurse. The book was a container for

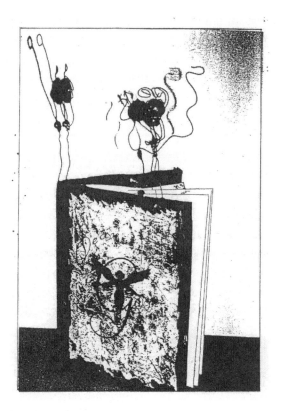

Figure 10.2 Artist's book by SM

hopes and dreams, and the simple stamp was the image that sustained her vision.

Putting it together: starting with client artwork

In my experience, creating a book from existing client artwork is more powerful and produces greater insight than starting with creating the book form first. Making a book from existing artwork is a potent project. It organizes, orders and contains products from past therapy sessions. A book is a concrete product that literally and conceptually has more weight than a pile of paintings or prints. It feels more serious, complete. Putting it together physically helps put it together emotionally.

The process of deciding which artwork to include in a book is an opportunity to review images, to sort out less important ones and to

revisit images that initially seemed to be 'a mess' or not understandable. Many clients' prints have unintentional paint smudges that with a second look become part of a greater image. Areas that did not print because of a technical 'mistake' reveal resistances that a client may not have been able to acknowledge when the print was first created. Opportunities to recreate images, to redefine, to embellish are numerous with the many prints and artworks collected. Often prints that are 'total disasters' become backgrounds for additional drawings or words when part of a book. See Chapter 7 for additional comments about embellishing and reworking prints.

For a very creative book, one student cut up stencils, drypoints and relief prints and glued them to sticks to build a book that could stand on its own and be positioned in different configurations (see Figure 10.3).

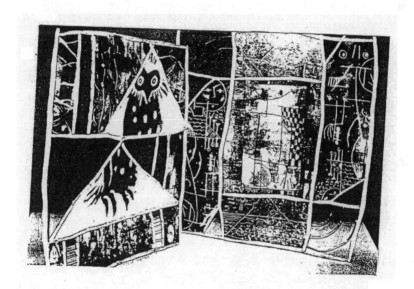

Figure 10.3 'Artist's book' by SD, stencils, drypoints, relief prints and sticks

When making a book from existing artwork, you will be working with different size and weight papers and wrinkled or ripply images. Review the section 'Technical skills' for aid in gluing, flattening and other aspects of crafting a book that will benefit its successful completion.

Art history illustrates the concept of sustained vision when we look at the many versions of the haystacks that Monet painted, in the morning, in

the rain, at noon, etc., Andy Warhol's silk screens of Marilyn Monroe and many other examples. Artists frequently dwell on repeated images. Some of our clients do this also. Sometimes this repetition of an image is obvious but often it is not. Reviewing artwork sometimes reveals a common theme, a sustained vision. Even if a sustained image does not appear to be there when clients make a book, he or she can arrange images and rework them to sustain a vision or pattern if he or she chooses.

Making a book from any artwork is a meaningful process, but I have included it here because the printing process produces multiples and often lots of them. 'Why produce so many multiples?' is a reasonable question especially when applied to printing as art therapy. Making books from multiples uses up some of the prints and allows the client to work with the same image for different purposes. Rarely do prints reproduce exactly alike, so there is opportunity to notice differences. See Figure 6.3 to see the difference wiping the paint can make. Subtle differences in applying paint make an image 'Healthy,' 'Evil,' 'Confused' or 'Fantasy.'

Most often I have used bookmaking as a termination project, but it could be useful in any stage of therapy. Putting images together requires a certain amount of material, but a book can include three images or three hundred. A book is a powerful way to sum up the therapeutic process and becomes an opportunity for insight and assessment.

Books do not have to be individual projects. Books can help increase group cohesion the same way images on a mural, banner or any other group project can. When clients have several prints they are more willing to let one be included in a group book because they still can retain one for themselves. When making a group book, it might be advisable to have assembled the book form ahead of time so that clients need only paste their images into the book. Even a loose-leaf binder with individual pages can become a simple group book that can grow and be changed. When working with printmaking, the idea of creating group books becomes very possible and a powerful termination project. Even when a client has left the group if his or her plate remains and the client has given permission, prints could be pulled from the plate to be included in the book.

Technical skills

A few technical skills help create an artist's book that holds together so that it can be appreciated. Too much attention on the technical aspects of creating a book becomes mechanical and takes away from creative energy making the process tedious and less spontaneous. The balance between creating a form for free expression and making a frustrating mess is a delicate one. The reason for making the book is paramount. Here are a few tips for helping the book go together and stay together successfully.

Gluing

White water-based glues such as Elmer's and Sobo are easily thinned with water and wash off when wet. They dry to a hard plastic that can be peeled off or scraped off if necessary. They are suitable to glue porous surfaces. Directly out of the container, they are often too thick to be spread evenly and create a lumpy, bumpy surface. Thin with one-third to one-half water and store in a closed container. Spread the water/glue mixture with a sturdy brush, and it flows easily. I use a recycled deli or cottage cheese container, poke a hole in the top cover and store my gluing brush protruding from the hole in the top of the container. The watered-down glue does not dry too fast, and the glue and brush are always together. Check it frequently; if the water evaporates making the glue too thick, simply add more water.

Place item to be glued on a piece of scrap paper. Spread glue from the center to the edges of the paper. Paper stretches along its grain and curls. Position the glued item where desired. Cover with another piece of scrap paper. Use your fingers or a dry sponge to smooth the glue from the center outward. Wipe up excess glue that oozes from between the two surfaces with a damp sponge.

Hinges

You may need to hinge artworks together to make longer pages or to make a fold book. Simply overlap the pages and glue. It is easiest to fold the pages first then glue the hinge. If there is not enough paper to fold, cut a strip of paper about an inch wide and as long as the paper and glue to

the backs of the two pieces. You can use tape on one or both sides if the look is acceptable.

Hinges are also a useful way to add prints to an already made book. Simply hinge the artwork to the book page from the top allowing the bottom to hang freely.

Flattening

Taking the time to flatten and dry covers and books is usually worth it and helps considerably to make a book that is sturdy. Some clients may not be able to wait, so use a minimum of wet glue. The problem with gluing in general is that the glue oozes out from between two surfaces when it is pressed. Wax paper placed on top of all glued surfaces before they are weighted down prevents the pages from sticking together. The wax paper can be reused many times. Press the artist's book between telephone books or any other heavy weight.

Folding

Getting too technical and demanding accuracy is usually not beneficial in a therapeutic context but all folding is a lot easier if the fold is pressed smooth. Use fingers, the back of a spoon or a bone folder if you have one to smooth the fold. If folding a thick board, hold a straight edge where you want to make a fold. Press firmly and draw a line along the edge. The fold will then crease easily and in a straight line.

Covers

Covers can be made from many materials. Firm covers are sometimes helpful to hold the form of a book. Use cardboard, corrugated, foam core, thin Masonite or plywood if you can cut it. For pliable covers, try construction paper (it fades), card stock or wallpaper. If you want a decorative paper to glue over a stiff cover, try wrapping paper, rice paper, cloth, contact paper, client prints or artwork on paper or fabric. For instructions see 'Traditional sewn pages book and cover' and be sure to allow enough time for the cover to dry.

Book forms

Storyboard

A storyboard is related to a book and may be understood as a preliminary book. A storyboard is a flat book with no pages. Storyboards link images to words and are used in filmmaking and video. Technically storyboards are sequences of pictures that tell a story or relate to a problem or product. They break down a message into cells or separate images and link text to pictures. In contemporary art galleries any image embellished with words falls into the category of Word and Image, but a storyboard implies sequencing. A storyboard is similar to a game board that tells a story.

A storyboard can be made from any single artwork by adding words to the images in sequential fashion. Several different artworks can be glued to a backing board or large sheet of paper, and words can be written in over the images or on separate pieces of paper and glued on top. The words do not need to be written. Let the images help the client to tell the story.

When a client has several prints taken from the same plate, the opportunity for story telling to explain the subtleties of the prints suggests a book or storyboard. The imprint of a printing plate even looks like a film cell or a cartoon block. The advantage of a storyboard is that all of the artwork can be seen at one time, there is no concealment or turning of pages.

Supplies: existing artwork, a backing board or large paper, glue, scissors, markers or colored pencils

1. Assemble artwork and arrange in sequence.

2. Glue artwork to backing board.

3. Add words if desired.

Scrolls

A scroll was originally a roll of parchment with writing on it. See 'History of books' for descriptions of some of the materials and covers traditionally associated with scrolls. Loosely rolled paper can be rolled all in one direction or rolled from each end to form two tubes. The paper needs to

be long enough to roll. Paper that is sold in rolls to be used for lining shelves makes a good scroll. Cutting long narrow strips from large pieces of paper give the feeling of a scroll.

It is easiest to print, draw, write or paint on the scroll before rolling it. Do not use tempera paint that will flake off when rolled. Cutting a large, abstract monotype into narrow panels, adding words and then rolling it creates a dramatic scroll. If you are starting with the scroll form then creating the contents, consider creating a scroll book with stamp printing because it will be easiest to handle. Gluing prints onto the strip will probably not work very well because of the rolling stress.

The closure is important to the look of the scroll. Use ribbons, elastic band or string to tie it. Tape it shut if the contents need to be sealed for privacy or to symbolically seal up a secret. Place the scroll in a cardboard tube, make a sleeve from paper or fabric, or roll the scroll in a cover paper and tuck the ends into the tube.

Supplies: blank paper if you are creating the artwork for the book or existing artwork, scissors, markers or colored pencils

Optional: ties, two sticks, long thin boards, wires or pipe cleaners, cover materials

Simplest scroll

1. The easiest scroll is made from a long strip of paper or artwork.

2. Create the artwork and story before rolling.

3. Roll from one side revealing the words and images from one side to the end, or roll from both sides revealing the middle first.

4. Tie with ribbons or string if desired.

5. Make a cover or container to store the scroll if wanted.

Traditional scroll

1. Cut a long, narrow piece of paper or a long strip from existing artwork.

2. Create the artwork and story or work with existing artwork.

3. Glue a stick or long narrow piece of cardboard to the two outside edges of the paper allowing it to protrude from top and bottom. Let it dry. Roll the paper from one or both ends. For a small scroll, use pipe cleaners with the protruding ends curled instead of sticks.

4. Roll from one side revealing the words and images from one side to the end, or roll from both sides revealing the middle first.

5. Tie with ribbons or string.

6. Make a cover or container to store the scroll if desired.

Box book

A box book is unbound. It is a box containing pages. The pages can be all the same size or in many sizes and shapes. There can be a formal order or be placed at random. This is a variation of the common self box familiar to most art therapists (Waller 1993, pp.59–62) and an inside/outside box. Often used at the beginning of a therapeutic group for clients to understand how they perceive themselves and how others see them from the outside, the self box or box book becomes a useful container for a series of prints.

Choose a box large enough to hold the prints but one that is flat and shallow, a box that will hold a print collection but not appear empty if it only contains a small stack of prints. Since all artwork reflects something of the artist who created it, even a seemingly unrelated group of prints can become a box book.

Supplies: a box, paper or artwork, scissors

Optional: cover paper or paints and stamps to print box, ribbons to tie box

1. Cover or decorate box outside and inside to reflect the intention of the interior contents.

2. Cut pages to go into the box then create the artwork and story or cut existing artwork to fit into the box.

3. Close with ribbons or other ties.

Mobile string book

Supplies: string or yarn, artwork or paper, glue, scissors, hole punch

1. Assemble artwork to be used. Glue pages together so each piece has artwork on both sides. Cut into uniform shape if desired. Arrange in order, front to back, all tops lined up.

2. Punch a hole in the top of each artwork at least 1" away from the edge.

3. Cut a piece of yarn or string long enough to stretch out as long as you want the book to reach plus extra for tying pages.

4. Leave 6" and tie the first page to the string. Go through the hole and tie a small knot above it so the string will not rip the hole and the page will stay put. Go to the next page and tie it on until all pages are attached to the string. Leave space between the pages so the individual pages can be seen when the book is hung up; the pages are like clothes on a clothesline. Leave enough string at the end so the mobile string book can be hung from the beginning and the end string when it is not assembled in a pile as a loose book.

Fan book

Variations of this concept are as numerous as there are shapes and imaginative ways to hold them together. Instead of being on a string, the pages are held together in one place but fan out as desired.

Supplies: paper or existing artwork, scissors, fastener, hole punch or awl

Optional: markers, paints, colored pencils

1. Cut rectangles, squares, circles, ovals, any shape pieces of paper. It will handle more readily if the shapes are consistent. Use clean, blank paper if starting from the form or cut existing artwork into uniform shapes.

2. Stack pages into a pile. Punch a hole in the same place on each page. Use hole punch, awl or needle.

3. Attach all together with a split ring for keys, paper clip, loop of yarn or clasp. Make sure pages can fan out and be seen one or two at a time.

4. For greater stability cut a cardboard cover for top and bottom slightly larger than the inside pages. If pages are not the same size, that is fine, but they will probably be more likely to hold together if a supportive cover is used to support the book.

Simple book

Supplies: paper or existing artwork, scissors, string, hole punch or awl

1. Assemble blank paper or cut existing artwork into uniform sized sheets.

2. Stack pages into a pile. Punch at least two holes in the same place on each page. Use hole punch, awl or needle.

3. Poke string through the top hole, through all sheets, to the back of the pile of pages. Poke the same string into the second hole from the back and pull to the front to tie.

4. For greater stability cut a cardboard cover for top and bottom slightly larger than the inside pages. If pages are not the same size, that is fine, but they will probably be more likely to hold together if a supportive cover is used to support the book. See Figure 4.2, 'Friends + Photos,' an artist's book that used a simple book format with stamping and photos that was held together by yarn tied up through two holes punched with a hole punch.

One sheet foldover

One sheet of regular typing or computer paper can quickly make an eight-sided book or a book with a cover and two pages with four sides.

Supplies: piece of paper or existing artwork

Optional: scissors, large needle and thread or yarn, hole punch, stapler, string, cover paper

1. Fold a piece of paper in half then again in quarters.

2. Hold the folded paper like a book and cut the folded edges to the center crease.

3. Use it as a loose book as it is. If you want the pages secured, staple or sew the four pages together along the spine, punch holes with a hole punch and thread through yarn or use a string to loosely tie the pages together.

4. For more pages, use additional sheets and stack together.

5. Try different sized papers to create long, narrow books, or tall thin books. Put the pages into a cover made from a stronger paper folded over and cut just slightly larger to form a cover.

Accordion, concertina, fold books

The concertina or accordion fold book is very interesting and adaptable for therapeutic use. It is also artistically compelling and challenging if you want the pages to be perfectly aligned and even. Folding and measuring perfectly is not easy or necessary. The form can be used successfully even though the pages are uneven. Uneven pages are easily embraced by a cover that is larger than the pages. If the paper you use is stiff enough, there is no need for a cover. The book will even stand up on its own if the paper is stiff.

The concept of this type of book is a series of folded pages all hinged together or folded from one long strip of paper. At each end a cover may be attached to the first and last page. A cover is up to an inch larger than the inner pages and of firmer material that can protect the inside pages

and provide safe, attractive protection for the inner contents. The cover can be decorated in any way and may have string ties or be plain.

Supplies: paper or existing artwork, pencil, cover stock, glue and brush, water

Optional: ruler

1. Cut a long strip of paper.

2. Determine the size of a page. Carefully measure for the size of each page and mark each on the top and bottom edge of the paper. Fold accordion style according to the marks. Try to match the pages evenly. If you end up with part of one page, cut it off.

OR

2. The other method is to fold in half repeatedly. Start with the full length of paper, and fold it in half. Now fold each half in half, folding the edges back to the center. Then fold each section in half again. The original fold is at the center and folded in the wrong direction, so it must be folded inward. As you fold, watch to see that the edges match.

3. Cut cover slightly larger than the pages. Cover with decorative paper if desired (see 'Cardboard decorative cover' under 'Traditional sewn pages book and cover').

4. Glue the first and the last of the folded pages to the inside front and back covers. See Figure 10.4, 'Experiencing Art and the Inner Self through Printmaking,' an artist's book that used an accordion format for a collection of drypoint and monotype prints.

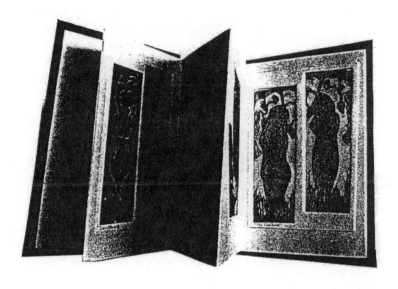

*Figure 10.4 'Experiencing Art and the Inner Self through Printmaking' by LSP,
an accordion fold Artist's Book with drypoint and monotype prints*

Flutter book

A flutter book is made exactly the same way as an accordion or concertina book except that the folded pages are glued to a cover that is hinged (see 'Cardboard decorative cover' under 'Traditional sewn pages book and cover'). The difference becomes obvious when the book is opened. The cover stays together, but the pages flutter out.

Triangle fold book

Supplies: paper or existing artwork, scissors, glue and brush, cover stock

Optional: cover paper

1. Cut a piece of paper or artwork eight times as long as it is wide.

2. Hold the long narrow strip of paper in front of you horizontally and keep it this way folding from right to left. Fold the top end down to make a diagonal fold. Match up edges carefully.

3. Fold the diagonal section to the back making a vertical fold.

4. Fold another diagonal from the bottom corner matching the top edges.

5. Fold diagonal section to the back making a vertical fold.

6. Continue to the end trying to keep edges even. The diagonal folds alternate with vertical folds to the back. You can not go wrong folding any way you can as long as you end up with paper in a triangular shape.

7. Cut stiff boards for a cover; make the cover slightly larger than your folded pages. If cover paper is desired, cut half an inch larger all around. Follow directions in # 8 to adhere. If a plain board cover is adequate skip to # 9.

8. Cover the triangular shaped boards with the pieces of cover paper using glue mixed with half water and smoothing out all bubbles and wrinkles. Fold over the corners by cutting off excess first on one side then another. Rice paper is wonderfully flexible.

9. Paste ribbons long enough to tie up the book on the inside of each cover. Let dry.

10. Paste the first page inside the front cover and the last page inside the back cover.

11. Cover glued areas with wax paper and press until dry.

See Figure 10.1, 'Humming with Purple Love,' a triangle fold artist's book made from a monotype with a stiff cover and ribbon ties.

Single sheet fold books (mazes or origami books)

These books are fun and fascinating when made from existing artwork. The folding and mystery involved is compelling to many clients, particularly children and adolescents. The books all work because of the concept of folding then cutting part of the folds to transform a single sheet of paper into a book. The cuts cause the pages to develop unusual forma-

tions that are similar to mazes in their complexity. There are places for stories, for images and hidden treasures. Even if you do not follow the directions accurately, the book will unfold and offer surprises and delights.

My favorite artists' books have been made from prints folded and cut into maze forms. Even realistic images take on new meaning when folded and revealed in this format. When creating your own folds on a completed artwork, start in the center and work out. Begin with the simplest folds and work up to the more complex. Start small and work up to a larger sheet.

Single cut maze or origami book

Supplies: paper or existing artwork, scissors

Optional: cover stock, glue and brush, cover paper, ribbons or string

1. Fold a sheet of paper or completed print in half lengthwise, in quarters crosswise; then open it again.

2. Cut down the lengthwise center with scissors to the beginning of the last quarter fold (see Figure 10.5a).

3. To make a book, pinch the two centers on either side of the cut. Pull apart, then out.

4. Fold pages accordion style to form a book. This gives you two tent-like folds that can be used to help the book 'stand up.' The folded pages can be slit to make the book fan out and up or can be glued together to make stiff pages.

T-shaped cut maze or origami book

1. Fold a sheet of paper or completed print in half lengthwise, in quarters crosswise; then open it again.

2. Cut a T starting at the center of one side (see Figure 10.5b).

3. Fold starting at the top of the T cut and into an accordion. This gives you two tent-like folds that can be used to help the book 'stand up.' The outside folded pages can be slit to make

the book fan out and up or can be glued together to make stiff pages. Do not slit the fold in the middle or you will have two separate books.

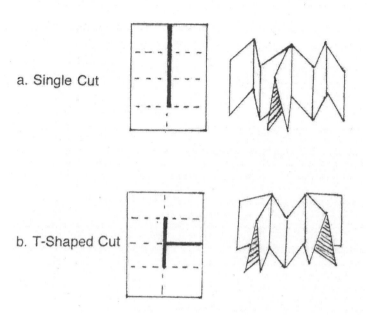

a. Single Cut

b. T-Shaped Cut

Figure 10.5 Single sheet fold books, a. Single cut and b. T-cut

VARIATIONS OF A T-CUT MAZE OR ORIGAMI BOOK

1. Fold the paper in thirds lengthwise and sixths across.

2. Cut the T in two spaces, across two spaces, down one and back making two back-to-back 'J's.

3. Fold beginning at the ends. Some pages will have a fold at the top; some will have a fold at the bottom of the pages.

MULTIPLE CUT MAZE OR ORIGAMI BOOK

1. Fold the paper in thirds lengthwise and quarters crosswise.

2. Cut two straight lines up to the last fold from opposite ends.

3. Pinch the paper at the ends of both cuts and start folding accordion style. It is correct for one of the folds to have a fold on the bottom.

4. A variation can be made by folding the paper in quarters both lengthwise and crosswise and making three cuts.

Note: following directions for folding these maze or origami books is confusing. Just experiment making the initial folds and one cut and then fold it up any way you want to.

Traditional sewn pages book and cover

This is the most complicated but most traditional book. Pages are folded, then sewn together, then glued or sewn to a cover. Fold over as many pages as you need. Keep it simple or make it thicker. Weigh the advantages of creating this book against the advantage of buying a simple notebook and concentrating on the contents.

Supplies: paper, awl or large sharp needle with quilting thread or dental floss, cardboard for cover, decorative paper or fabric for cover, Elmer's or Sobo glue and brush, water, wax paper

SEWN PAGES

1. Fold four or more sheets of paper in half. Cut cover now if you want to sew it with the pages. Cut cover a quarter of an inch larger than the pages. If you want to make a cardboard decorative cover see below.

2. Poke five holes evenly into the fold of the paper (and cover) with awl.

3. Thread needle and sew starting at the outside top hole leaving the end loose. Sew into hole #1, back through #2, into #3, back through #4, into #5, back to #4, into #3, back to #2 then tie off with the original end of the thread.

CARDBOARD DECORATIVE COVER

1. Cut two pieces of cardboard half an inch larger than the folded page for front and back covers.

2. Place two cardboards side by side but half an inch apart in the middle. Cut decorative paper an inch larger all around. (Clients could make this decorative paper in previous session or have them print a cover or paint it after this part is finished.) Trace around the cardboard and cut off extra paper on the four corners.

3. Glue cardboard to paper using half glue to half water mixture, leaving half an inch channel between the two covers. Fold over extra border and glue to cardboard. Use a bone folder or your fingers to press out bubbles from the inside edge outward before the glue dries. Cover the decorative paper with another scrap piece of paper while pressing to keep it clean.

ATTACHING COVER TO PAGES

1. When the pages are sewn and the cover made and dry, spread open the cover and put glue in the channel between the two covers. Use a brush to put white glue thinned with half water on the inside cover.

2. Open up the sewn pages and glue the first page to the inside of the cover, line up the sewn edge and the channel between the covers.

3. Using a scrap piece of paper over the surfaces, press and smooth the first page to the cover and press the pages into the channel.

4. Glue the back inner cover to the last page of the sewn pages. Before you smooth it securely, close the book to be sure you have left enough space to allow the book to close.

5. When all the gluing is smooth and excess glue carefully wiped up, place wax paper between the inside covers and the pages and weigh down the book to dry overnight.

Portfolios

A variation of the sewn book as described above is the portfolio. Following the directions above for making a covered decorative cover and simply use that cover to fold over a collection of prints. Vary the distance between the covers to accommodate a size of the stack of prints to be included.

EASIEST PORTFOLIO

1. Simply fold over a piece of stiff paper. Use construction paper, card stock, a piece of wallpaper or print a separate piece of paper for the cover. The portfolio should be larger than the prints it contains.

2. Slide prints into the fold.

SIMPLE PORTFOLIO

Supplies: cover stock, tape, scissors

Optional: cover paper, string or ribbon

1. Cut two pieces of cardboard large enough to cover all prints.

2. Use duct tape or masking tape to make a spine. Cut the first piece of tape longer than the covers. Place covers on top of the tape evenly spaced but leaving a channel where the tape is exposed. Fold over the tape on the top and on the bottom. Cut the second piece of tape the size of the covers and stick on top making a flexible hinge. If a stiff back is desired, a cardboard strip can be placed down the center of the hinge, leaving a space of an eighth to a quarter of an inch on either side depending upon the size.

3. Poke holes through the edges of the portfolio with an awl or hole punch if you want to attach strings or ribbons for ties.

When to Use Printmaking for Art Therapy

The American Abstract Expressionists

From April to June of 2001, the Worcester Art Museum presented an exhibit, The Stamp of Impulse: Abstract Expressionist Prints. This remarkable collection of prints by Clifford Still, Louise Nevelson, Robert Goodnough, Alfred Leslie, Franz Kline, Grace Hartigan, John Grillo, Hans Hoffman, Mark Rothko, Adolph Gottlieb, Robert Motherwell, Helen Frankenthaler and 88 others is stunningly expressive. The exhibit is traveling to other museums in the United States until 2003.

The prints were reproduced in a full color catalog (Acton 2001). Acton's accompanying text describes the evolution of the movement that began before World War II in New York. The painters who identified this uniquely American style were working in 'an immediate, unpremeditated manner, seeking to tap the universal creativity of the subconscious mind' (Action 2001, p.9). Although the movement began with painters, printmaking became an accepted and respected part of this unique focus.

After the war, printmaking flourished in universities where experimentation rather than rigid adherence to established techniques was the norm. The center of printmaking in the 1950s was in California's universities. In contrast to the movements' founders, postwar painters and printmakers enjoyed the freedom of self-discovery as well as the economic prosperity.

Throughout the evolution of Abstract Expressionism, the camarade-
rie and support of artists for one another was evident. They socialized,
collaborated and spent hours discussing theory and opinions. The arts
were their life, and that life included poetry and music. A project called 21
Etchings and Poems was inspired by the work of William Blake and
started the Word and Image collaboration that was so popular in the
1990s.

Artists' books flourished at this time. Artists and poets worked
together in lithography studios. Many printing studios sought out
painters and supported their exploration of print media. Innovation
thrived. The artists found that printmaking can be immediate, 'can be
quite direct, and that a drypoint plate or lithography stone can record a
momentary creative impulse. The artists discovered too that printmaking
has its own language and look, its own creative pace and rhythm' (Acton
2001, p.17). Even the reality of having to create images in reverse
produced new understanding of the creative process. The challenge of
unfamiliar materials counterbalanced resistance to traditional methods.
Their newness to the process produced accidents (I call them 'gifts') that
expanded and led to new images.

The impact of this exhibition, which opened at the end of writing this
book, was profound to me. Even the title underscores the power of
printmaking to contain and support creative artmaking in a therapeutic
context. The free, spontaneous, abstract images are very different from
the examples of traditional relief and intaglio prints that are shown in
Figures 2.1 and 2.2.

The exhibition catalog, *The Stamp of Impulse*, includes 100 prints by
100 printmakers; the full-page, full-color reproduction is on one side and
a bibliographic sketch of the artist and the techniques employed is on the
facing page.

Often my clients' rudimentary attempts at monotypes and relief
prints look like the prints in the exhibition catalog. Scribbled lines on a
mystery monotype are people interacting to one of my Down Syndrome
clients. His work looks like James Kelly's lithograph 'August' (p.113).
Colors oozing together from too much paint on a simple collagraph
reflect the conflict of a sophisticated woman who comes to art therapy to
try to balance her career and personal life. Her print reminds me of Helen

Frankenthaler's 'First Stone' (p. 187). Many depressed clients paint pictures that resemble Milton Resnick's untitled lithograph (p. 247). The anthropomorphic, linear etching 'Tropical Formation' reminds me of many drypoint prints created by art therapy students struggling with their own body image issues and carefully holding their lives together. My thoughts return to Edvard Munch and his struggle with physical and mental illness and the difference between his paintings and prints.

Art history and art therapy

In her article 'Dali to Beuys: incorporating art history in art therapy treatment plans,' Alter Muri (1996) describes her experience and conviction that clients benefit from seeing artworks from established artists. Alter Muri does not teach techniques or evaluate the artwork; she exposes clients to the art and artists as history and encourages discussion.

In her first case example, Alter Muri discusses Client W and how his self-esteem and concept of himself changed as he learned about artists whose work seemed similar to his. I also worked with this client on one of his inpatient stays; his artwork was raw and angry when he was hospitalized. As he stabilized, his work became more integrated and painterly. He understood himself as an artist and knew that he needed to paint. His example reminds me to have art history books in my art therapy studio and to leave *The Stamp of Impulse* available on the counter. I wonder if I had introduced Client W to simple printmaking how he would have responded to it. The value of printmaking as a safe container for intense imagery and emotions is yet to be explored.

Alter Muri's last illustration of exposing elderly clients to the art of abstract expressionists in order to encourage them to 'take risks, create larger works, and "free up"' (Alter Muri 1996, p.106) should have prepared me for my own discovery of the power of such imagery. Although I had read the article, I did not make the connection until I saw the Worcester exhibit The Stamp of Impulse. Seeing abstract expressionists' prints together confirmed my focus for this book. The power of printmaking to encourage spontaneous imagery is still new for art therapists (see Figure 11.1).

Figure 11.1 'Stary Night' by ML, drypoint

Advantages and disadvantages

The decision to introduce printing techniques to clients and then the choice of which to suggest can only be made on an individual basis. Each therapist or teacher first needs to understand and have personal experience with the printmaking materials and processes. Experiment. Practice. Explore. Then watch, guide, learn and experience the process with clients.

During the time that I have taken to get this book written, I have conducted a group called 'Painting for Joy'[©] for survivors of cancer. The group began at the request of Cancer Connection, Inc. as one of their programs to support survivors of cancer and to particularly address the issue of isolation and to provide an alternative form for expression. Advertised in large print is the phrase, 'No art experience necessary.' We use large brushes and acrylic paints and 'just paint.' Most paintings seem abstract initially with everyone painting at once and moving around the table. When the piece is hung up, images of body parts affected by cancer

are prevalent. Due to the physical limitations of some members, one hour is devoted to painting and the remaining time to discussing the experience and the images that seem to appear magically from the abstract collection of lines and shapes.

The first year of 'Painting for Joy,' the group created at least one 3" x 6" or circular acrylic painting each session. At the end of the year, the murals were hung in a huge conference hall during the annual Rays of Hope Cancer Survivors' Day and made a spectacular, joyful yet emotionally moving statement.

In the second year, group members began working individually for several reasons. The participants changed constantly due to illness, work commitments and death of one member, so periodically we returned to group work to reestablish community or welcome a new member. Some of the members moved on with personal imagery and individual painting styles and are committed to their own artistic process. One participant is a graphic designer and used simple, handmade stamps over her paintings, sometimes to cover up images that emerge unconsciously that are too painful to allow. She brought in supplies for others to make stamps, and I have suggested it frequently, but only one other person has used stamp printing to enhance her work.

The most enthusiastic member is also an an administrator of the program and thus in a dual role in the group. To address her frustration with repeating the same images and patterns and her expressed need for making parallel lines and 'making it perfect,' I introduced the group to monotypes. Some members were not interested and proceeded with their own painting. Oil paint proved to be too noxious smelling for some (as did some brands of acrylic,) so we use water-based block printing paint. We now have several participants enthusiastically making monotypes each week. The woman who was so enthusiastic yet frustrated with her own painting loves monotypes. She says, 'No responsibility!' 'So what, I can't control it...' 'I can't make parallel lines even if I try!'

This situation was a very appropriate use for the printmaking which has rekindled interest in the creative process. The monotype process has given certain members freedom to make messes and relinquish some control. Monotypes allow freedom that other processes and painting

skills will not. The group also needed to try something new even though the established process was working very well for most members.

The clinical examples in other chapters of this book suggest times to introduce printmaking, but ultimately the decision is up to you. The instructions provided here should be simple enough for anyone to follow, but the time to experiment is before you suggest a certain technique with a client. Unless you are familiar with the process and understand the problems as well as advantages of these materials, printmaking will be frustrating and unrewarding. Your comfort and facility with any one of these techniques is the beginning of any decision to use it. Then think of why it would be beneficial.

Three overriding concepts make printmaking different from painting, drawing, clay modeling and other artmaking traditionally used in therapeutic situations. Most importantly, printmaking increases the distance between the artist and the art created. Because it is an indirect process, the image initially created goes through at least one additional step before the end product is produced. This increase in creative distance can be a distinct advantage to reduce resistance to artmaking. The process itself becomes the focus of the session, and the image produced can be viewed with more objectivity. Many printmaking techniques do not require any drawing skills which is a great relief to most people. Perhaps the process just appears to be less serious or revealing. Kramer (1975, p.33) articulated how crafts seem to feel safer and do not reveal pathology as blatantly, and printmaking has the same feel to it. Consider using simple printmaking as an introduction or when your client or group is stuck or resistant. Perhaps use a printmaking process to include members who have not responded to other media.

The second other general advantage of printmaking is that it can provide artistic expression for many people who can not produce art using traditional media. Disabled, physically weak, ill or unfocused clients can participate in printmaking. The steps can be broken down into manageable ones; adaptive materials can allow many to create their own images. With luminous colors and interesting materials, clients who otherwise would have only been able to create extremely limited and often elementary looking paintings, drawing or sculptures can produce satisfying images and useful products.

The third major advantage of printmaking is that there are so many different techniques that you can choose one specifically to meet the needs of an individual client. Does the client like to draw? Would simple shapes or abstraction be more suitable? Does your client need the safety and containment of a small plate? Would focusing on adhering tapes to a plate for a relief print help calm and soothe him? Would rolling bright colors for a monotype free her to discuss control issues? Would a self-portrait drypoint aid an adolescent struggling with emerging identity? Would making cards for others in a nursing home get your client out of her room and socializing with others? The choices are many and can be made based on skill level, need for expansion or containment, safety, materials available, time, number of meeting times, the number of clients involved or other needs.

Table 11.1 is a list of advantages and disadvantages which has been prepared to get you thinking. You will notice that the columns seem to balance one another. Always make decisions based on your best under-standing of what would benefit your clients. Remember that printmaking is one of many choices but a good one in many situations.

Table 11.1 Advantages and disadvantages of printmaking

Printmaking advantages	Printmaking disadvantages
increases the therapeutic distance of client to art	client may need to work directly, or may not understand the abstraction
process is indirect	may be too many steps
uses simple available supplies	requires specific supplies
may be an unfamiliar art process	may be an unfamiliar art process
offers control and containment	some techniques may be too controlled
interesting to many age groups	initially may seem infantilizing
adaptable for disabilities	some processes too physically demanding

can be very messy	can be very messy
use found objects to create art	some objects do not print well
prints can be reworked, repeated	produces many images quickly
process can be broken down into small steps	requires several steps
each step can be separated	each step requires time
images can be reproduced easily	reproductions may vary
some processes do not require drawing skills	some processes require drawing skills
can be new and reduce resistance	can be overwhelming
simple techniques can be done by anyone	more difficult techniques may be too demanding for some clients
develops problem-solving skills	some techniques require problem-solving skills
can create beautiful, useful products	making products may not be indicated
success can be empowering and increase self-esteem	mistakes or technical failures may be discouraging
process can redirect behaviors	clients can get compulsive
materials can be inexpensive	materials (paper) can be expensive
creates a graphic look	can be regressive
different processes appropriate for different clients	different processes appropriate for different clients
delays gratification	two steps required to create print
client see images in a new way	images often are not what client envisions

Appendix

Sources for Supplies

ASW Art Supply Warehouse
for acrylics, paint, printing paper
5325 Departure Drive
North Raleigh, NC
USA 27616-1835
TEL: 1 800 995 6778; INTERNATIONAL: 001 919 875 5077
FAX: 1 919 878 5075
www.aswexpress.com

Boesner Warehouse Store for Arts Supplies
Nunsdorfer Ring 2
12277 Berlin
Germany
TEL: 72 00 83 33
FAX: 72 00 83 55

Createx™ Handels, GmaH
for Createx™
Kirchhoffster 7
D-2568 Kaltenkirchen Germany
TEL: 4191 88277
FAX: 4911 85912

Dick Blick Art Materials

for Litho Sketch®, screen supplies and Speedball Screen Filler and Drawing Fluid, paints, relief plates, paper, paint, presses, Flexi-Cut, soft cut, E-Z Cut, printfoam, brayers, etching ink, Mark-Ease, screen printing chart, printing paper

PO Box 1267
Galesburg, IL
USA 61402-1267
TEL: 1 800 447 8192; INTERNATIONAL: 001 309 343 6181
FAX: 1 800 621 8293
www.dickblick.com

Discount School Supplies

for refillable large marker/stampers, washable paint, roller stamps

PO Box 7636
Spreckels, CA
USA 93962-7636
TEL: 1 800 627 2829; INTERNATIONAL: 001 831 333 2000
FAX: 1 800 879 3753
www.earlychildhood.com

Jackson's Art Supplies Ltd

for paint
PO Box 29568
London, N1 4WT
TEL: (0)20 7359 7718
FAX: (0)20 7354 3641
www.jacksonsart.com

Jerry's Artarama

for Createx™, paper, paint, Max paints, presses, printing paper, etching inks

PO Box 58638
Raleigh, NC
USA 27658
TEL: 1 800 827 8478; INTERNATIONAL: 001 919 878 6782
FAX: 1 919 873 9565
www.jerryscatalog.com

NASCO Arts & Crafts

for Magic Stamp™, presses, paper, Speedball Screen Filler And Drawing Fluid, paints, Createx™, refillable large marker/stampers, fabric paints, Mask-Ease, screen supplies, Litho-Sketch, Safety-Cut, Scratch-Foam, flexible printing plates, brayers, styrofoam with adhesive backing, printing paper
901 Janesville Avenue
Fort Atkinson, WI
USA 53538-0901
TEL: 1 800 558 9595; INTERNATIONAL: 001 209 545 1600;
001 920 563 2446
FAX: 920 563 8296
info@eNASCO.com

Reynolds Metal Company

for Reynolds freezer paper (available at US grocery stores)
Richmond, VA
USA

Triarco Arts & Crafts

for Litho Sketch®, screen supplies, Createx™, paint (many supplies only in kits), Wax-O™ stencil paper, large refillable marker/stampers, Soft-Cut, Balsa-Foam, brayers, presses, paper
14650 28th Avenue North
Plymouth, MN
USA 55447
TEL: 1 800 328 3360; INTERNATIONAL: 001 763 559 5590
FAX: 763 559 2215
info@triarcoarts.com

References
and Additional Reading

References

Acton, D. (2001) *The Stamp of Impulse: Abstract Expressionist Prints*. Worcester, MA: Worcester Art Museum, Snoech-Ducaju and Zoon.

Adire, C. (2001) 'Asante Adinkra Cloth.' http://www.adire.clara.net/adinkrara introduction.htm

Allen, P. (1995) 'Coyote comes in from the cold: the evolution of the open studio concept.' *Art Therapy: Journal of the American Art Therapy Association 12*(3), 161–166.

Alter Muri, S. (1996) 'Dali to Beuys: incorporating art history in art therapy treatment plans.' *Art Therapy: Journal of the American Art Therapy Association 13*(2), 102–107.

ARTnews (2001) 'The 32,000-year-old woman.' *ARTnews 100*(7), 80.

Ault, R. (1986) *The Healing Vision*. Video. Topeka, KN: Menninger Foundation.

Avrin, L. (1991) *Scribes, Scripts and Books: The Book Arts from Antiquity to the Renaissance*. Chicago, IL: American Library Associations and London: British Library.

Baffier, D. and Feruglio, V. (1998) 'First observations of two layers of dots at Chauvet-Pont-d'Arc cave (Pont-d'Arc Valley, Ardèche, France).' *INORA International Newsletter on Rock Art, 22*. www.culture.gouv.fr/culture/arcnat/chauvet/en/rech4.htm

Caplan, T. (1993) *The First Twelve Months of Life*. New York: Perigee.

Cole, B. and Gealt, A. (1989) *Art of the Western World*. New York: Summit.

Conroy, R. (1986) 'Process-centered art therapy in anorexia nervosa.' *British Journal of Occupational Therapy 49*, 322–323.

de Hamel, C. (1992) *Medieval Craftsmen, Scribes and Illuminators*. London: British Museum Press.

Drucher, J. (1995) *The Century of Artists' Books*. New York: Granary.

Dunlop, I. (1977) *Edvard Munch*. New York: St. Martin's Press.

Farrelly, M. (2000) '"Buffalo Spring," monoprint and colored pencil.' *Art Therapy: Journal of the American Art Therapy Association 17*(3), cover.

Gister, C. (1981) 'Art for children with very special needs.' *SchoolArts 81*(4), 24–25.

Graham, J. (1994) 'The art of emotionally disturbed adolescents: designing a drawing program to address violent imagery.' *American Journal of Art Therapy 32*, 115–121.

Hurwitz, A. and Day, M. ([1958]1995) *Children and their Art.* New York: Harcourt Brace.

Kasfir, S. (1999) *Contemporary African Art.* New York: Thames and Hudson.

Katz, E. (1993) 'Art, aging and developmental disabilities.' *Activities, Adaptation and Aging 17*(4), 11–15.

Kläger, M. (1992) 'Nonverbal thinking and the problems of decoding exemplified by artwork of people with development disabilities.' *American Journal of Art Therapy 31* (2), 41–45 (Nov).

Kramer, E. (1971) *Art as Therapy with Children.* New York: Schocken.

Kramer, E. (1975) 'Art and craft.' In E. Ulman and P. Dachinger (eds) *Art Therapy in Theory and Practice.* New York: Schocken.

Kramer, E. (1979) *Childhood and Art Therapy: Notes on Theory and Application.* New York: Schocken.

Kramer, E. (2001) 'Art therapy with Edith Kramer.' Workshop at Springfield College, Springfield, MA, April 21, 2001.

Landgarten, H. (1990) 'Edvard Munch: an art therapist viewpoint.' *Art Therapy, Journal of the American Art Therapy Association 8*(30),11–16.

Lee, S. ([1964]1982) (4th edn) *A History of Far Eastern Art.* New York: Prentice-Hall.

Linderman, T. and Stewart, K. (1999) 'Sensory integrative-based occupational therapy and functional outcomes in young children with pervasive developmental disorders: a single subject study.' *American Journal of Occupational Therapy 53*, 207–213.

Lowenfiled, V. (1970) (5th end) *Creative and Mental Growth.* New York: MacMillan.

Lowenfeld, V. and Brittain, W. (1987) *Creative and Mental Growth.* New York: MacMillan.

Ludins-Katz, F. and Katz, E. (1990) *Art and Disabilities, Establishing the Creative Art Center for People with Disabilities.* New York: Brookline.

McGraw, M. (1995) 'The art studio: a studio-based art therapy program.' *Art Therapy: Journal of the American Art Therapy Association 12*(3), 167–174.

McNiff, S. (1995) 'Keeping the studio.' *Art Therapy: Journal of the American Art Therapy Association 12*(3), 179–183.

Malchiodi, C. (1995) 'Studio approaches to art therapy.' *Art Therapy: Journal of the American Art Therapy Association 12*(3), 154–156.

Malchiodi, C. (1998a) *Understanding Children's Drawings.* New York: Guilford Press.

Malchiodi, C. (1998b) *The Art Therapy Sourcebook.* Los Angeles, CA: Lowell House.

Pichini, C. (1994) 'Vanishing initials.' *SchoolArts 94*(2), 44–45.

Preble, D. and Preble, P. ([1973]1994) (5th edn) *Artforms.* New York: HarperCollins.

Quiller, S. (1989) *Color Choices, Making Color Sense out of Color Theory.* Oxford: Phaidon.

Raunft, R. (1981) 'The desperate printmakers.' *SchoolArts 80*(8), 18–22.

Robbins, A. (1994) *A Multi-Modal Approach to Creative Art Therapy.* London: Jessica Kingsley Publishers.

Roberts, J. (1989) 'Dog prints.' *SchoolArts 89*(11), 20–21.

Romano, C. (1980) *The Complete Collagraph.* New York: Free Press.

Saff, D. and Sacilotto, D. (1978) *Printmaking, History and Process.* Orlando, FL: Holt, Rinehart and Winston.

Schneider, S., Ostroff, S. and Legow, N. (1990) 'Enhancement of body-image: a structured art therapy group with adolescents.' *Art Therapy F90*, 134–138.

Selz, J. (1976) *E. Munch*. New York: Crown.

Sietsema, J. (1993) 'The use of a game to promote arm reach in persons with traumatic brain injury.' *American Journal of Occupational Therapy 47*, 19–24.

Skophammer, K. (1994) 'Art with an attitude.' *Art and Activities N*, 14–15.

Sprayregen, B. (1989) 'Brief inpatient groups: a conceptual design for art therapists.' *American Journal of Art Therapy 28*, 13–17.

Steinbeck, T. (1986) 'Purposeful activity and performance.' *American Journal of Occupational Therapy 40*, 529–534.

Stember, C. (1977) 'Printmaking with abused children: a first step in art therapy.' *American Journal of Art Therapy 16*(3), 104–109.

Storr, R. (1998) *Chuck Close*. New York: Museum of Modern Art.

Stronach-Buschel, B. (1990) 'Trauma, children, and art.' *American Journal of Art Therapy 29*, 48–52.

Timm-Bottos, J. (1995) 'ArtStreet: joining community through art.' *Art Therapy: Journal of the American Art Therapy Association 12*(3), 184–187.

Waller, D. (1993) *Group Interactive Art Therapy*. London and New York: Routledge.

Weiss, J. (1984) *Expressive Therapy with Elders and the Disabled: Touching the Heart of Life*. New York: Haworth.

Yalom, I. (1985) *The Theory and Practice of Group Psychotherapy*. New York: Basic Books.

Additional reading

Alter Muri, S. (1998) 'Texture in the melting pot: postmodernist art and art therapy.' *Art Therapy: Journal of the American Art Therapy Association 15*(40), 245–251.

Ayres, J. (1993) *Printmaking Techniques*. New York: Watson-Guptill.

Baker, P. (1978) *African Art: Adinkra Cloth*. Urbana, IL: African Studies Program, Illinois University.

Bilderbacker, T. (1977) 'Students print a calendar.' *SchoolArts 77*(4), 18–19.

Boyle, V. (1980) 'Exploring Eskimo Territory.' *Teacher 98*, 58–59.

Cappetta, A. (1990) 'Book craft.' *SchoolArts 90*(4), 37–38.

Dawson, J. (ed) (1981) *The Complete Guide to Prints and Printmaking: History, Materials and Techniques from Woodcut to Lithography*. New York: Quill.

Emberley, E. (1970) *Fingerprint Drawing Book*. Boston, MA: Little, Brown.

Emberley, E. (1977) *Great Thumbprint Drawing Book*. Boston, MA: Little, Brown.

Emberley, E. (2001) *Drawing Books of Animals*. Boston, MA: Little, Brown.

Eydenberg, M. (1986) 'Art therapy for the severe and profound.' *Child and Family Behavior Therapy 8*(2), 1–3.

Garfield, N. (1972) 'Silk screening on a shoestring.' *Art Teacher 2*(3), 37.

Haeseler, M., Fleming, M., Knowles, L. and Spaniol, S. (1996) 'Who owns the artwork? Or "Do the right thing!"' *Art Therapy: Journal of the American Art Therapy Association 13*(2), 89–90.

Harden, E. (1995) *Print Making*. Edison, NJ: Chartwell.

Henley, D. (1990) *Exceptional Children, Exceptional Art: Teaching Art to Special Needs.* Worcester, MA: Davis.

Hughes, J. (1989) 'Art in psychosocial (OT): guidelines for use and an art exercise battery.' *American Journal of Occupational Therapy 36*, 14–23.

Johnson, C., Lahey, P. and Shore, A. (1992) 'An exploration of creative arts therapeutic group work on an Alzheimer's unit.' *Arts in Psychotherapy 19*(4), 269–277.

Kerr, M.P. (1995) 'Collagraph prints under pressure.' *SchoolArts 95*(3), 31–32.

Koscis, R. (1983) 'Monomask printing.' *SchoolArts 83*(8), 30–31.

Lloyd, C. and Papas, V. (1999) 'Art as therapy within occupational therapy in mental health settings: a review of the literature.' *British Journal of Occupational Therapy 62*, 31–35.

Lynch, M. and Margolis, C. (1985) 'Multi-sensory printmaking.' *SchoolArts 84*(8), 16–17.

Mansfield, P. and Sanford, B. (1979) 'Tin can textile printing.' *SchoolArts 78*(9), 36–38.

Mayer, R. (1991) *The Artist's Handbook of Materials and Techniques.* New York: Viking.

Miller, L. (1976) 'Printmaking from an inner tube.' *SchoolArts 75*(5), 46–47.

Moore, R. (1983) 'Printmaking on a tight budget.' *SchoolArts 82*(8), 35–38.

Morris, J. (1989) 'More lessons from a Master Teacher! Frank Wachowiak.' *SchoolArts 89*(3), 34–35.

Neri, L. (1999) 'Alienated kids.' *Lesley Magazine F99*, 26–29.

Newman, T. (1977) *Innovative Printmaking.* New York: Crown.

O'Malley, W. (1972) 'Polystyrene prints.' *SchoolArts 69*(4), 20–23.

Orleman, J. (1998) *Telling Secrets, an Artist's Journey through Childhood Trauma.* Washington, DC: Child Welfare League of America.

Schwartz, B. (1988) 'Kenojuak Ashevak: young owl takes a ride.' *Art Education 41*(1), 25–26.

Schwartz, N. (1996) 'Observer, process, and product.' *Art Therapy: Journal of the American Art Therapy Association 13*(4), 24–51.

Skophammer, K. (1994) 'Art with an attitude.' *Art and Activities N*, 14–15.

Solga, K. (1991) *Make Prints.* Cincinnati, OH: North Light Books.

Spaniol, S. (1989) 'Exhibiting art by people with mental illness: issues, process and principles.' *Art Therapy: Journal of the American Art Therapy Association 7*, 70–78.

Spaniol, S. (1990) *Organizing Exhibitions of Art by People with Mental Illness: A Step-by-step Manual.* Boston, MA: Center for Psychiatric Rehabilitation, Boston University.

Spaniol, S. (1994) 'Confidentiality reexamined: negotiating use of client art.' *American Journal of Art Therapy 32*(30), 69–74.

Stilwell, J. (1987) 'The development of manual midline crossing in 2–6 yr. old children.' *American Journal of Occupational Therapy 41*, 783–789.

Stoltenberg, D. (1975) *Collagraph Printmaking.* Worcester, MA: Davis.

Summers, J. (1990) 'The book as an art form.' *SchoolArts 90*(4), 32–33.

Warren, B. (ed) (1993) *Using the Creative Arts in Therapy.* New York: Tavistock/Routledge.

Wenniger, M. (1975) *Collagraph Printmaking: The Techniques of Printing from Collage-Type Plates.* New York: Watson-Guptill.

Glossary

Brayers: rollers.

Chalkboard: blackboard.

Clothespins: clothes pegs.

Cornstarch: corn flour.

Craypas: an inexpensive type of oil pastels.

Duct tape: very strong, sticky, usually silvery tape with many uses.

Elmer's Glue: an all purpose, non-toxic white glue that dries fast and Clear.

Faucet: tap.

Found objects: any common object found in house or classroom, i.e. spools, bottle caps, hair curlers, sponges, corks, forks, potato mashers, egg cartons, package inserts, lace, textured cards, glasses, pot lids, corrugated board, foil, anything with interesting flat shape or texture.

Giclee: a very high quality, high-resolution computer generated fine art reproduction.

Kerosene: a thin oil distilled from petroleum used to clean up oil based paint (British equivalent is paraffin).

Lestoil: a concentrated, heavy duty cleaner for grease stains. Made by the Clorox Co. Oakland, CA, USA, www.colrox.com.

Mandala: in Asian art and religion, any of various designs symbolic of the universe. In art therapy, interpreted in many ways but usually applied to symbols arranged in a circular form.

Masonite: a type of inexpensive, brown fibreboard used for panelling, partitions or insulation that comes in panels 4' x 8' and in

1/8" and 1/4" thicknesses. Can be cut and scored with a utility knife. Found in building supply stores.

Mat board: paper board available in varying degrees of thickness, commonly from 2 ply to 14 ply, used as a stiff paper frame around a print or to make a plate.

Medicaid: US form of socialized medical care.

Murphy's Oil Soap: a gentle household cleaner for wood surfaces that emulsifies grease. Made by Colgate-Palmolive Co. New Your, NY, USA, 1-800-486-7627 or www.murphyoilsoap.com.

Plexiglass®: a light, permanently transparent, weather-resistant thermoplastic used as a non-breakable substitute for glass. Found in building supply, hardware and picture framing stores.

Ronald McDonald Houses: in the US, near most major hospitals there is a house where family members of hospitalized children may stay free of charge. The houses are just neighbourhood houses that are purchased, maintained and staffed by the McDonald Corporation and community volunteers.

Sobo Glue: similar to Elmer's Glue but withstands freezing and seems to be stronger.

Soft paper: paper made for printmaking of 100 per cent rag fibre, various weights and sizes, such as Rives BFK, Arches, Cover, Somerset and Folio. Available from art supply stores and catalogs.

Styrofoam: a light, resilient polystyrene plastic used in US grocery stores to package meat and vegetables, also used by fast food stores to sell hamburgers (not neoprene).

Wisk: a laundry detergent that is especially effective in removing screen filler from polyester screens available at most US grocery stores or www.eshop.com or www.wisk.com.

Subject index

Author index

10405669R00142

Printed in Great Britain
by Amazon.co.uk, Ltd.,
Marston Gate.